MANUFRACTURED

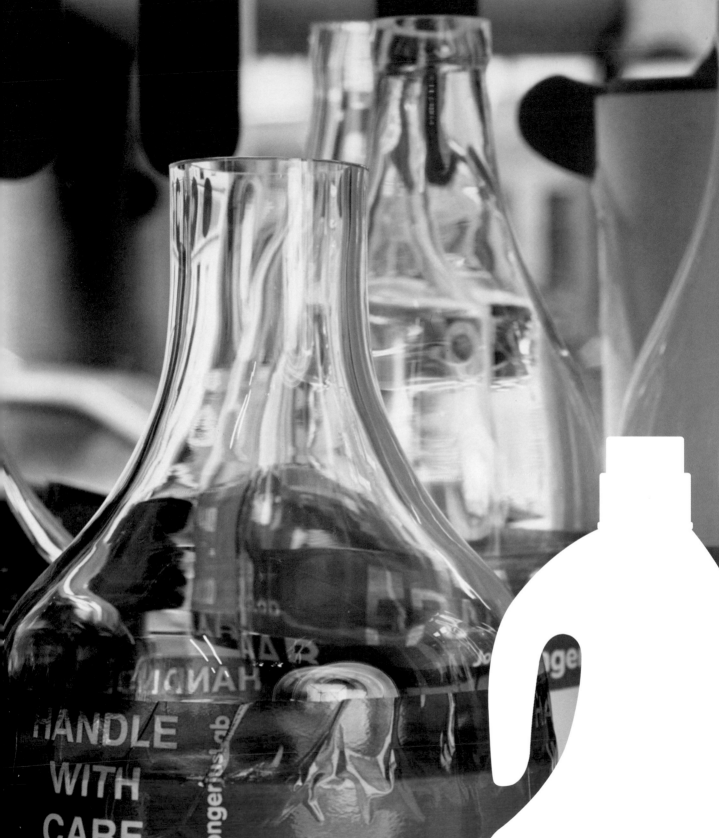

Steven Skov Holt and Mara Holt Skov

MANUFRACTURED
The Conspicuous Transformation of Everyday Objects

CHRONICLE BOOKS
SAN FRANCISCO

Do what you believe in—and then you'll be able to believe in what you do.

Fight the power(s).

Bridge boundaries.

Refuse work that creates unnecessary barriers between people.

"This is not my beautiful house. This is not my beautiful car. This is not my beautiful wife." —Talking Heads

People rarely, if ever, solely own anything outright—we only borrow things for a short while.

"It's easy enough to choose between a 'but' and an 'and.' It's a bit more difficult to decide between 'and' and 'then.'" —Albert Camus

We humans are both the stumbling block and the enduring mystery.

"You have to open yourself up to the data." —Don Delillo

The most radical thing that we can do today is to care.

"Ars longa. Vita brevis." —Hippocrates

"Tempus fugit." —Virgil

"Every moment matters." —Us

Library of Congress Cataloging-in-Publication Data available.

ISBN: 978-0-8118-6509-8

Manufactured in China

Design by Gregory Hom of fishbowl design, with creative connections by Steven Skov Holt and Mara Holt Skov.

Pages 157–160 constitute a continuation of the copyright page.
BubbleWare is a trademark of William R. Sistek.
The Chartpak Colored Film Sticker is a trademark of Chartpak, Inc.
Extreme Adhesive Glue is a trademark of Adhesive Engineering & Supply, Inc.
Jell-O is a trademark of Kraft Foods Holdings, Inc.
The Letraset Marker Pen is a trademark of Esselte Pendaflex Corporation.
Plexiglas is a trademark of Rohm and Haas Company.
Prozac is a trademark of Eli Lilly and Company.
Slim-Fast is a trademark of Unilever Supply Chain, Inc.
Styrofoam is a trademark of Dow Chemical Company.
Thorazine is a trademark of GlaxoSmithKline plc.
Zoloft is a trademark of Pfizer Inc.

10 9 8 7 6 5 4 3 2 1

Chronicle Books LLC
680 Second Street
San Francisco, CA 94107

www.chroniclebooks.com

Page 2
Hella Jongerius
Groove and Long Neck Bottles 2000
Glass, porcelain, plastic packing tape

Page 6
Régis Mayot
Dissection 2001
Photograph of carved plastic bottles

To our parents in Idaho and Connecticut, to Larson, and to each other (e.m.m.).

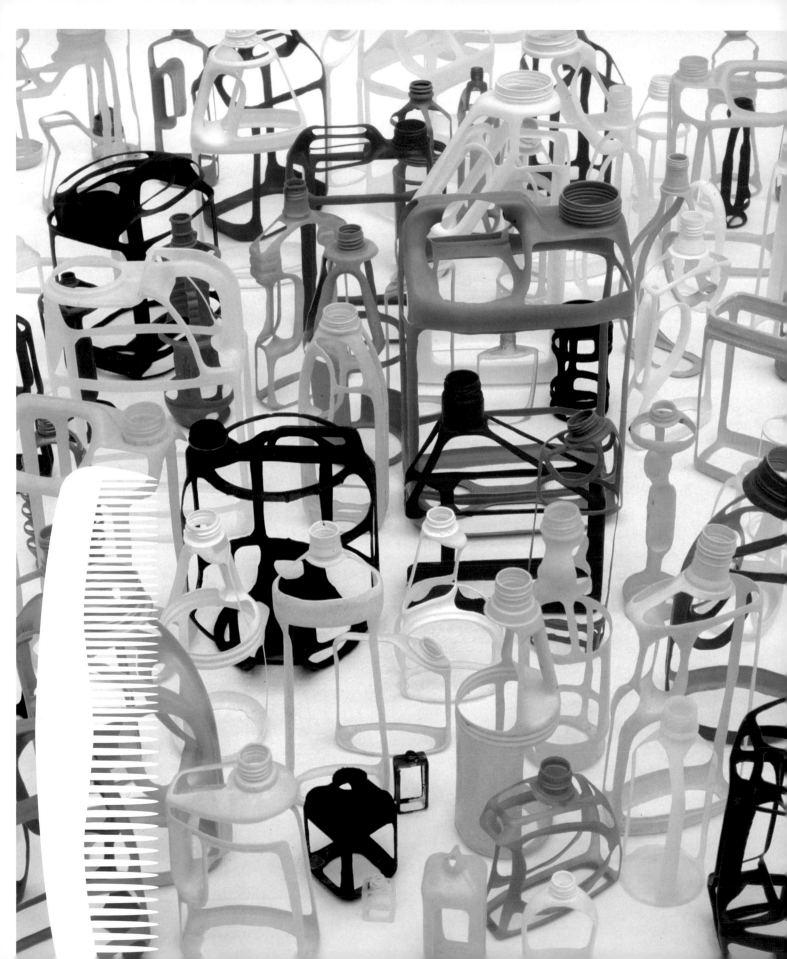

"The connections, the connections. It will in the end be these details that … give the product life." —Charles Eames, designer

Contents

"What pattern connects the crab to the lobster and the orchid to the primrose and all the four of them to me? And me to you? And all the six of us to the ameoba in one...

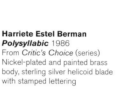

Harriete Estel Berman
Polysyllabic 1986
From *Critic's Choice* (series)
Nickel-plated and painted brass
body, sterling silver helicoid blade
with stamped lettering

Acknowledgments

Like so many projects that are worth doing, this book was both a pleasure and a struggle. It would not have been possible without the contributions of many people who have provided moments of inspiration and assistance of a nontrivial nature; the following deserve special mention.

At Chronicle Books our editor Alan Rapp proved to be as flexible and amenable as always. Team members Bridget Watson Payne, Tera Killip, Doug Ogan, Molly Jones, Patti Quill, and Brooke Johnson provided timely administrative, production, editorial, and design assistance. We were honored to have the opportunity to add book number two to their hip and varied list of titles.

This was our second book project (after *Blobjects & Beyond* in 2005) with art director Gregory Hom and Tracy Powers, cofounders of San Jose–based fishbowl design. Gregory, our dear friend and colleague, oversaw every page from conception through production; his engagement in *Manufractured* is evident in the book's confidently crafted and appropriately artful design. Additionally, graphic designer Kate Rascoe (a past student of ours at California College of the Arts) assisted in the initial image preparation, and close friend Katherine Gin helped us with photographs.

At the Museum of Contemporary Craft in Portland, Oregon (host of the exhibition component of *Manufractured*), our thanks to curator Namita Gupta Wiggers who has been passionately engaged in this project since we first proposed it in the spring of 2006. In addition, we are grateful to Executive Director David Cohen and his staff for their ongoing support. Special thanks to Curtis and Mary Rob Finch, former board members who were our initial points of contact and who have shared their enthusiasm for *Manufractured* from the very beginning.

Thanks to our colleagues at California College of the Arts in San Francisco, where we both teach, notably President Stephen Beal, Executive Vice President David Meckel, Chair of the Industrial Design Program Yves Behar, and Chair of Graduate Design Studies Brenda Laurel. CCA provided key initial support, including a faculty research grant that assisted in our early investigations.

Friends and colleagues Jay Baldwin, Hartmut Esslinger and Patricia Roller, A.V. Klotz, Leslie Speer, Michael McDonough, and Corinne Trang provided welcome encouragement and editorial opinions. Due to personal and medical challenges, Steven needed special support and he received it from many people; the following were especially inspiring—Harrison Alter, Thomas Bley, Gamelieh Hubp, Gary Natsume, Laura Stanley, Tucker Viemeister, and Lori Ann Weitzner.

Adding to the pleasure of realizing the project, five of the individuals selected for *Manufractured* have been longtime colleagues and frequent sources of creative inspiration to Steven since he first came to know their work in the 1980s. They are Harriete Estel Berman, Constantin Boym, Boris Bally, and the late Gaza Bowen and Dan Friedman. Each one of them provided some of the seeds for *Manufractured* over the years through the interdisciplinary and interrogative nature of their work. To them, and to all the individuals whose work is represented in this book—no matter their creative label—they are the prime movers, the ones who innervate the inorganic, who truly show every day that curiosity and creativity are the highest human conditions we may ever aspire to.

In closing, we want to say that *Manufractured* wasn't simply an authorial and curatorial opportunity. It was a passionate mission we undertook, another step on our journey to do projects that matter, that have intrinsic meaning, and that offer new ways of "searching for the patterns that connect" people and their objects. Like our earlier book (*Blobjects & Beyond*), we orchestrated this entire project. Some call this series of activities "book packaging," but this feels like an ancient term—a pre-internet, dusty, 1980s New York kind of term. *Manufractured* was more than just a packaging exercise. It was a three-way collaboration—a Holt, Skov, Hom production—that reveled in our subject's apparently infinite complexity, even as it suffered through the schedule's seemingly similar duration. During the course of this project we were able to empirically verify that that which does not kill you can make you stronger. However, we also verified that even if the project doesn't kill you, certain aspects of it can still confound, disturb, disfigure, injure, emotionally maim, and generally mess you up but good. If nothing else, we now know that either we are not so good at this sort of thing, or we must be doing something very wrong. Like breaking a commandment or flouting a law of nature.

So why on Earth do we do this? What is our problem? We do it because we don't really have a choice. We do it for the same reason(s) that any other artist does—because we are compelled to do it. Compelled by our ideas and subject matter. It's a commitment, a responsibility. Something honorable that we feel only we can do, at least in the particular way that we do things. How many people can say that about their work? We choose it, but it certainly feels like it chooses us as well. As we shape the content, we listen to it and it guides us, and we in turn are shaped by it. When it's humming, it's a recursive loop, a back-and-forth dance of creative discovery that engages us on the most meaningful of levels. (When it's not, well, the word *grueling* comes to mind.) We hope that we have shared some of the excitement we have for these strangely robust, elegantly abnormal, patently artificial constructs that we have labeled manufractured objects—the truths that they tell us of ourselves, our society, and our cultural moment request no less.

Steven Skov Holt and Mara Holt Skov
San Francisco, California

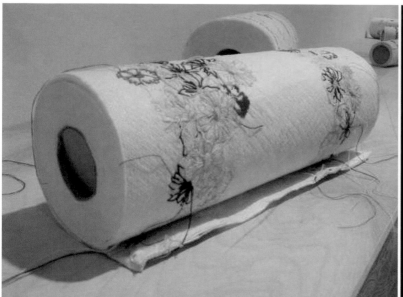

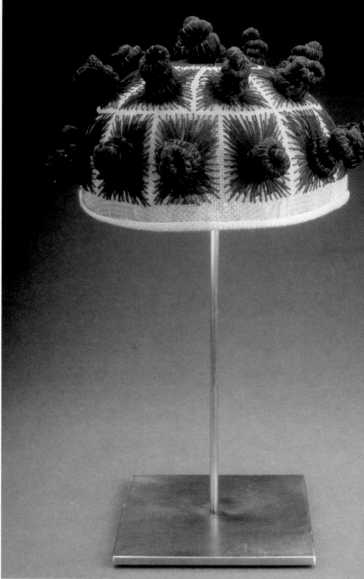

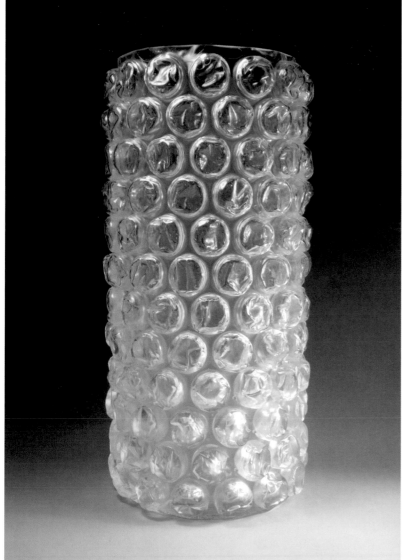

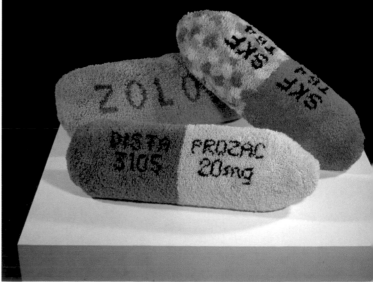

Steven Skov Holt

Introduction: Art, Craft, and Design Realigned

At the beginning of this new century, craft was in crisis mode. Craft was being banished from institutions, organizations, and general civilized discourse, sending craft-centric circles spinning with anxiety about the future of their field. Some of the greatest fears took hold when New York's Museum of American Craft became the Museum of Arts & Design in 2002. Just a year later, the California College of Arts and Crafts (where I have been on the faculty since 1995) became California College of the Arts. But it wasn't just the large urban institutions that were shifting semantic positions. Even small-town arts organizations were experiencing similar existential moments. In historic Avon, Connecticut, the Avon Arts and Crafts organization, a group of modest but sincere practitioners (my mother included), dropped the term crafts to become the Avon Art Association in the belief that the change elevated their collective pursuits. Some in the craft world embraced the changes while others responded with grumbling, confusion, and even anger.*

Did this banishment of the term signal a final farewell to craft? Did the globalization of the 21st century finally vanquish what the great machines of the previous century could not? Did the craft meme collapse under the weight of its stubborn traditionalists and their own overwrought, hand-made, undoubtedly weighty baggage, or were malevolent forces from the outside doing it in?

The answer, of course, was an immediate, an unequivocal and resounding *No*. Craft was not expiring as much as it was changing, evolving in a way that few could identify and that even fewer could anticipate. In fact, the small-scale titular loss of craft on one level turned out to be the rediscovery of craft on numerous others. Craft materials emerged as a key constituent of contemporary sculpture; craft processes found new relevance as industrial designers explored the promise of rapid prototyping and individualized production; luxury brands focused marketing muscle on their products' artisanal traditions; a surge in hand-made typography reenergized graphic projects everywhere—from restaurant menus to corporate identities.

In retrospect, what we experienced (with the term "craft") was merely a linguistic switcheroo, not the radical systemic shift that insiders feared. Even though the word lost some of its prominence, the key signifiers of craft remained undiminished. Craft—the process, the intention, and the action verb centered on a deep and abiding sense of materiality—has seemingly been inserted back into everything that matters most in visual culture. It is not that everyone is doing it, but select artists from nearly every creative field—from art to design, music to theater, and cinema to literature—have been quick to claim or reclaim "craft" as part of their professional heritage, an integral part of their toolkit, and absolutely essential to the creation of great work. While the word may have disappeared from some very visible marquees, the good news is that the material concerns, processes, and transformations that craft addresses are enjoying larger and more visually literate audiences than ever before.

This is not surprising. In the wake of a drawn-out military escalation, a new level of political disenchantment has set in. With repeated announcements of local and global environmental degradation, and all-too-real experiences of economic decline, the first years of this century have been challenging for everyone. Clearly, times such as these demand different types of creative responses. First among them has been a strong impulse to simplify and to get back to basics, coupled with an almost desperate desire for authentic experiences. People from all walks of life have sought out the sense of community offered by knitting, sewing, and scrapbooking circles, just as they have developed new kinds of communities in the virtual world through blogging, MySpace, and other social networking sites. Various "slow movements" in food, design, and living have taken shape. The do-it-yourself (DIY) impulse has generated a new and willing demographic and become a market force in its own right. Craft has been a key part of all of these trends.

The leading edge of craft embraces technology and new materials, especially the often derided industrial workhorse—plastic. Plastic has allowed craft to break out of traditional boundaries into areas previously thought to be the exclusive territory of art and design. This new kind of craft (from which *Manufractured: The Conspicuous Transformation of Everyday Objects* was born) favors ambiguity and seizes upon the opportunity to produce hybrid forms. It is increasingly augmented by computer modeling and buttressed by an array of molding, machining, and prototyping technologies. It looks to scientific forms and mathematical formulae for inspiration, but also to new areas of expression in the visual arts. Most important, craft is now frequently infused with highly conceptual thinking. Craft has become an abstract proposition in which ideas count—it is now thoroughly and unmistakably contemporary.

Recently, a series of difficult-to-categorize craft-based projects have come into view. Massive, full-scale cozies knit as covers for decommissioned missiles. Vases made from glass blown to mimic the texture of plastic bubble wrap. Chandeliers, bowls, and chairs made from scavenged materials. "Drawings" sewn on fabric and paper. Sculptures constructed from dozens, if not hundreds, if not thousands of the kind of banal objects we encounter every day yet pay minimal attention to.

Taking a step back, I see a welcome willingness among artists, craftspeople, and designers to approach, absorb, and act upon new ideas, new ways of making, and new types of materials. The results so far have been three-fold: one—the creation of a class of mysterious objects that are art-craft-design hybrids, two—the utilization of a wide range of already manufactured products as a powerful and ample new kind of raw material, and three—an elevated attention, curiosity, and dialogue among growing numbers of visually literate afficionados, collectors, and consumers. More people than ever are turned on to the merits, opportunities, and pleasures endemic to twenty-first-century object-making.

It no longer matters whether curators, educators, critics, or other media mavens label these individual objects as art, craft, or design. The projects presented here in *Manufractured* are all three of these. The old debate over the role of craft versus art versus design may well be babbling on somewhere, but from where I sit the debate is exhausted, unlikely to produce important new work or fresh thought on the subject. The outpouring of work in these pages confirms the fundamental irrelevance of this argument and the fundamental vigor of the new "manufractured" paradigm.

As object-making has gone in the direction of manufracturing, it has increasingly drawn upon and brought together the lessons, processes, and intellectual challenges that artists, crafts-people, and designers negotiate at the highest echelons. Many interesting questions are suddenly clamoring to be asked. These questions (even more than the answers perhaps) will accelerate the rate of innovation and the possibilities for change in the visual arts, indeed in all of creative culture.

In so many ways, craft is still about what it was always about—the integral process of making, the joy of mastery, material exploration, secret but attainable knowledge, the mark of the maker, reference points to human scale, the kinesthetic relationships between hand and mind, and honest and sincere rendition. But such a moment as ours—deeply quixotic, post-credible, and intimately interwoven—offers the opportunity to see craft for its symbiotic connection to other creative disciplines. The infusion of these craft-defined qualities into other creative fields only serves to strengthen them all.

Lifting a lesson from popular culture (something that manufractured objects are prone to do), consider the story of the venerable Obi-Wan Kenobi. He died a noble death in *Star Wars*, willingly succumbing to Darth Vader's light saber so that his energy could be released throughout the universe. In a similar way, craft has vanished one moment only to manifest more broadly than ever a moment later. This time it has been absorbed into seemingly every element of creative culture—a powerful force and equally powerful source guiding the makers of objects whenever and wherever questions of material-based poetics are raised, celebrated, and rewarded.

*Another historic craft institution went through a similar questioning period around the same time as the Museum of Arts and Design and California College of the Arts, but with different results. In 2007, the 70-year-old Contemporary Crafts Museum & Gallery in Portland, Oregon, changed its name to The Museum of Contemporary Craft, and focused on the term "craft" in it most active form, as a verb. This book and its eponymous exhibition (August 28, 2008–January 4, 2009) are part of their mission to present new, relevant, and expansive ways to define the discipline.

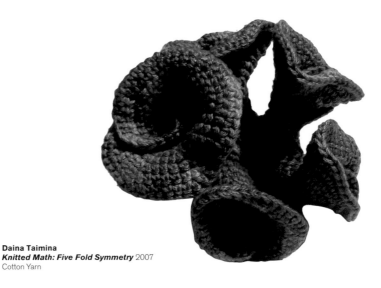

Daina Taimina
Knitted Math: Five Fold Symmetry 2007
Cotton Yarn

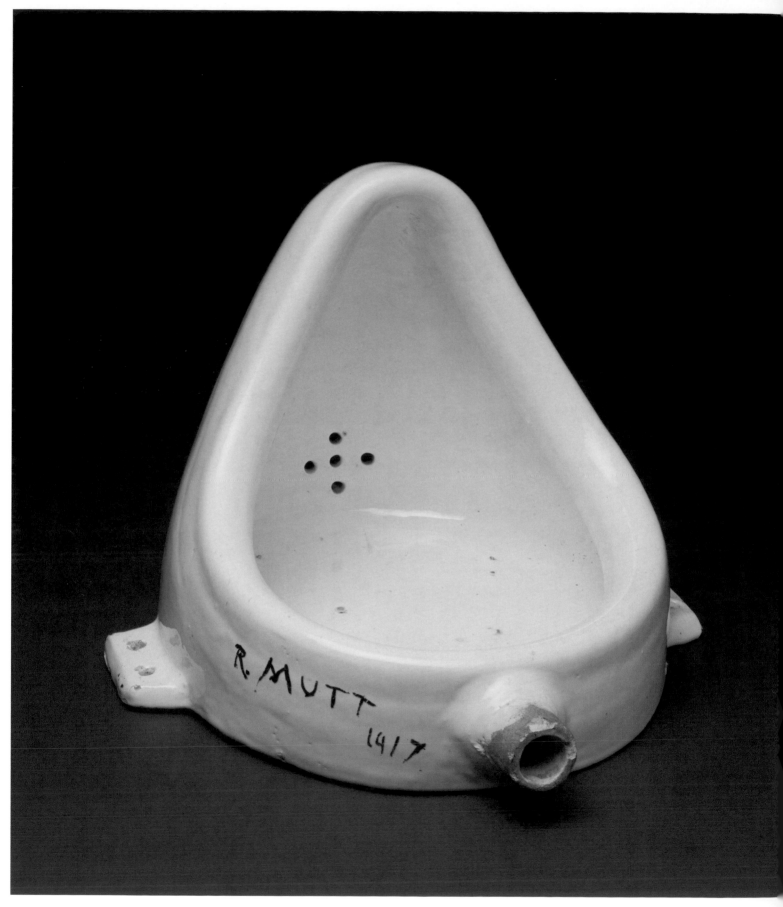

Manufactured **From Readymade to Manufactured: Some Assembly Required**

Steven Skov Holt

FROM READYMADE TO MANUFRACTURED: SOME ASSEMBLY REQUIRED

Arguably, the most important piece of sculpture in the entire twentieth century—perhaps the most significant cultural creation in all of the visual arts—was barely even seen as a work of art when it was first submitted for exhibition. If anything, it was seen as a joke. As an example of art's untimely yet predictable demise. As a protest over the artist's conceit that it was possible to create something new just over a decade after Pablo Picasso and Georges Braque had fractured the flat picture plane in their Cubist explorations.

In the end, the piece was never shown in the context it was created for—The Society of Independent Artists 1917 exhibition in New York City. It was barred from display and disappeared shortly thereafter. But its story has not been lost and the sculpture has since been accepted into the canon of modern art history, labeled by academics and practitioners alike as one of the twentieth century's most influential artworks. From the time of its creation, the object's message was as simple as it was radical, that **art might be anything**, and **anything might be art**.

That piece, of course, was a white ceramic urinal laid on its side, signed R. Mutt, and given the logical if comic title of *Fountain*. It has since become an iconic symbol for its artist (Marcel Duchamp), its movement (Dada), and its time (the early twentieth century). *Fountain* was one of Duchamp's classic readymades—sculptures that were never sculpted, art objects artfully made from found manufactured products. It was a lightning bolt that sparked numerous isms and movements: among them, surrealism, pop art, minimalism, and conceptual art. Duchamp has not only been credited with helping to push sculpture off its dusty pedestals, but more important, *Fountain* left in its wake an impact that has been felt by nearly every subsequent generation of artists since it was first *never* seen.

Today, nine decades later, the readymade is giving way to its twenty-first-century successor, the manufractured object. It is almost as if the spirit of Duchamp reappeared in the mid-to late 1990s, animating artists, craftspeople, and designers alike with a new and liberating sensibility that could be utilized to repurpose, if not extract, life from manufactured goods. Now not only might anything be art, but **anything might be art, craft, and design.**

The result has been an entirely new and fascinating class of objects. They are strangely familiar, although they look like nothing anyone has seen before. They have emerged not only from the art community but from the craft and design communities as well. The fact that this new work comes from all over the creative map portends a new period of fertility for object making. *Manufractured* focuses on a particular group of practitioners who have come to regard finished products (existing consumer goods) as their own unique raw material. Their work provides an unexpected model for creativity—a way of showing how innovation, invention, and beauty can emerge from anywhere, even the most familiar, ordinary, and seemingly banal sources.

From ancient times to the present, humans have always found creative ways to reuse materials for pragmatic, economic, and even political reasons. They have repainted canvases, melted down sculptural metals, even pilfered columns or entire buildings for new purposes. In the modern art and craft worlds, this creative reuse has consisted primarily of scavenging throwaway items and redeploying them as raw materials for collage and assemblage. Picasso affixed a scrap of printed chair caning to canvas and called it art. Robert Rauschenberg created aesthetically and socially charged "combines" from found furniture, painted signs, photographs, and fabrics. Louise Nevelson assembled ragtag stacks of turned table legs and wooden objects into structural modules, unifying them through the application of pure black or white paint. The quilters of Gee's Bend, Alabama, sewed together bits and pieces of worn-out clothes and made unmistakably bold graphic statements (and warm blankets) in the process. Dan Friedman combined furniture parts scavenged from Downtown New York streets to create resplendently fluorescent pieces that were for looking at and thinking about (rather than sitting on). All these approaches have given found objects and materials new life and uncommon purpose.

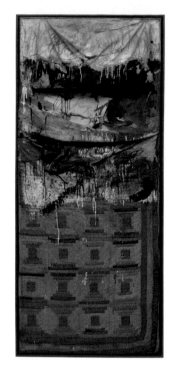

Robert Rauschenberg
Bed 1955
Oil and pencil on pillow, quilt, sheet on wood supports

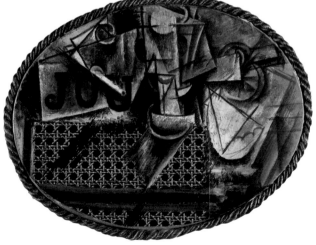

Pablo Picasso
Still Life with Chair Caning 1912
Oil and oilcloth on canvas, rope frame

Opposite page

Louise Nevelson
Dawn's Wedding Feast 1959
Wood construction painted white
Installation at the Museum of Modern Art,
New York, New York

Dan Friedman in collaboration with Paul Ludick
Mutant Chair 1985
Painted wooden furniture parts

Qunnie Pettway
Lazy Gal Variation quilt 2003
Corduroy

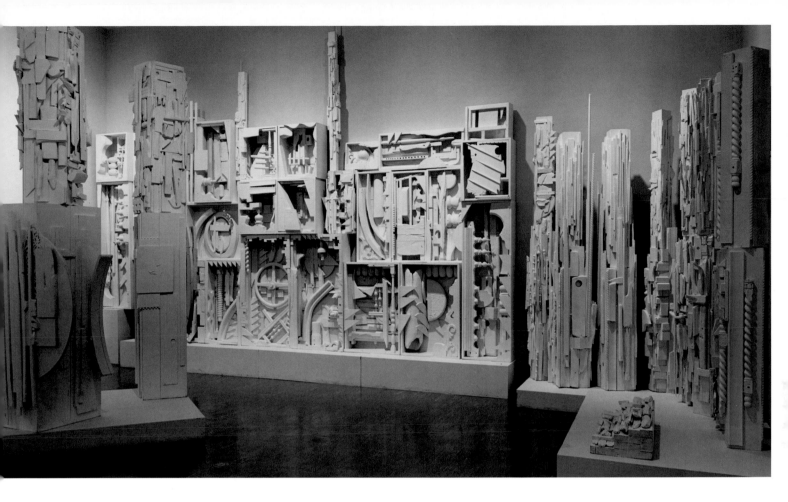

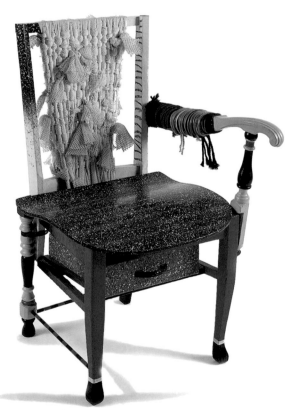

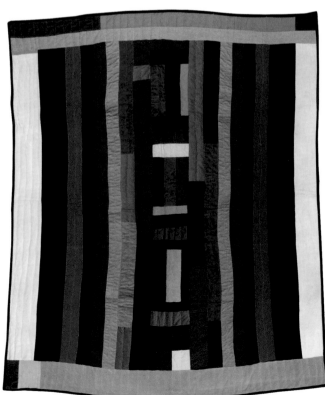

The pattern that connects…John Chamberlain and Sarah Sze

Both artists manufracture transformative sculptures that make the banal seem dramatically sublime and that make use of materials that are otherwise neglected. Each stages a cosmic act of redemption for those quotidian materials such that they become ground-breaking and extraordinary, visually energetic indicators for the way in which a disposable culture might be simultaneously explored and exposed for what it is. Their disorienting, room-dominating sculptural pieces are capable of blurring, blending, and playing with the lines between life, work, and creative output—and in the same spirit between art, craft, and design.

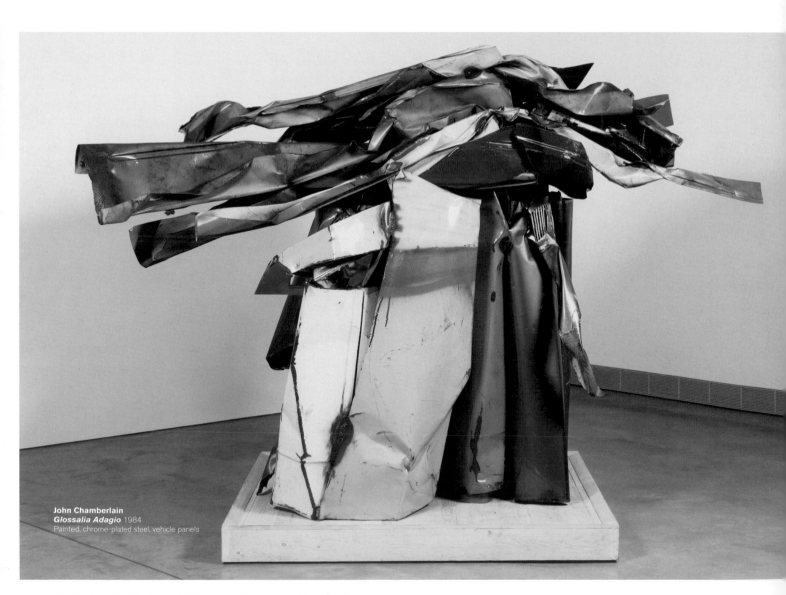

John Chamberlain
Glossalia Adagio 1984
Painted, chrome-plated steel, vehicle panels

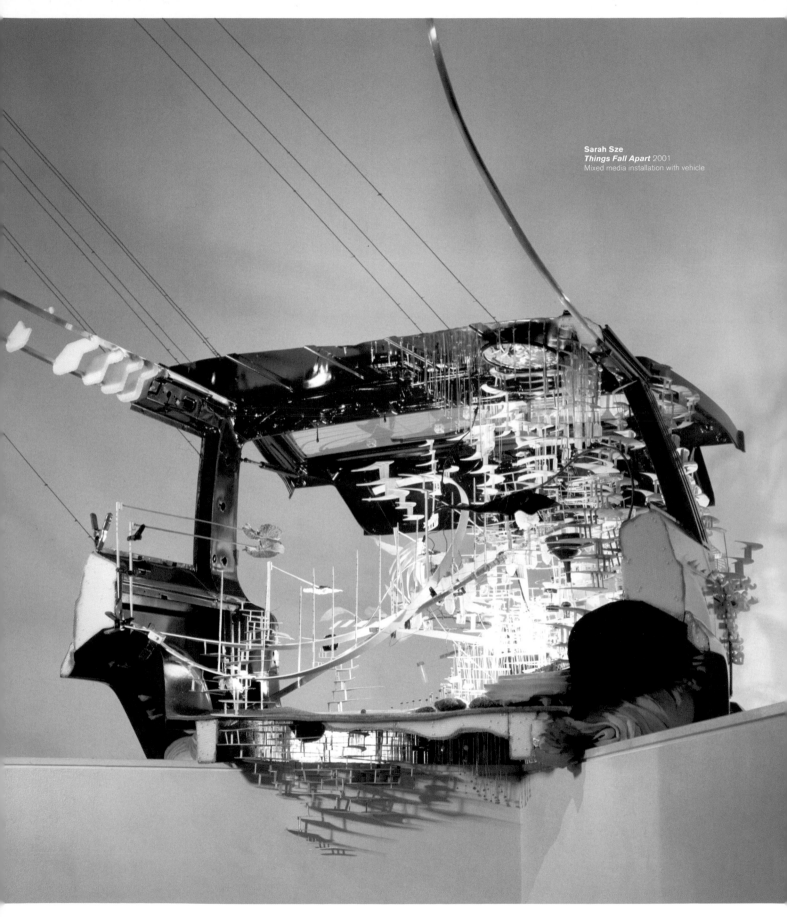

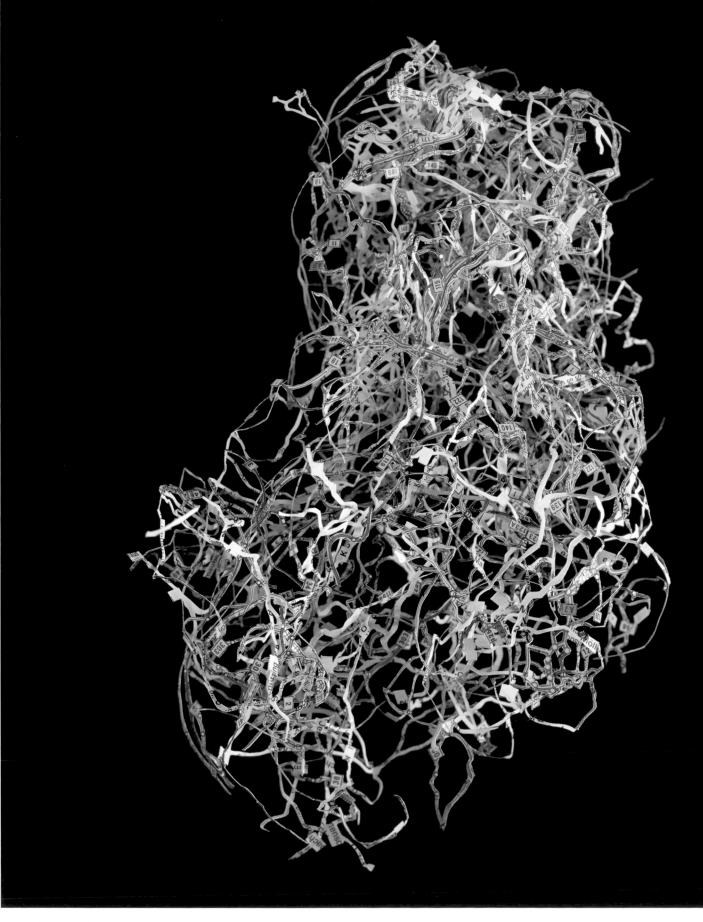

Nina Katchadourian
Austria (photo) 2006
C-print of dissected Austrian road map

The thing that is new in manufactured objects, the phenomenon that is gaining momentum, is this: It appears to be the first time that such creative reuse is pulled from the racks of pristine manufactured goods. **Finished products are the newest raw materials** in today's art, craft, and design realms. Because these products are produced in such profound abundance, they can be acquired in vast quantities with the relative ease of getting one's groceries. Such materials can be accreted and multiplied by whatever power the artist chooses. Pedestals can overflow, corners can be filled, whole walls can be covered; complete rooms can be outfitted, dwarfing the metric of human scale.

The craft of these objects and installations is evident, but it is clear that this is not the craft of yesteryear. The typical craft-world features are absent—particularly the technical mastery of a single natural material. In their place is an attention to detail of a new type and a new scale, but one that still comes straight out of craft traditions. It is almost as if the manufacturing process, which turns out scores of perfectly identical units, has paradoxically encouraged the creators of manufactured objects to be even more obsessive and thorough in the conception and assembly of their work.

Manufractured objects have certain inherent qualities. They routinely favor richness, ambiguity, and vitality over their more pure or traditional counterparts. They are hybrid, compromising, distorted, ambiguous—yet also accommodating, meaningfully redundant, multileveled, vestigial, and formally and functionally innovative. They are a new kind of combinatory construction, surprisingly open to multiple interpretations. By combining the root "manu" with the word "fracture" to indicate the fragmented nature of our contemporary moment, manufracturing presents a model whereby creative intervention can heal our fragmented culture. Taking something apart and putting it back together in a way never previously seen is a strong endorsement for the merits of creative process—and a testament to the optimistic, can-do, and even whimsical spirit that is simultaneously threaded and embedded throughout many of these pieces.

Boris Bally
Pennsylvania 79 c. 2001
Ride! c. 2005
Man in Stereo: Muybridge Platter 2007
Recycled traffic signs

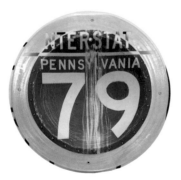 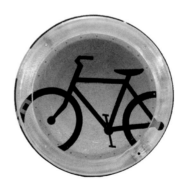 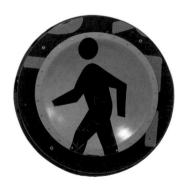

A manufractured object is one that has been made not once but twice. Both Nina Katchadourian's and Boris Bally's highway-inspired projects were first brought into the world via industrial mass production and then transformed through hand-based, idea-driven manipulation: a road map in which all but the roads have been cut away, and highway signs that are "humanufactured" into die cut and pressed bowls and platters. In these projects the original form and function is forever changed and a new kind of preciousness is revealed. It is the dismembering and fragmenting—both physically and contextually—that is the key to their creation.

Conspicuous Transformation

In *The Theory of the Leisure Class* (1899), economist and social critic Thorstein Veblen coined the term "conspicuous consumption" to describe what he saw as the desire of the moneyed elite to acquire goods as an overt and ostentatious display of their wealth. More than a century later, what we are seeing in art, craft, and design is "conspicuous transformation," with consumer products used as base components in overt displays of intellectual and creative wealth. Although more than a century apart, what unites conspicuous consumption and conspicuous transformation is that in both, consumerism, materialism, and creativity are in powerful alignment, although to very different ends.

Each of the artists, craftspeople, and designers in *Manufractured* embody the concept of conspicuous transformation in one way or another. They use a vast array of consumer goods as their raw material: tin cans, paper plates, detergent bottles, cellophane tape, marker caps, foam packaging, plastic combs, drinking straws, and more. They take these often virgin products of consumer culture and either separate them into modules, or aggregate them together in great numbers, or both. This is **manufracturing; the active and thoughtful accumulation, organization, and transformation of materials through a novel combination of hand, tool, machine, and production processes.**

Conspicuous transformation as a strategy for object-making has changed the conditions for the practice of art, craft, and design. The result is a new fusion of sensibilities whereby the creators of objects look outside their profession-bound sources for fresh insights. The search for potential materials has taken them to unconventional places—to grocery and hardware stores, to recycling and scrap piles, to cosmetics counters, even directly to manufacturers. They are in search of manufactured goods that are plentiful and inexpensive—either brand-new and straight from the warehouse or barely used post-consumer finds—and they have found them in abundance.

Kim Beck
Holymoley Land 2006
Laser-cut insulation foam, paper chipboard, wall drawing

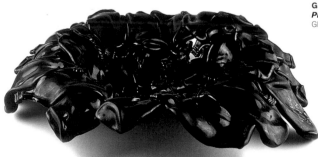

Gaetano Pesce
Pharmacie Bleu bowl 1988–92
Glass bottles

Hella Jongerius
Groove and Long Neck Bottles 2000
Glass, porcelain, plastic packing tape

The creators of manufractured objects conspicuously transform manufactured products into unexpected new forms, making strong statements about our current cultural conditions of abundance and overload. Sharp attention is focused on reconsideration of the ordinary: Gaetano Pesce's scavenged bottles are melted together to form a multi-layered bowl; Kim Beck's branded, imprinted construction foam is usually hidden by finished architectural surfaces; Hella Jongerius' molecularly impossible vessels (glass/porcelain combination) are fused together with pre-printed packing tape. Through the labor-intensive processes of cutting, stacking, and layering their materials, they create work that is equally of the present moment at the same time that it provides conceptual models for future exploration.

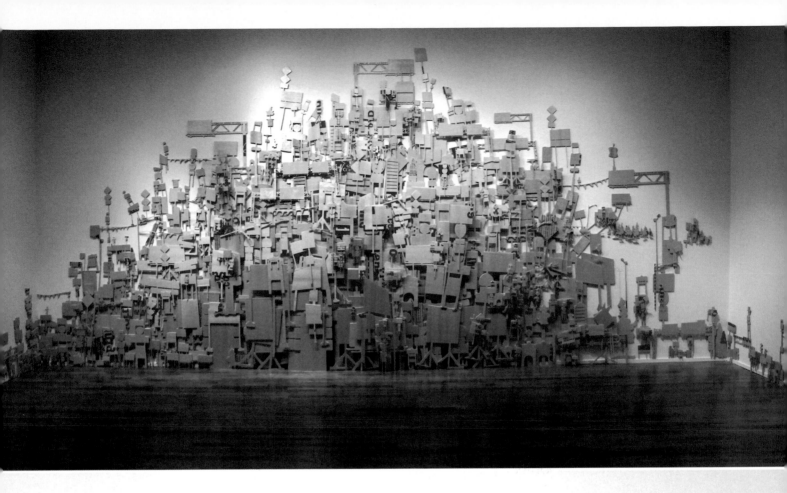

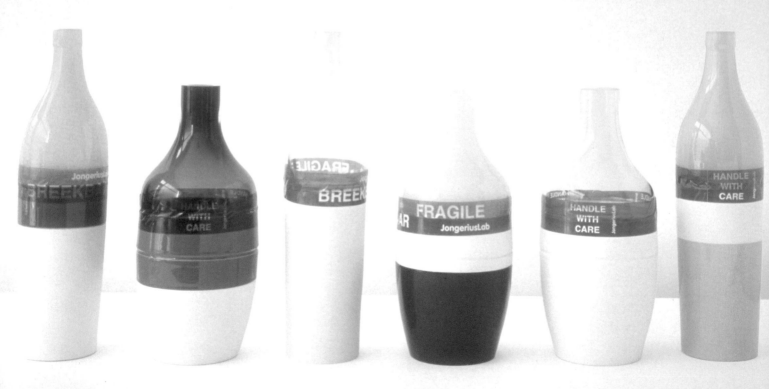

Chris Jordan
Shipping Containers 2007
Photograph of digital composition.
Depicts 38,000 shipping containers, the
number of containers processed through
American ports every twelve hours.

Chris Jordan
Shipping Containers (detail) 2007

Rik Nelson
ClearCut 1994–95
Approx. 140 assorted plastic containers,
wood frame

The pattern that connects...Rik Nelson and Chris Jordan

Both are committed to creating a new, controversial type of beauty that emerges out of the excessive production, inbred waste cycles, and thoughtless consumption habits of our consumer culture. Both take everyday cast-offs and conspicuously transform them into urgent, compelling subject matter by treating the non-precious in decidedly precious ways using the quilt-form as a metaphor. Nelson carefully crafts pieces cut from throw-away household containers into densely patterned wall installations while Jordan quilts together digital images of shipping containers into enormous photographic works. Nelson's tale is of local environmental loss, while Jordan's repetition and daunting statistics portray consumption at a macro level. One gently chides while the other yells, but both, like the proverbial canary in the coal mine, sound the wake-up alarm concerning the consequences of our culture of convenience.

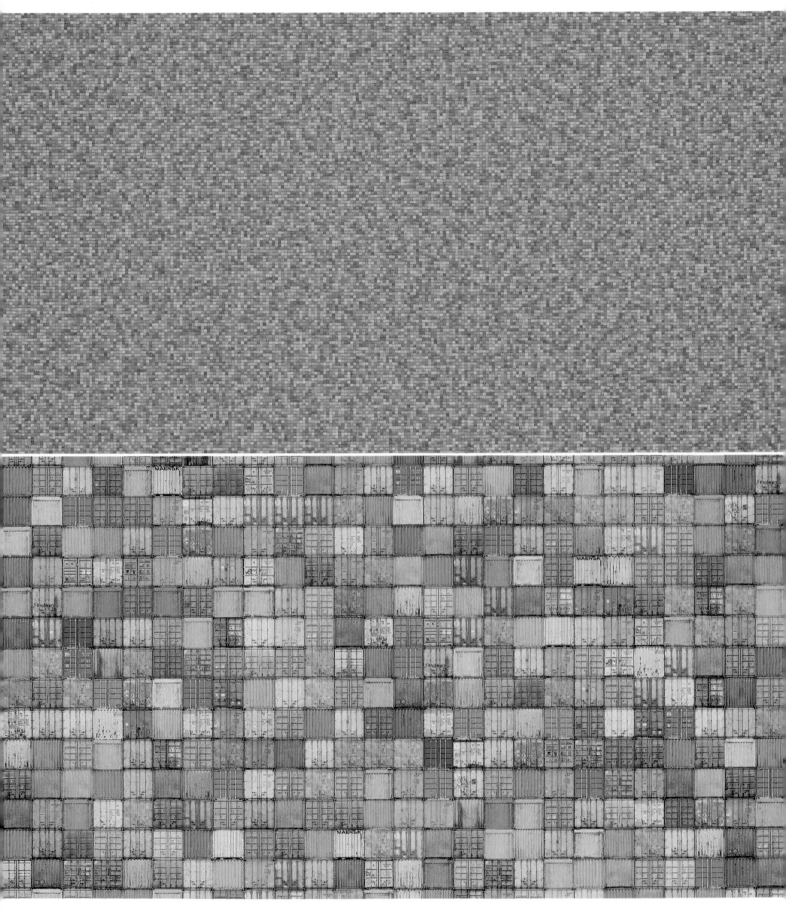

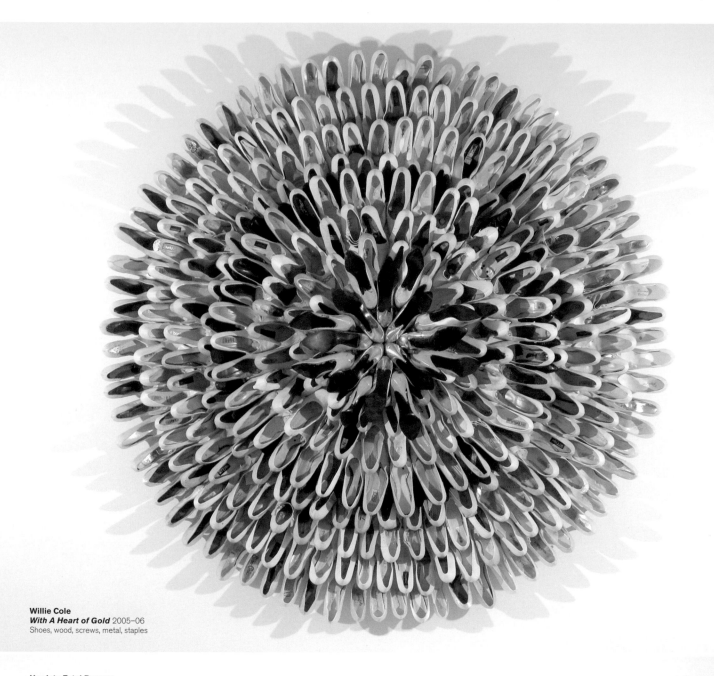

Willie Cole
With A Heart of Gold 2005–06
Shoes, wood, screws, metal, staples

Harriete Estel Berman
Square Yard of Grass 1998
Recycled tin containers, copper base

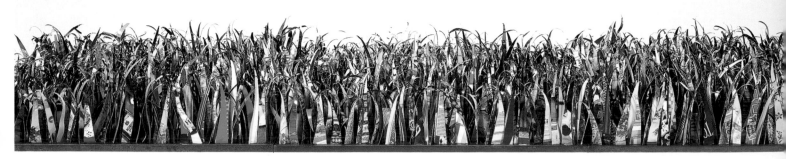

Abundance in Contemporary Culture

There is more of everything in the twenty-first century: more information at our fingertips, and more ways to get at that information; more opportunities for entertainment and diversion; more chairs, and televisions, and plastic cups. In the past several decades, we have entered a period of late-stage capitalism, with goods, services, images, and choices so plentiful as to become a burden. Some people have become paralyzed by indecision. Amid the grand profusion of things of every conceivable size, shape, and attribute existing already in the world—in an economy of such overload and chronic over-production—how do we make sense of it? By calling into question the **cornucopia of consumer commodities**, and by vaulting those materials into the front ranks of the avant-garde, manufactured objects are one logical response to this hyperabundant late-stage capitalist period. They provide multiple examples of what the true and authentic object class of our era might be.

For the better part of human history, the struggle has been to survive. To make do with little in the face of an often unforgiving environment. To settle and adapt, pick up and move when necessary, to have the time and energy to address only basic needs. But the current problems of material society are fundamentally different. How do we respond to the fullness, abundance, satiety, and consumer choice occurring in our lives at every level? How do the best and brightest minds, the most creative thinkers of our time respond to prosperity, to the possibilities of enough and even "too much"?

This condition of hyperabundance is, of course, bitterly ironic given the true poverty that exists within our society and much of the rest of the world. Manufactured objects may be a first-world response to third-world efforts to treat every material as a resource that can be used over and over. This tendency richly illustrates that creativity is an overarching trait that all humans share, part of our genetic makeup, our biological birthright. The creative impulse is simply applied to different ends in different cultures, depending upon the essentially randomized matter of one's postal code.

Jerry Bleem
Monument (After Barlach)
(front and back) 2001
Found corrugated plastic, staples

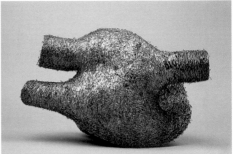

Many manufractured projects are hyper-assemblaged Duchampian descendants, united in turn by their profligate use of everyday materials. Abundance is almost an insufficient term for the kind of density they exhibit. Products such as Willie Cole's high-heeled shoes, Harriete Estel Berman's blades of printed tin "grass" and Jerry Bleem's staple-saturated vessels assume obsessive (to the point of fetishistic) significance. Material abundance is transformed into wryly-purposeful narratives that tell a deeper truth about each material's essential qualities. The idea of playful excess is mined for its cultural symbolism, as a reminder that abundance is not a politically neutral or value-free proposition.

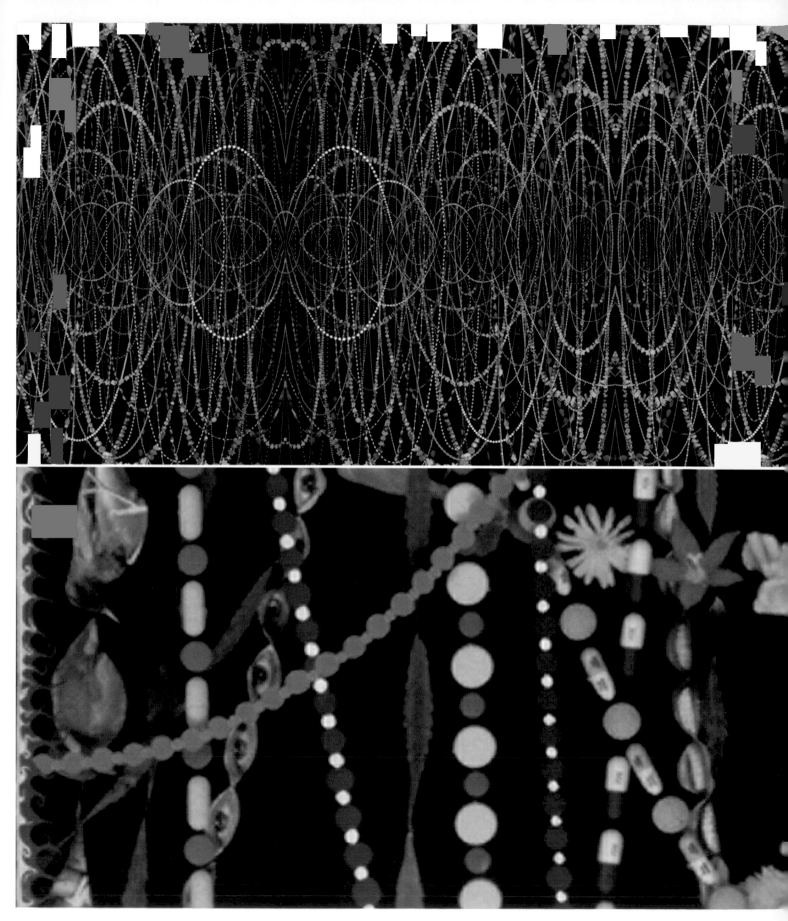

Fred Tomaselli
Echo, Wow and Flutter: Sideways,
Flopped and Mirrored 2006
Wallpaper

Rex Ray
Paper Collages 1997–2006
Magazine clippings on watercolor paper

The pattern that connects…Fred Tomaselli and Rex Ray

Orchestrated organic forms flow and grow together into lyrically liquid composi-
tions that aspire to three-dimensional depths. Things are not necessarily what
they seem to be in the kaleidoscopic assemblages of Tomaselli and Ray. Both
artists create dazzlingly vivid constructions that are meticulous yet abundant,
flamboyant in their excessiveness yet repetitive in their structure. Bits of ephemera
are coated in a clear chemical cloak of high-gloss resin, like fossilized insects
trapped in amber. The scavenged elements in each—pharmaceutical capsules,
foliage and butterfly wings in the case of Tomaselli, and organic shapes "drawn"
with scissors from magazine pages by Ray—add up to more than the simple
sum of their parts.

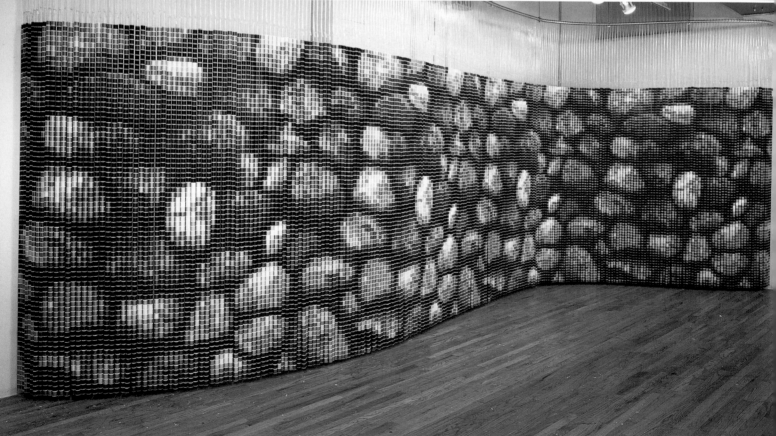

Manufactured **From Readymade to Manufactured: Some Assembly Required**

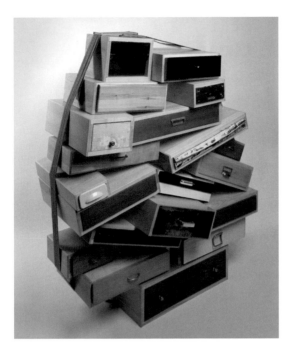

Multiplicity and Repetition

Manufractured projects reflect the multiplicity that the late Italian author Italo Calvino discussed in his final treatise *Six Memos for the New Millennium* (1988). The fifth memo, "Multiplicity," is a way to think about **the abundance of possibilities, variations, and diversity** that humans create and face every day. As envisioned by Calvino, it entails "weaving together the various branches of knowledge, the various 'codes,' into a manifold and multifaceted vision of the world."

Interpreted for the purposes of visual culture, multiplicity is expressed literally as a repetition of materials and figuratively as an excess of concepts, forms, or typologies—each nonetheless united in a cohesive and meaningful arrangement. In its richest expression, it can even become a path to higher awareness about the potential of a specific technique, a material truth, a formal expression, or a human ambition.

The borders between art, craft, and design are now beyond permeability. They have become provocatively pneumatic. Concepts, techniques, and materials from one area are easily thrust into the others. Multiplicity has emerged as a strategy-of-choice, a way to come to terms with all of the abundance, possibility, variation, and diversity that people face every day.

Manufractured projects reflect our profligate and ecstatic consumerist moment and its concomitant abundance of goods—all courtesy of the latest stage of late-stage capitalism. But there is a sense that excess must be controlled, and multiplicity and repetition are two strategies for coping. Tara Donovan's multitude of bundled paper plates evokes cells in mid-mitosis expansion. Devorah Sperber's thousands of thread spools self-assemble into an imagefield where the massive is made from the minute. Tejo Remy's agglomeration of mismatched drawers is unified by the sameness of their simple maple frames. All three give considerable form to what would otherwise be pure excess; the resulting work feels unified, appropriate, even natural.

Sampling and Appropriation

As our society becomes ever more fragmented, sampling and appropriation can knit certain elements back together, often in unexpected ways. As early as 1979, Jean-François Lyotard's *The Postmodern Condition: A Report on Knowledge* laid the groundwork for a society of the *bricoleur*, a society of massive and rampant borrowing. That same year, in a New Jersey recording studio, the Sugar Hill Gang produced "Rapper's Delight," the first rap song to become a radio hit, sampling a riff from "Good Times," the disco hit from the group Chic from earlier that year. From the top-down academic European intellectual musings to the ground-up street-smart American narrative invention, every sound, riff, line, hook, track, and more was suddenly **mind-blowingly available for secondary creative reuse**, subject, of course, to the escalating complexities of legal permissions, rights, and reproductions. Now today, sampling and appropriation are considered keen responses to the argument that it is no longer possible to create anything new or original.

Blending, mashing up, looping, building up a rhythm through repetition—these techniques are already evident in many areas of creative culture, most notably in music, but also in art, poetry, cinema, and literature, although some are considered more acceptable than others (witness the recent legal battles between authors over questions of plagiarism). Now we are seeing the same trend toward borrowing elements, materials, techniques, and stylistic conventions from other disciplines in the areas of craft and design, all the while integrating high and low cultural references to more meaningful ends.

Fernando and Humberto Campana
TransPlastic 2007
Plastic lawn chairs, woven apuí, lighting components
Installation at Albion Gallery,
London, United Kingdom

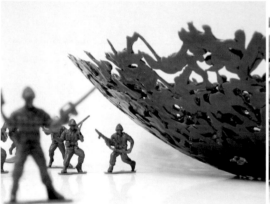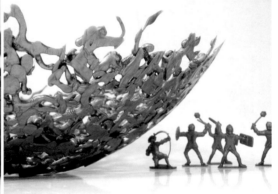

Dominic Wilcox
War Bowl: Green Soldiers 2002
War Bowl: Knights 2002
Melted plastic army soldiers

In Dominic Wilcox's *War Bowls* and the Campana Brothers' *TransPlastic* project, individual products are blended into integrated meta objects. Each *War Bowl* is made from legions of plastic soldiers melted together to form a crenellated and perforated vessel. An ironic take on the senselessness of war, they highlight how scandalously mutable the body (and the vessel) can be when subjected to pressure. The craft-based–basket metaphor is envisioned at room-sized scale in the Campana's undulating *TransPlastic* furniture pieces. Woven apui (a tree-choking vine) envelops a group of patio chairs, seamlessly integrating the manufactured and the handmade. Both projects seek to balance metaphorical legibility and confused form in organic colonies of sampled manufactured goods.

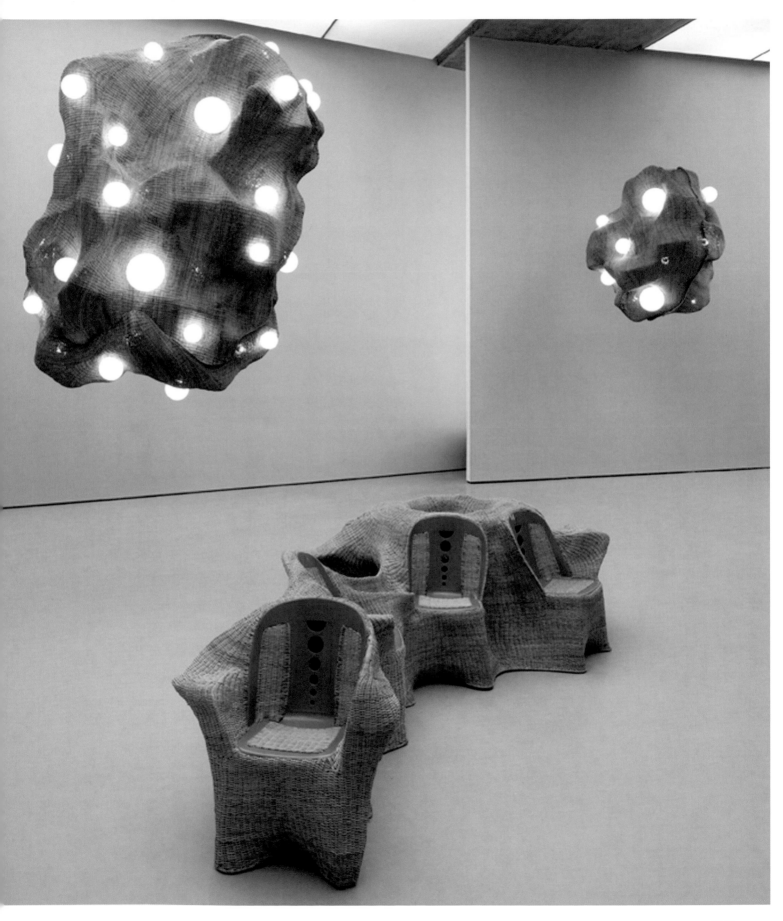

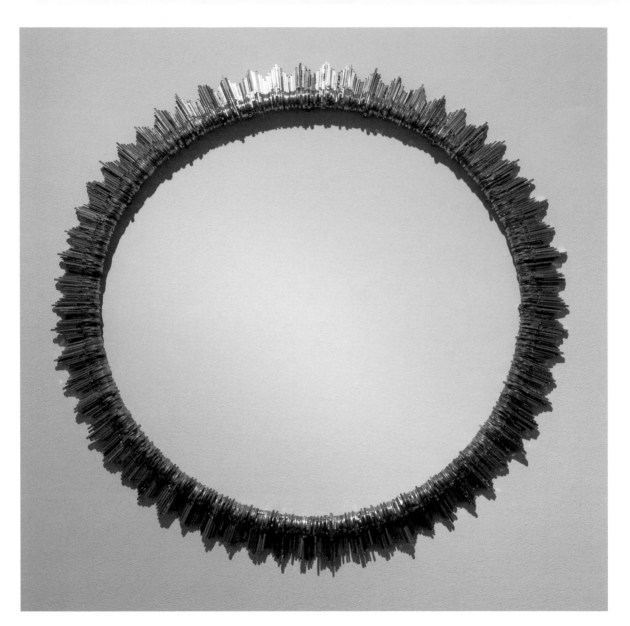

Cat Chow
Keeper 2008
Keys, steel ring

The pattern that connects…Cat Chow and Stuart Haygarth

Both artists utilize a single material family to create sculptural forms that are more than the simple sum of their parts—found keys of all shapes and sizes, and a Technicolor array of scavenged beach plastics. Each is a hypnotically integrated spectacle of unusual objects. So strong is the manufacture of these elements that the obsessive organization of each one gives the appearance that there is no more logical way for their post-salvaged parts to come together. Their radiating circular forms are symbolic of purity, cyclical repetition, and the unity of life, creating form statements of surprising conceptual content.

Stuart Haygarth
Tide Chandelier 2004
Found plastic objects

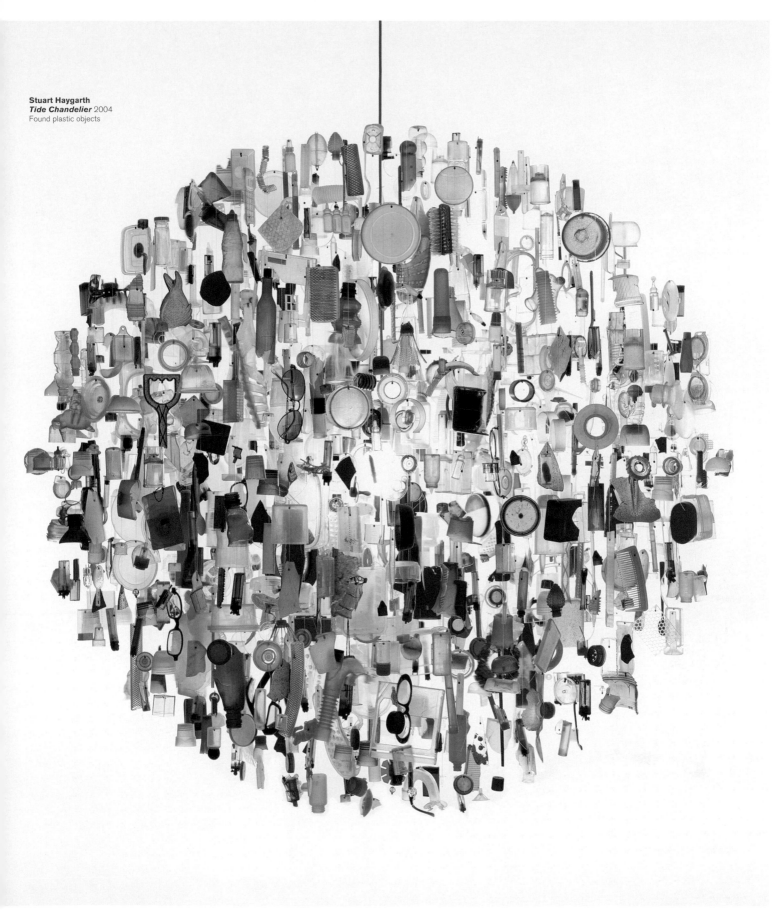

Salvaging and Scavenging

Manufractured objects highlight an important response to the riches of an overabundant culture. By adopting a strategy of material and cultural salvaging, artists, craftspeople, and designers are literally creating something from nothing—that is, from nothing of perceived worth; creativity provides the added value. This tendency to become **twenty-first-century hunter-gatherers of discarded, underappreciated materials** has led to new ways of thinking about the conservation of resources and how art, craft, and design might fit more critically into the larger cultural ecology. The problem of waste has been largely ignored by society until recently, as the movement toward sustainability has demanded that we think about the byproducts of our prodigious overproduction and overconsumption.

The meaning of scavenging in visual culture has changed greatly since Picasso first applied printed chair caning to his canvas. Now a century later, as the prodigious output of manufactured materials (both virgin and used) has spread to every corner of the globe, a waste stream of cosmic proportions has emerged. In numerous instances, the act of scavenging provides a real-life model for what the DIY-oriented everyman might begin to do to make a difference. In this way, the salvaging- and scavenging-based projects of artists, craftspeople, and designers has taken on a near-heroic edge as they rescue materials and harvest their still extant benefits from trash cans and landfills, parks and beaches.

Tom Fruin
Phillie Clouds 2006
Found drug bags, thread

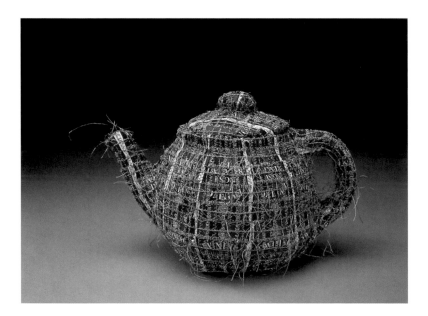

Donna Rhae Marder
English/Irish Teapot 2003
Sewn teabag wrappers, wire, fabric

Chakaia Booker
Acid Rain 2001
Rubber tires, wood

The scavenged aesthetic celebrates the rawest of the raw materials. Though they may be scratched, faded, soiled, and worn, each offers something that more pristine materials cannot: evidence of past lives. Consumer waste is reborn, providing an exemplar for dealing with eco-sustainability. There is no typical re-use scenario for the throwaway tea packaging, drug bags, and auto tires reclaimed by Donna Rhae Marder, Tom Fruin, and Chakia Booker. All are now recrafted into something more lyrical—replete with the artificial equivalents of craft-based knots, burls, bubbles, drips, and slubs. Manufractured objects made from scavenged materials are perplexing remnants of cultural progress that increase environmental awareness (if only for a moment) of what we own, produce, and consume.

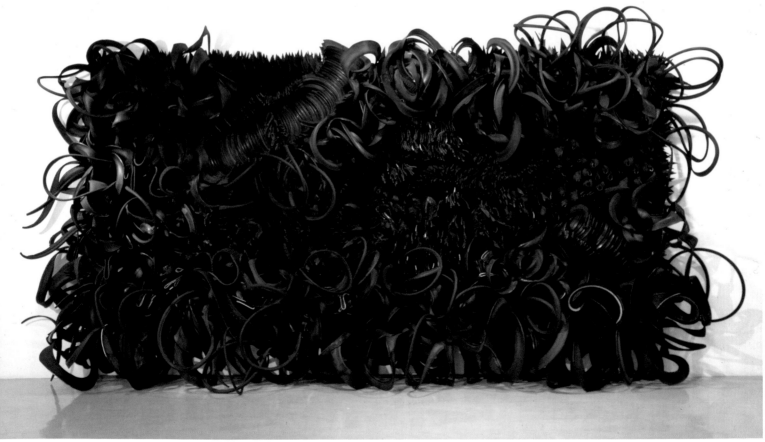

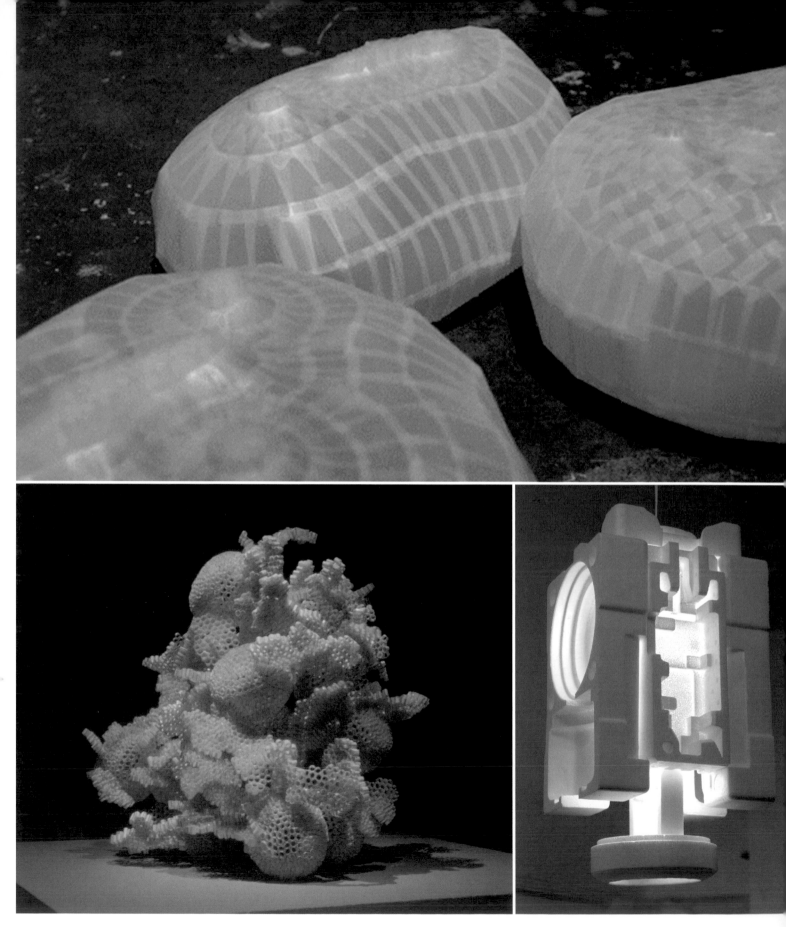

Making

The act of making is more integral to craft than to any of the other visual arts, and the visionary object makers that populate the pages of *Manufractured* continue to push new ways of making, whether or not they are aware of their key roles in this organically developing phenomenon. What we see repeatedly is the development of systematic processes for working with unusual material choices. These practitioners have a highly tuned dexterity of hand, eye, and brain, and their kinesthetic intelligence is keen and unusually elevated. They seem able to make use of both sides of the brain at the same time—the analytical grounding of the left brain and the blue-sky intuition of the right brain. This quality further links manufractured projects to the classic crafts coda: the maker's hand and mind joined in unitary pursuit, a celebration of the mark or stroke that deeply humanizes a piece. This allows for the necessary variation that the human perceptual apparatus favors, leading to projects that offer layers of sustained discovery as well as momentary satisfaction.

In many of these projects, elements of unique production are integrated with elements of mass production; both the "mark of the hand" and "the mark of the machine" are evident. Every one demonstrates a deep and abiding commitment to materials and **the creation of tangible materiality**; a plethora of similar or identical elements are brought together in quantities that often far exceed what the casual observer would consider to be normal or natural. Then those materials are worked over, figuratively or perhaps literally broken apart, and painstakingly rearranged. The final forms often assume certain strategic patterns: clusters, clouds, stacks, nests, accretions, scatterings, and accumulations, a synthesis of the familiar, but magnified, multiplied, and abstracted—stretching to the limits of comprehension.

Plastic, "the great emulator," is able to masquerade as nearly every other traditional craft material—wood, metal, glass, clay, and textiles. And when handled in craft-intensive ways, it can be as precious as any other material. Plastic, "the great enabler," is the ultimate polymorphous sculptural substance—the embodiment of flexibility and flow; it rarely finds a shape it does not like or a form it will not take. In its infinite variations between soft and hard, thick and thin, opaque and transparent, smooth and textured, plastic shape-shifts to fit our desires, and has increasingly become a launch pad for interstitial possibilities and interdisciplinary investigations.

The impulse to make is primordial, nonnegotiable, and irresistible. But the impulse to make sense runs just as deep, for making sense of what we make is what makes making meaningful. In each of the vastly different projects in *Manufractured*, thinking and making go hand in hand; the inner *Homo sapiens* (man the thinker) is intimately connected to (and grounded by) the outer *Homo faber* (man the maker).

Making is integral to the practice of art, craft, and design, but making with manufactured plastic objects is by necessity a practice of re-making. Mitra Fabian layers strip after strip of Scotch tape to form the basket–weave-patterned skin of lighter-than-air translucent vessels; Eduardo Aberroa deconstructs and reconstructs clusters of plastic straws into cell-like coral and floral formations; and Jason Rogenes' configures polystyrene packing materials (literal building blocks) into lighter-than-expected glowing structures. All three provide definitive examples of how prosaic plastics can become expressly poetic through the labor-intensive process of making and re-making.

The pattern that connects...Gloria Crouse and El Anatsui

Although these pieces could not be more different in their manifestation, each one offers a new way of thinking about what a textile can be. Their raw materials are common—plastic six-pack rings and rip-stop nylon selvage, liquor bottle caps and wrapping—but the manufractured context in which we see those materials makes all the difference. Each textile offers a visual complexity that operates simultaneously at multiple scales—from the micro to the macro view. Each offers the timely lesson that any material can be a site for conspicuous transformation and reminds us that the palette of material possibilities is immense, expanding, and reason for continued creative optimism.

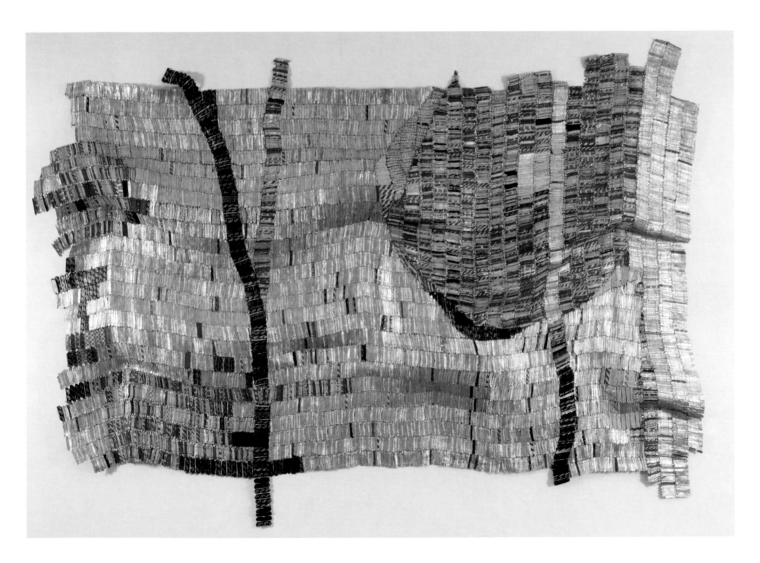

Gloria Crouse
Tying the Knot **wedding ensemble** 1996
Plastic six-pack rings, rip-stop nylon selvage

El Anatsui
Sacred Moon 2007
Aluminum liquor bottle caps, copper wire

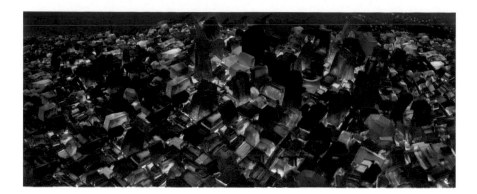

Post-credible Context

Somewhere toward the end of Ronald Reagan's presidency in the late 1980s, our culture shifted toward a new era of post-modernism, toward a "post-credible" world. In this supersaturated realm of rich and poor media experiences, many things that we see or hear seem literally beyond belief. The news, for example, regularly stuns us with one improbable story after another. But after such prolonged and elevated exposure, our threshold is high and our reactions are often just a shrug, a glimmer of a vicarious thrill. Even when something bizarre but undeniably real happens to us, our first reaction is often one of disbelief.

We can sense the zeitgeist—**today's pattern of post-credibility**—by listing just the briefest list of news bits: Bob Dylan plays a gig at West Point. Scientists grow human ear replacements on the backs of lab mice. Kobayashi eats dozens of hotdogs in a single sitting to become a world champion. Eminem and Elton John hug on stage. Arnold Schwarzenegger becomes a serious politician (as did Reagan before him). In our post-credible world, our receptors are conditioned to accept the strange as normal.

There is the persistent feeling in post-credible culture that "You can't make this stuff up." This is what makes manufactured objects such important and paradigmatic expressions of our time. They seem strange because they are; they appear unlikely or even unbelievable especially at first viewing. But make no mistake: Our culture—with its demands for excessive abundance and its system of late-stage capitalism in place to provide it—made the appearance of manufactured objects almost inevitable. It was only a question of when.

The lesson is that every time disaster strikes, or entropy looms, or the hour is late—and it seems as if nothing new will ever again be possible—invention, ingenuity, and innovation come to the rescue. Manufactured objects provide just the latest example of this cultural phenomenon.

Post-Credible manufractured objects are paradoxical, over-scaled, surreal, and above all, unbelievable. Liz Hickok molds individual casts of buildings in Jell-O to express the paradigmatic instability of San Francisco's quake-wary built environment; Brian Jungen combines select fragments of ubiquitous plastic patio chairs to convincingly render a bleached-bones whale skeleton; Nancy Rubins's gravity-resistant mid-air collision of a colorful armada of brand-new boats, accelerates into the black hole of a single vanishing point. Together these projects speak in the secret logic of incongruity. The lesson they offer is that abnormality has been normalized—the surreal now moves fluidly from one medium to another.

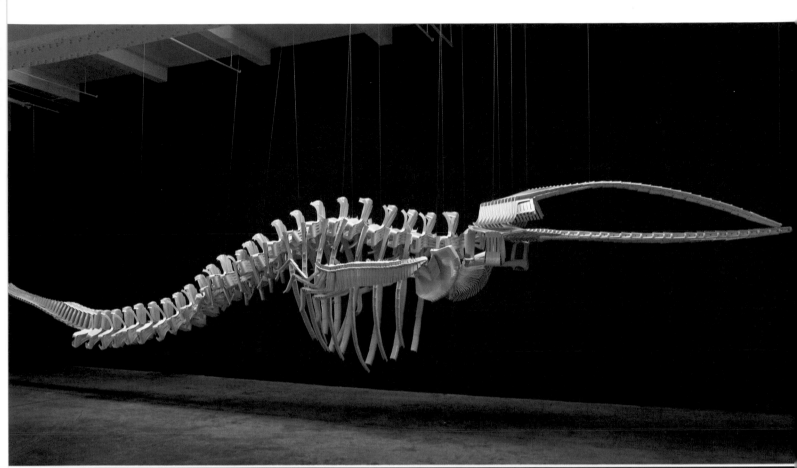

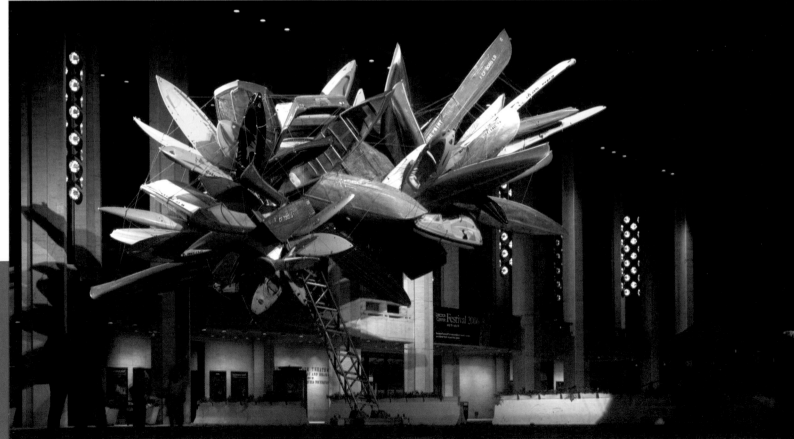

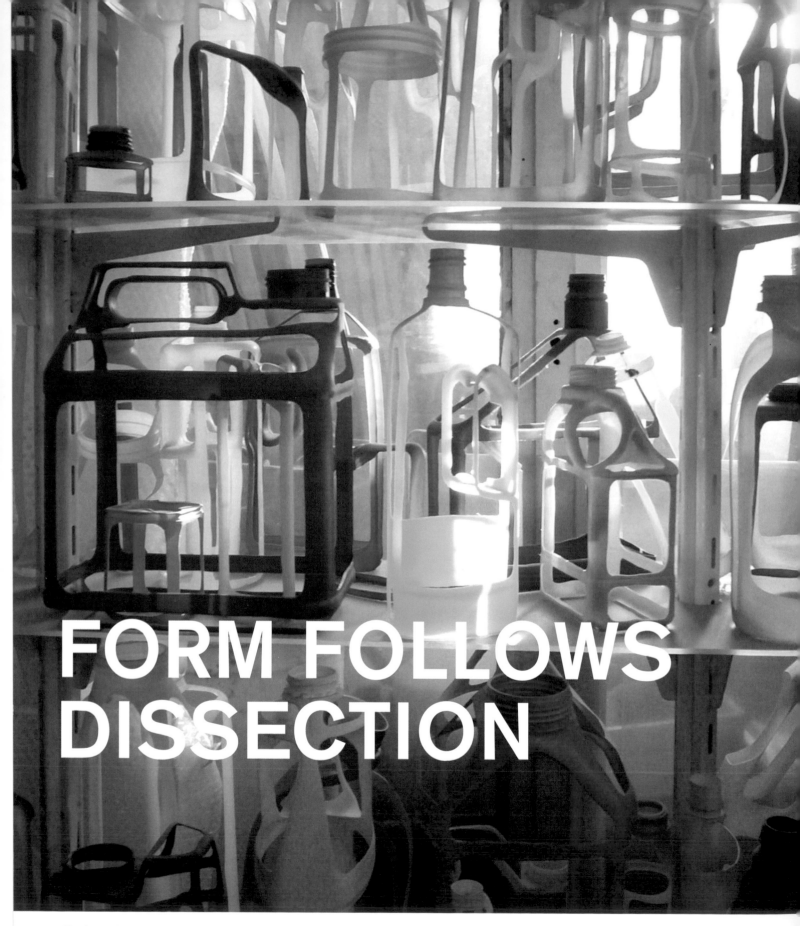

FORM FOLLOWS
DISSECTION

"[I create] objects transformed into the structures of objects." —Régis Mayot

Grand Magasin (detail) 2001
Carved plastic bottles, metal, Plexiglas

Mara Holt Skov

Born in Paris, France, works in Paris, France

Régis Mayot. A bright and colorful screen of stick-like structures rises, one level after another into the air, like balloon-frame houses for a miniature city. Each structure derives from a different hand-carved plastic bottle; each bottle carries its own personality and attitude. The sides have been carved away, leaving only the parts that are structurally necessary. What remains, paradoxically, has a surprising sense of presence—self-contained, complete, and endlessly varied—that fills the void.

Sometimes it takes an artistic vision to see the full range of possibilities in an undervalued material. Régis Mayot, seeing the potential for beauty in discarded plastics, appropriates the cast-off containers that once held laundry detergent, bleach, hair products, spray cleaners, motor oil, and other fluids to create sculptures that engage at the same time as they instruct.

Mayot works like a kind of urban archaeologist, mining the trash bins of French consumer culture for his materials. After sorting through their varied shapes and colors, he begins by carving away at the walls of each bottle, leaving only the threaded openings, the bases, the corners, and the seams. Mayot works as a master craftsman with the most unconventional of materials and tools:

Raw material

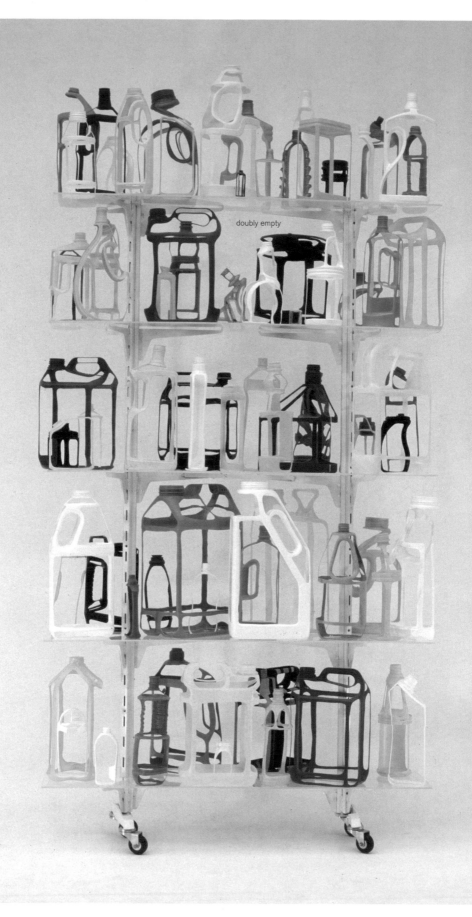

doubly empty

Manufactured **Form Follows Dissection: Régis Mayot**

"The detergent bottles…create a surrealist lace that serves as a screen or an accumulation on shelves that becomes a miniature city." —François Leduc, journalist

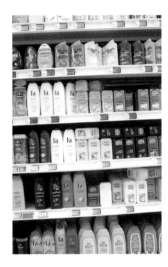

Store shelves, Paris, France

the plastic bottle and the X-Acto blade. When he is finished, what remains is a veritable skeleton of the former bottle, emptied not only of its liquid contents, but also sheared of its defining skin. By treating each bottle in this manner, by removing all but the essential structural elements, he arrives at the most minimal expression of each shape possible. What emerges is a new and unexpected aesthetic—one that addresses the material's absence at the same time as its presence.

Formally, each individual sculpture functions as an artistic exploration of line, structure, and volume as if it were a 3-D drawing. By placing up to 15 uniquely deconstructed pieces in an animated array on glass and metal étagères, Mayot creates a full-color assemblage of visual delights. Shelf pieces such as *Grand Magasin (Department Store)* are appealing on many levels, capturing our attention with the charm of a brightly lit candy store, a miniature playground, or a child's puzzle.

Mayot's question is essentially a simple one: How much of a plastic container can you take away and still maintain the essence of that container? His artful interventions both enhance our perception of each object as intimately connected to commerce at the same time as they remind us that the commercial utility of each bottle is long since past. What was once filled with a product is now empty, rendering each bottle useless, essentially garbage. Yet Mayot has turned such garbage into a deconstructed conceptual art form, embracing this byproduct of consumer culture as his raw material.

Grand Magasin 2001
Carved plastic bottles, metal, Plexiglas

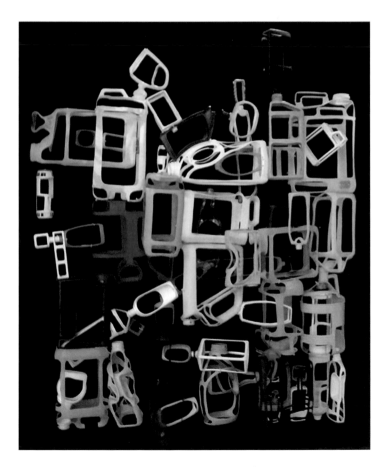

Enfin, y'a plus de pétrole 2005
Carved plastic bottles

"More than a substance, plastic is the very idea of its infinite transformation....And it is this, in fact, which makes it a miraculous substance; a miracle is always a sudden...

Mayot's sculptures beg us to see the packaging that surrounds us in a new light. To that end he often gives his work titles that allude to the ubiquity of plastic and the environmental impact it carries: *Grand Magasin (Department Store)*, *Enfin, y'a plus de petrol (Finally, There's No More Gas)*, and *Bidonville (Bottlecity)*.

Even in the most environmentally aware, technologically advanced societies, when a bottle is emptied of its contents, it is finished. We toss it out, often without thinking. It goes into the landfill or is melted down to make a new, not particularly versatile material. Yet the greatest irony is that these objects have been so thoughtfully designed to begin with. Entire creative teams expend enormous energy to create seductive and memorable shapes, colors, labels, and logos for objects whose lifespans are measured in days and weeks and whose final destiny is to be buried for decades before decomposing into toxic goo. Mayot is fully aware of this conundrum, and his act of appropriating the highly designed containers as raw material can be viewed as a heroic (though futile) gesture, a contemporary *résistance* in opposition to the consequences of rampant consumer culture.

Mayot's work encourages us to think twice about the deeper meanings of the consumer goods we encounter on store shelves. Each bottle of detergent, fabric softener, and shampoo vies aggressively for our attention. At times, the saturation of visual information and choice can be overwhelming to the point of paralyzing.

In Mayot's Parisian *supermarché*, products have catchy names such as *Omo, Skip, Ariel, Gama, Bonux, Soupline,* and *Vigor*. Although these European products might be unfamiliar to us, each one has its counterpart in other countries and other cultures. *Cascade, Sunlight, Downy, Wisk, Tide, Shout,* and *Joy* populate U.S. store shelves. Their names speak of efficiency and possibility, even happiness. What irony! Each name has been designed specifically to appeal to our desires and aspirations—sparkling dishes, whiter whites, new, improved, softer, fluffier, easier, and happier. Of course, the reality of these products rarely measures up to such promises. Cleaning house and laundering clothes is still considered drudgery, no matter how upbeat the product message.

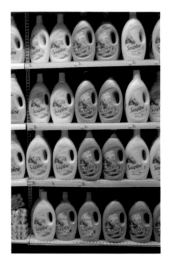

Store shelves, Paris, France

Connections: Consumer Abundance Inspires Art
Andy Warhol turned iconic brand packaging into conceptual art. Andreas Gursky photographs endless product landscapes. Kevin Landers carefully re-creates fictitious products and packaging. All celebrate industrial production even as they address the wasteful nature of consumer culture.

Andy Warhol
100 Campbell's Soup Cans 1962

Andreas Gursky
99 Cent 1999

Kevin Landers
Chip Rack 2005

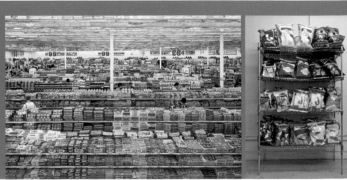

Manufactured **Form Follows Dissection: Régis Mayot**

...transformation of nature." —Roland Barthes, literary critic

Mètres 1999
Carved plastic bottles

L'echantillon (prototype) 2007
Carved plastic bottles

Bidonville 2007
Carved plastic bottles

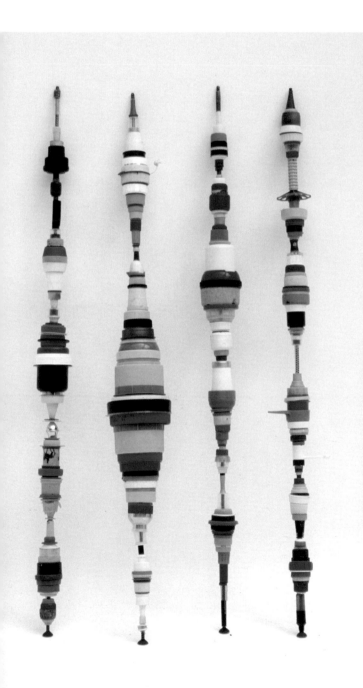

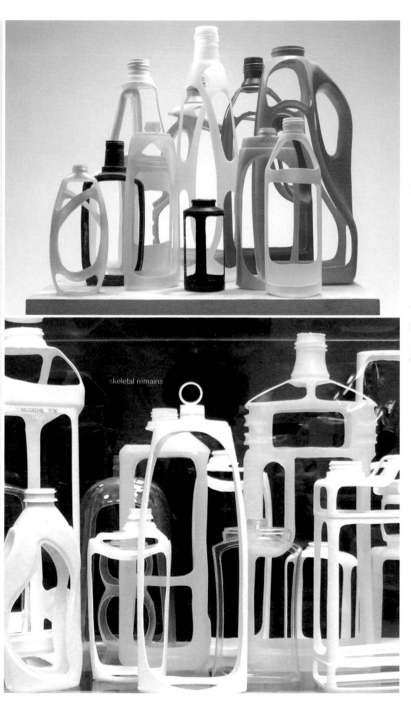

skeletal remains

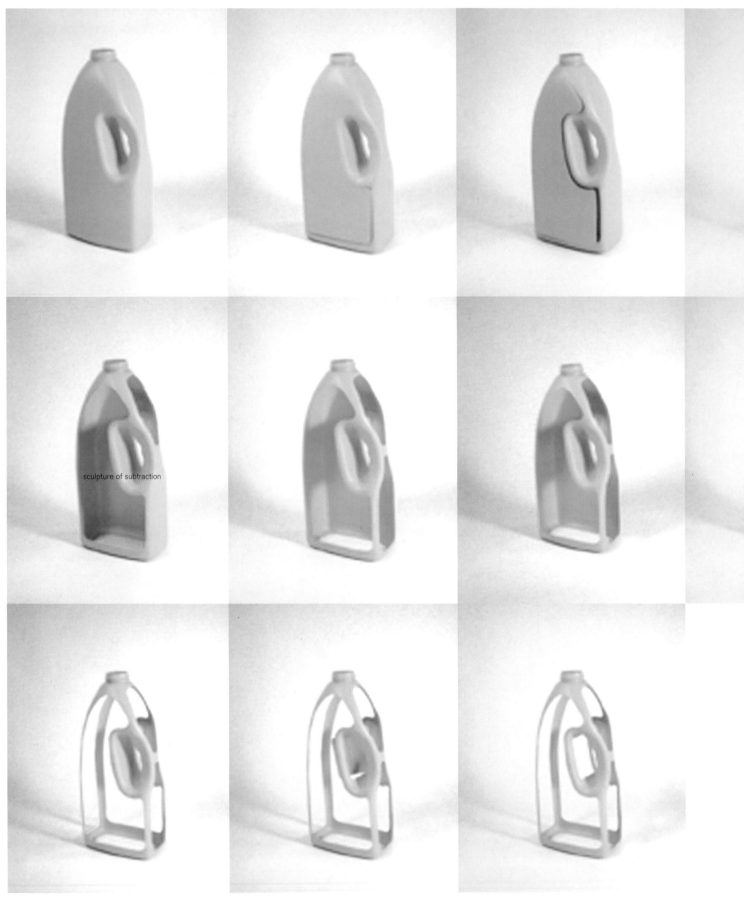

sculpture of subtraction

Manufractured **Form Follows Dissection: Régis Mayot**

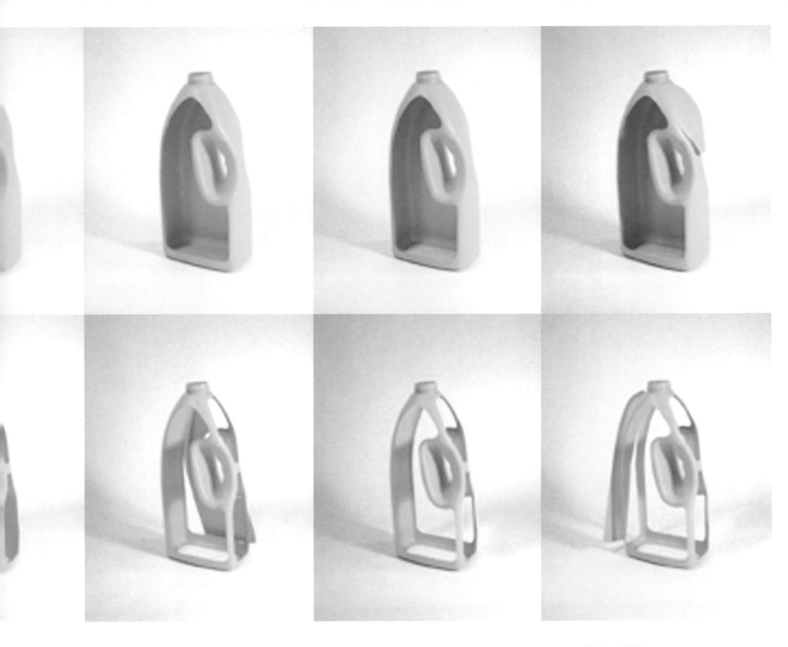

Flip book 2007
Process photographs of bottle dissection

"Plastic is the emblematic material of the end of the 20th century substituting for all the others—wood, metal, glass, fabric....It is the preferred material of industry; saving weight, time, material, energy...and paradoxically, it is the most neglected, the most negatively viewed by the public." —Régis Mayot

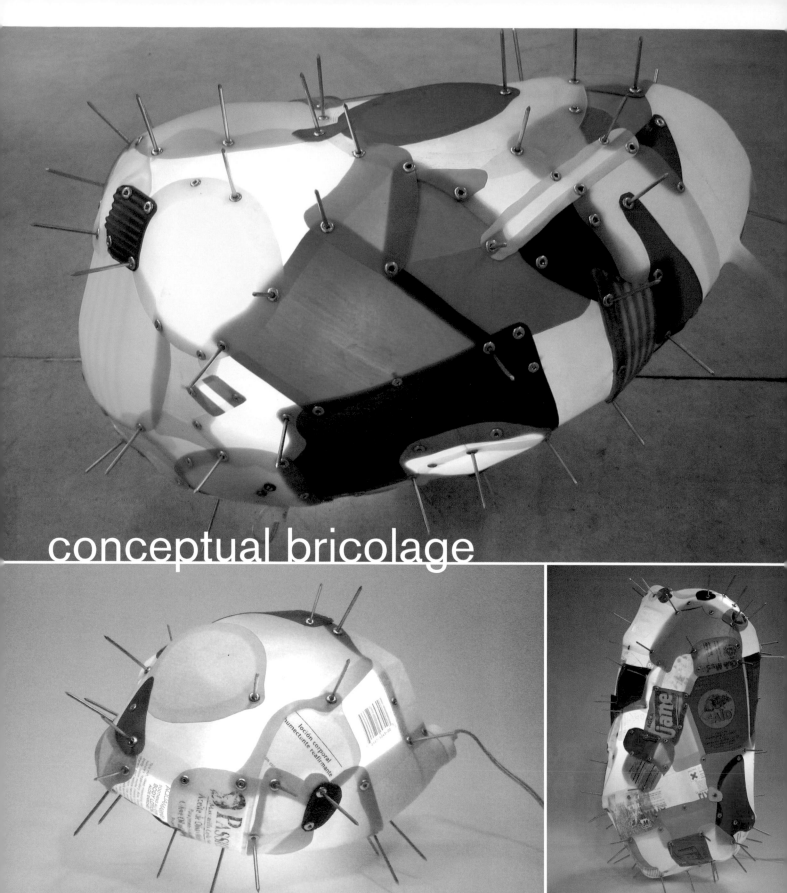

conceptual bricolage

Mayot's artistic project is an earnest attempt to give throwaway objects new life. To that end, he resurrects even the remains of the bottles that he has carved for his étagères and arrangements. Almost nothing goes to waste. He takes the curvaceous pieces that have been cut away—bright colors that recall the stained glass in Gothic cathedral windows—and joins them with tiny rivets at key connection points, forming and bending them into organic, amoeba-like light sculptures he calls *Mînes*.

In complete contrast to the cool, ghostlike architectural nature of the carved bottle pieces, Mayot's *Mînes* are densely packed petlike creatures: Polyglot and personality-rich, they might even appear cuddly if it weren't for their spiky metal spines sticking out in all directions. The *Mînes* emanate not only a soft glowing light, but a sweet emotional warmth, thanks to their organic forms and the curvy cuts of colorful plastic from which they are assembled.

Régis Mayot draws us into his work innocently enough, but once we are there, there is no getting around its grim reality: Our all-encompassing, late-stage capitalist lifestyle is rife with hyperconsumerism, false advertising, and environmental ills. Inherent in every plastic piece that he has so consciously and carefully transformed is a clear message of environmental awareness. Although the implications are ominous, Mayot's work is anything but heavy and dogmatic. Instead, he makes playful magic from the overfull shelves and trash bins of consumer culture. He celebrates the infinite shapes, structures, and colors that product marketers have proffered, even as he has dissected their physical form and deconstructed their symbolic meaning. Most importantly, he takes something worthless and transforms it into something of great value—and in doing so, he has given us a new definition of beauty and an expanded sense of optimism and possibility.

Mîne 2005
Recycled plastics, rivets, fluorescent lights

Mexican Mîne (Tulium Beach) 2007
Recycled plastics, rivets, fluorescent lights

Scribemîne 2005
Recycled plastics, rivets, fluorescent lights

haiku for r.m.
*dissected vessels
remade in patchwork patterns
enigmatic skins*
—s.s.h.

Mînes (couple) 2001
Recycled plastics, rivets, fluorescent lights

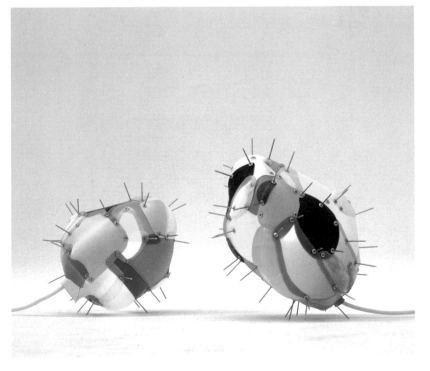

FORM FOLLOWS FABRICATION

Zipper Dress (detail) 1999
Single length of zipper, thread

Mara Holt Skov

Born in Morristown, New Jersey, works in Brooklyn, New York

Cat Chow. Imagine a seemingly endless spiral zipper beginning at the floor and traveling upward, circling around the curves of an undeniably female form, each row of teeth connecting one layer to another, until the final spiral ends just below the collarbone. Obsessively excessive but at the same time purely minimal, what was formerly a raw industrial sewing notion—through the benefit of series of experiments—has assumed a particularly poetic expression; a prime example of design becoming performance, fabrication elevated to art form.

For Cat Chow, the dress form began as a conceptual vehicle: both a container and creator of cultural meaning, a fully loaded artifact that has evolved to reflect our society's prodigious consumer culture. Using a variety of models—Eastern (kimonos), Western (aprons and evening gowns), and historic (chain-mail suiting and 1950s housedresses)—Chow's projects address, undress, and redress the dress as the key archetype of constructed female identity.

In Chow's hands, the dress became a foil for a vast array of unlikely materials, many of them the invisible subproducts of the garment industry—zippers, snaps, bobbins, rivets, tape measures, and jewelry tags. Even more far-fetched types of materials captured her attention as well—rubber and metal washers, vials of fluid, baby bottle nipples, aluminum miniblinds, wine corks, Astroturf, sandpaper, Band-Aids, Power Rangers trading cards, and even 1,000 carefully shredded dollar bills. Time and time

Raw material

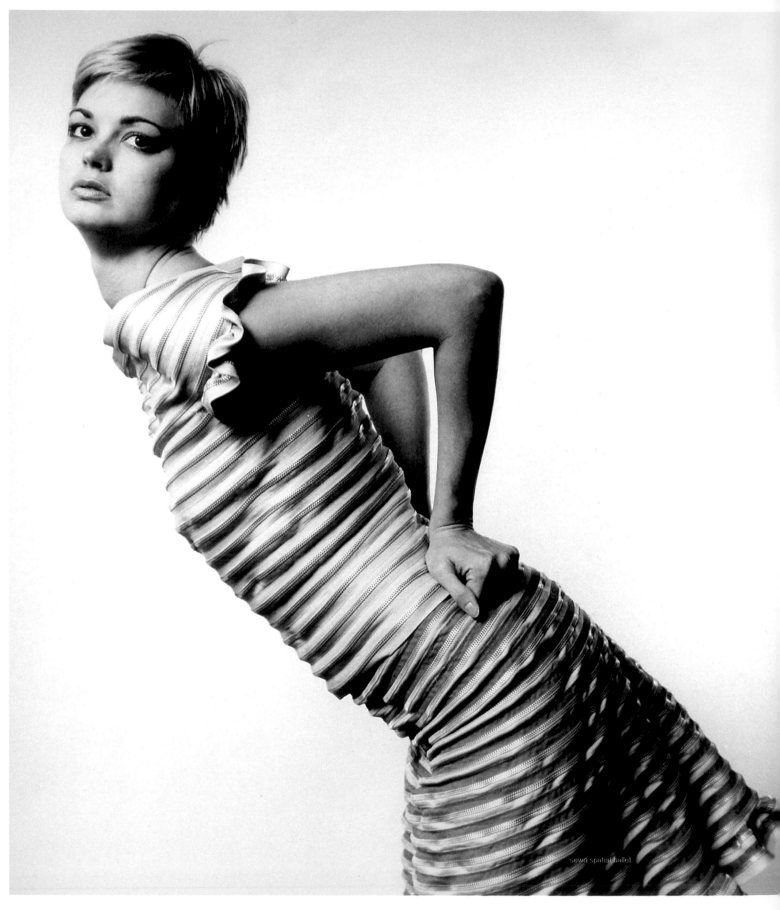

sewn spatial ballet

Manufactured **Form Follows Fabrication: Cat Chow**

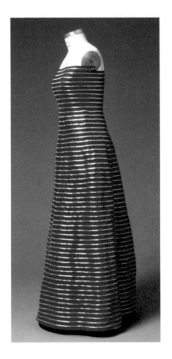

Zipper Dress 1999
Single length of zipper, thread

Zip Set (modeled) 2001
Two lengths of zipper, thread

again, Chow found hidden beauty in these common materials and emphasized their machine-art roots. Hers was an intellectually driven approach to garment making and her concept-rich dress constructions operated well outside the typical boundaries of fashion.

Chow's work reflects the time she spent as a student at Northwestern University, first in mathematics and then in costume design. Because of her mathematics background, there is an ordered rational inquiry inherent in every one of her pieces. Some even appear to be 3-D expressions of mathematical equations, obeying the minimalist principles of Occam's razor: "All things being equal, the simplest solution tends to be the best one."

Largely self-taught as an artist, craftsperson, and designer, Chow embraces art-world concepts and fine-arts constructs; she employs sewing, knitting, and craft techniques; and she utilizes aspects of the design process in her work at every level. She has become a unique synthesis of all three disciplines and thus is comfortable operating outside of set aesthetic boundaries.

Chow's hybrid approach to her work developed in the late 1990s, when she began designing costumes from uncommon materials. Then came the first paradigm shift, the moment in 1999 when she discovered her first zipper spools: 100-yard-long, continuous zippers that came in a variety of colors. Almost immediately, she imagined a spiraling strapless dress made from the zipper, but she didn't yet know how to fabricate it. With this single, simple vision, a manufactured industrial sewing notion became a virgin raw material full of potential for continual exploration.

As Chow began to experiment, she found that the zipper could indeed be sewn into a continuous, curving form—providing that the body measurements were exact. The garment had to fit like a glove. But as straightforward as the zipper dress seemed, it was also mysterious—a mathematical and conceptual riddle rendered in human scale and in three dimensions. Like most simple ideas, however, it took a great deal of mastery to work out the details for the first prototype: establishing exact proportions, developing a special graduated stitching technique, and determining the finishing details for the body-hugging spiral.

The resulting prototype dress was, to use the fashion industry term, surprisingly *wearable*. It was not only beautifully constructed, but it fit and flattered the body as well. The first zipper dress opened the door to others as she experimented with a variety of silhouettes and color combinations. A high point came in 2003, when one of her zipper dresses was accepted into the Permanent Collection of the famed Costume Institute of New York's Metropolitan Museum of Art.

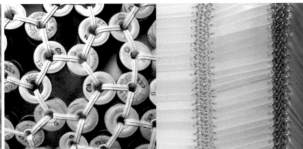

Materials: Baby bottle nipples, bobbins, plastic strips, rubber washers, metal washers

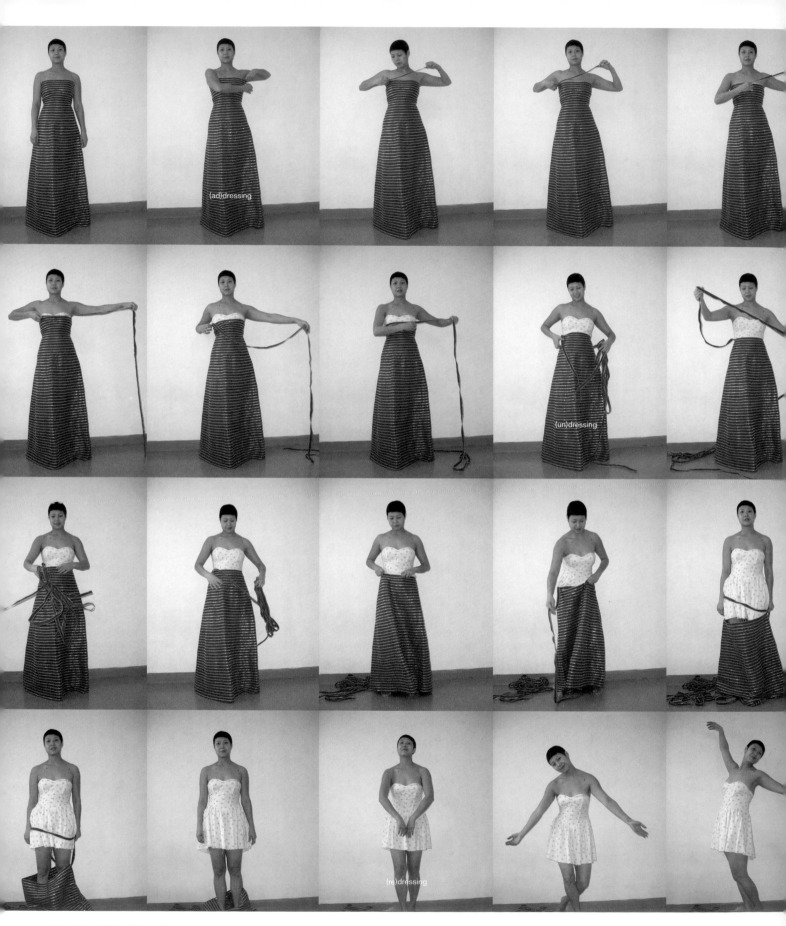

(ad)dressing

(un)dressing

(re)dressing

Manufractured **Form Follows Fabrication: Cat Chow**

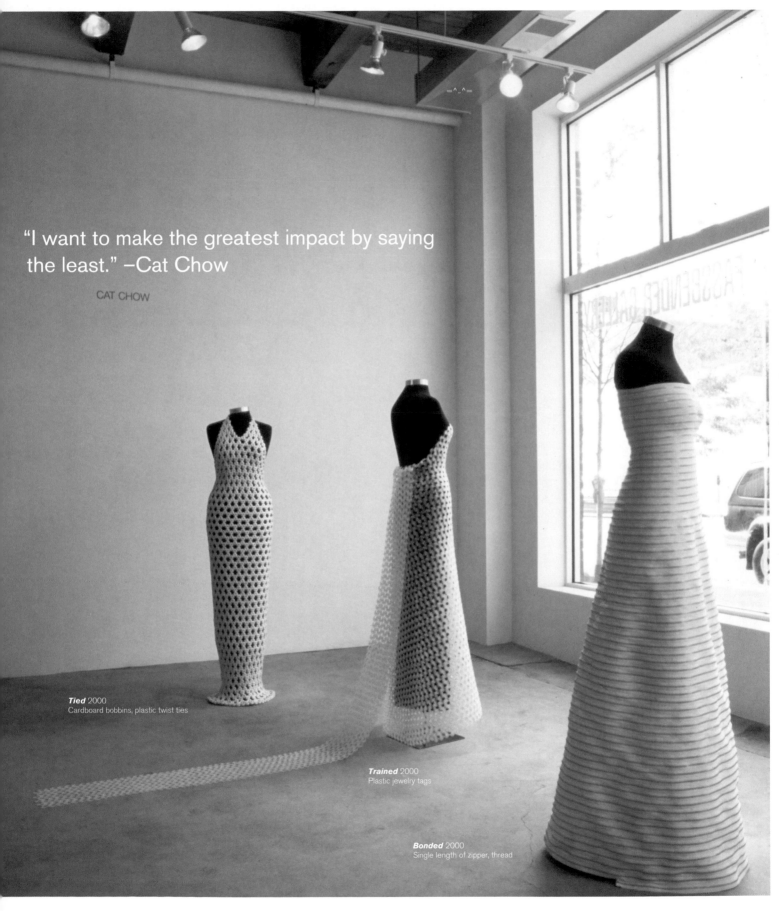

"I want to make the greatest impact by saying the least." –Cat Chow

CAT CHOW

Tied 2000
Cardboard bobbins, plastic twist ties

Trained 2000
Plastic jewelry tags

Bonded 2000
Single length of zipper, thread

"Fashion is also a verb…all of Cat Chow's work is about the act of making." —Valerie Steele, curator

Chow's meticulous methods of construction and focused intent link her art practice to those of studio and domestic craft. Each material, no matter how unconventional or banal it may seem, is painstakingly explored for its poetic and technical limits. How can the intrinsic hardness of a metal be softened? How can a flexible fabric assume a structural role? And most significantly, how can a nonprecious material be treated in a precious way?

Not only does Chow challenge the status of her materials, but she also challenges the dress as a signifier of women's identity and as an outward expression of female beauty. For emphasis, she gives many of her pieces emotionally charged titles: *Bonded*, *Tied*, and *Trained* are three elegantly shaped wedding dresses that focus on the limiting aspects of the marriage union. Similarly, *Measure for Measure*, a 1950s-inspired housedress made from woven measuring tapes, is a wry commentary on women's domestic roles and how their real lives never quite measure up to the expectations placed on them. Other titles also allude to the making and meaning of objects. *Not for Sale* is a crocheted piece made from 1,000 shredded one-dollar bills collected from 1,000 donors, a piece that Chow accordingly refuses to sell. Her *unDress* is essentially a white *Bonded* dress unzipped and coiled flat on the floor— a cool, minimal negation of the dress form collapsed into itself.

These conceptual pieces became Chow's bridge into the art world, as curators began to see her work as more than just fashion objects. Her next important paradigm shift came about when she took a zipper skirt off the body and hung it directly on the wall. All of a sudden, she saw the possibility of a new art form: It was no longer just a garment, it was an idea about a garment, and this new conceptual work belonged in galleries, not on catwalks.

Chow's appropriation of the sewing machine as a tool for art making was an equally radical step for an artist to take. Pieces like *Consume* explored the natural ruffling quality that the zipper could express when sewn just the right way. They seemed to illustrate the biological structures of flowers and leafy ferns, or mathematical concepts of curving and bending space. Although structurally related to her zipper dresses, conceptually these works represent a definite departure into another more complex realm of objecthood.

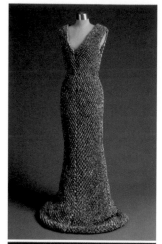

Not for Sale 2003
1000 shredded U.S. dollar bills, fishing line, glue, list of 1000 sponsors

Measure for Measure 2003
Woven measuring tapes, fishing line, buttons

Connections: Channeling the Spirit of Eva Hesse
Chow's gestural repetition and material explorations consciously evoke the repetitive, even obsessive spirals, knots, geometric forms, and wrapping techniques of Hesse's ground-breaking conceptual minimalist sculptures from the 1970s.

Eva Hesse
Ringaround Arosie 1965

Eva Hesse
Untitled or Not Yet 1966

Eva Hesse
Accession II 1969

Manufactured **Form Follows Fabrication: Cat Chow**

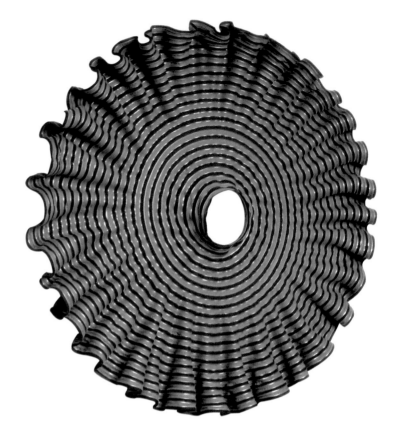

Consume 2003
Two single lengths of zipper, thread

unDress 2004
Single length of zipper, thread

minimal/maximal

"If something is meaningful maybe it's more meaningful said ten times... repetition does enlarge or increase or exaggerate an idea or purpose in a statement." —Eva Hesse

Ceremony 2008
Brass chain mail

Repeater 2007
Leather belts, nails

One Hit Wonders 2007
Leather belts, nails

haiku for c.c.
transforming notions
spiraling, encircling
beyond infinite
—s.s.h.

This simplicity of form expressed by *unDress* ushered in Chow's next period of growth that continues to the present. Chow's new work is stripped down and more conceptual than ever, but it still reveals the same interest in evocative titles. Sculptural floor and wall pieces made from coiled leather belts carry titles such as *Record (Test Pressing)* and *One Hit Wonders* that allude to Chow's second avocation as a musician. Although these new pieces have clearly grown from the strong foundations laid by pieces such as *unDress* and *Consumed*, they operate in an entirely different manner.

Chow continues to appropriate industrial materials and finished products as first explored in her zipper, metal washer, and chain-mail dress pieces. But her new objects have left the body altogether; they are no longer meant to appear functional or be wearable. She continues her labor-intensive, repetitive construction techniques, employing simple gestures that build layer upon layer. But now the act of producing these pieces is less a method of construction. Each chain-mail connection made, each new spiral of material added, becomes a record of a conscious artistic act where form making and meaning are imbedded and intertwined. These new pieces exist more clearly than ever as enigmatic art objects, moving her practice and purpose into the realm of post-minimal conceptual object making where they take on more primal and symbolic functions.

Cat Chow successfully merges a tinkerer's passion for solving material challenges with a dressmaker's innate sense of form and a minimalist's interest in conceptual thinking. Technically seductive, her work resides comfortably in the Venn diagram–like intersection where the worlds of art, craft, and design meet, and her greatest strength remains her power to transform ordinary materials into extra-ordinary objects.

FORM FOLLOWS ACCRETION

Manufractured **Form Follows Accretion: Jason Rogenes**

project 7.47a 1998
EPS foam inserts, electrical components

Mara Holt Skov

Born in Milwaukee, Wisconsin, works in Brooklyn, New York

Jason Rogenes. Light emanates softly through compressed layers of millions, even billions of tiny polystyrene balls molded into a multitude of baffling pure white geometric shapes. One part actively draws inward to fill the interior void, while another pushes outward to magnify the exterior relief. The result is an exercise in joining three-dimensional forms that shows the telltale signs of both an active intelligence and a skilled hand.

Polystyrene. A material familiar at a glance to anyone who has ever opened a packaged appliance or electronic device. Commonly (although inaccurately) referred to as Styrofoam, polystyrene is an unsung packing and shipping workhorse: strong in compression, lightweight in volume, and moldable into an endless variety of shapes. It submits to any form we fashion. But it has a tragically short life cycle; it is molded at the factory, sent off to fulfill a single protective mission, and then, more often than not, it is tossed into the landfill. Unable to be recycled without great energy, expense, and toxic effect, polystyrene is a green evangelist's nightmare.

But Jason Rogenes found beauty in lowly polystyrene, and he developed a working method to bring that beauty to light. In the vast variety of polystyrene packaging—remnants of consumer culture—he discovered an aftermarket goldmine of possibilities. The myriad sizes, shapes, and patterns available as raw material are astounding, each one so specialized that we can only guess at the product it

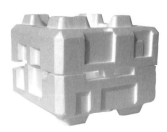

Raw material

was originally designed to protect. Using equal doses of spatial intuition, careful craftsmanship, and artistic vision, he constructs what can only be described as vertical cityscapes, floating spacecraft, space-dominating totems, and other enigmatic structures large and small.

Rogenes first considered polystyrene as a raw material when he was living and working in Los Angeles. In the commerce-driven environment of big-box stores, strip malls, and accessible garbage areas, the material was inexpensive and easy to procure. Discovering a new kind of beauty in this byproduct of consumer culture, he was able to see the potential for transformation, and ultimately for magic, especially when artfully arranged on a large scale.

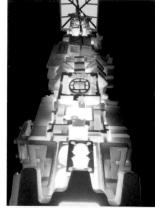

Rogenes' structures glow white-on-white from within—varying surface pattern and translucency provide the primary impression. In their proportion and presence they have the irresistible feel of a twenty-first-century archaeological monument, bringing to mind the otherworldly obelisk from Stanley Kubrick's classic film *2001: A Space Odyssey*. Even though Rogenes' structures are as translucent, faceted, and uplifting as Kubrick's obelisk was solid, smooth, and ominous, each carries its own seductive power and mysterious significance.

The same characteristic that makes polystyrene the perfect packing material—strength without weight—also makes it an ideal sculptural medium for Rogenes. Once each sculpture's internal metal armature is constructed, the lightness of the material enables him to build higher and more dramatically; for example, his *transpondor* installation for the Armory Center for the Arts in Pasadena, California, stretched the expanse of an open stairwell nearly six stories high.

Like *transpondor*, nearly every sculpture relates directly to the parameters of a specific site—from an intimate gallery setting to a glass-walled four-story atrium. In the planning stages of every project, Rogenes marries the possibilities of his material to the space the piece will inhabit, responding to the height, volume, light, and structural concerns he encounters. He often reconfigures existing pieces to respond to new settings, as in the case of *transpondor*'s most recent incarnation. Here, the vertical piece shape-shifted to a horizontal format for an urban San Francisco atrium. Rogenes contrasts pure white

transpondor 2005
EPS foam inserts, electrical components
Installation at One Colorado Tower,
Pasadena, California

Connections: Science Fiction as Inspiration
The detailed futuristic environments envisioned by science fiction writers such as Neal Stephenson and filmmakers such as Stanley Kubrick are remixed and reconfigured by Rogenes: his polystyrene installations are glowing, orbiting, sci-fi constructions.

Neil Stephenson
Snow Crash book cover 1992

2001: A Space Odyssey movie poster 1968

Stanley Kubrick
2001: A Space Odyssey film still 1968

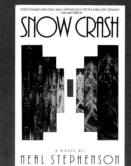

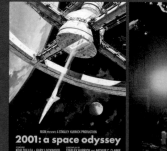

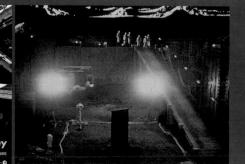

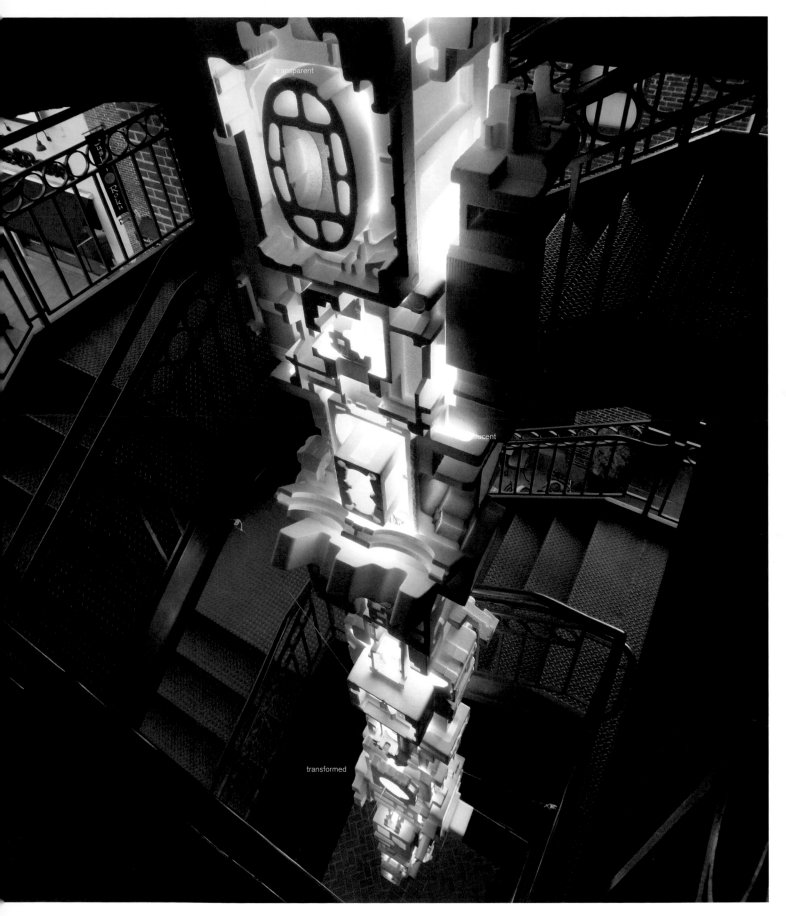

transparent

translucent

transformed

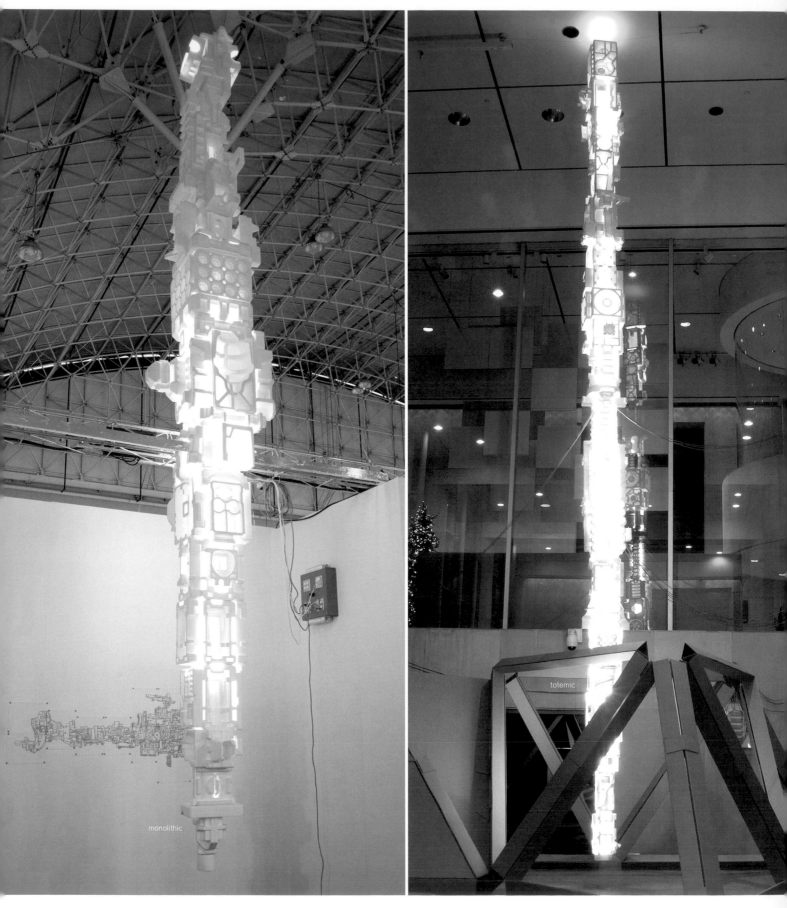

monolithic

totemic

Manufactured **Form Follows Accretion: Jason Rogenes**

project 7.47a 1998
EPS foam inserts, electrical components

leroy lightning 2007
EPS foam inserts, electrical components

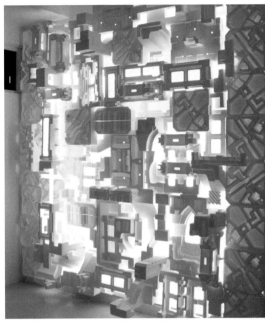
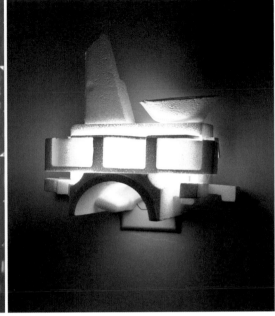

project transmission 2002
EPS foam inserts, electrical components
Installation at Art Chicago, Navy Pier,
Chicago, Illinois

locus 2007
EPS foam inserts, cardboard, electrical
components
Installation at Whitney Altria, New York,
New York

floating polystyrene sculptures with earthy ground-based cardboard structures, or for more dramatic effects, he installs them inside multilayered cardboard room-sized environments where the only light emanates from the floating sculpture itself.

When his concept is ready for realization, he labors over each piece of polystyrene with the same care and attention given to the most precious materials. Just as the master mason selects exactly the right stone, then shapes and carves it to fit into the continuum of a wall, Rogenes also begins by carefully selecting each molded polystyrene component. Then he carves and shapes the pieces by hand before fixing them into position, using plastic-based glue as his mortar. He repeats this process with anywhere from five to 100 or more individual pieces, depending on the scope of each installation. The latter grand-scale sculptures are products of accretion, growing piece by piece into whole systems of connected and interlocking parts—complex, endlessly expanding three-dimensional puzzles.

There is something completely familiar yet ultimately strange about each of Rogenes' sculptures, in part because they are made from such a ubiquitous material lifted from our consumer-centric lives. The sad truth is that we rarely give polystyrene a second thought or see it for what it truly is: a marvel of design and manufacturing ingenuity. The greatest irony is that each factory-shaped piece of polystyrene is designed almost as carefully as the object it is meant to protect, yet one is considered valuable and the other, once its packaging role is over, is essentially worthless.

Unlike traditional raw materials used by sculptors or craftspeople—stone, metal, wood, clay, or glass—Rogenes' materials come pre-cast, ready-to-use, and uniform in color. While others are limited by a scarcity of materials or the often-expensive means to work them, Rogenes's main cost is his time spent gathering the most pristine and structurally interesting discarded pieces. From there, he

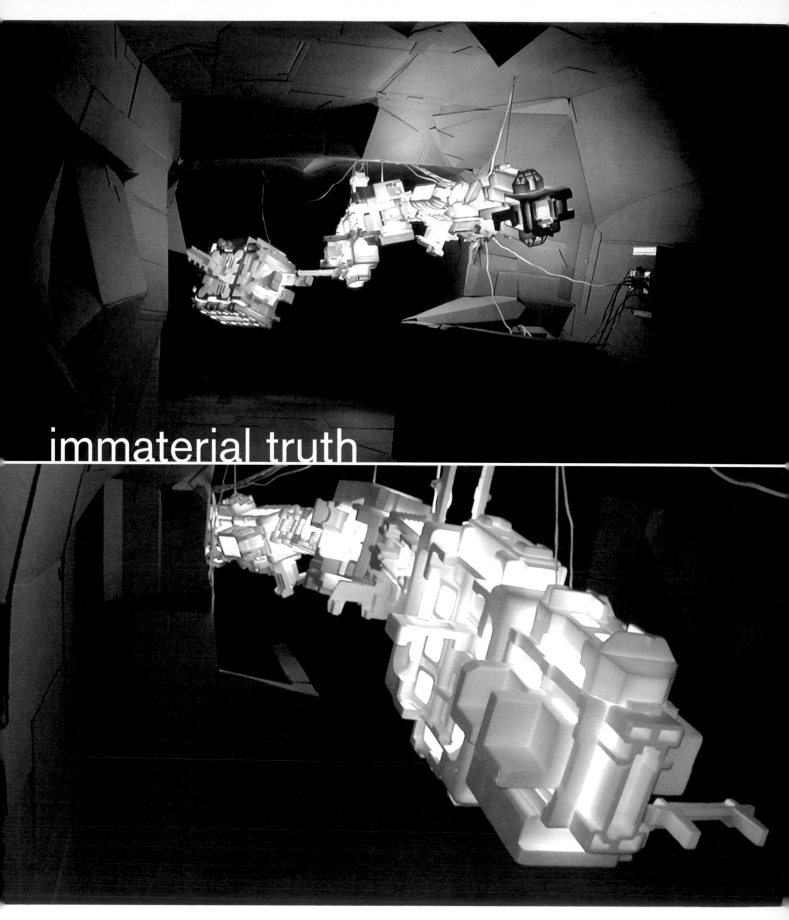

immaterial truth

Manufactured **Form Follows Accretion: Jason Rogenes**

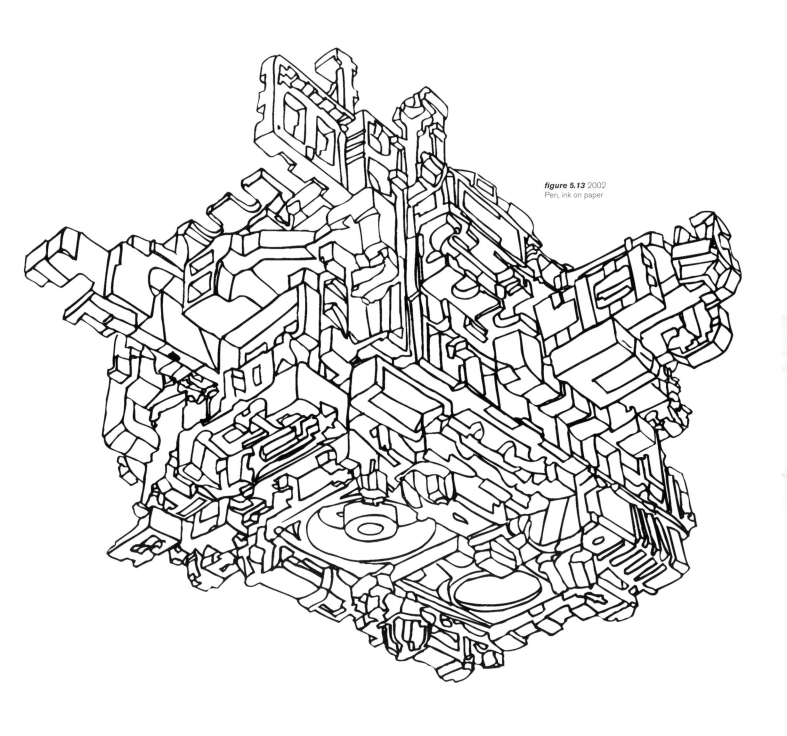

figure **5.13** 2002
Pen, ink on paper

project 9.08f 2001
EPS foam inserts, cardboard, electrical components
Installation at Susanne Vielmetter Los Angeles
Projects, Los Angeles, California

develops an intuitive system of organizing his accumulated boxes and blocks into larger structures and systems. His finished work has both a visual and structural affinity with legendary sculptor Louise Nevelson's scavenged wood assemblages, many of which she created around an open box form (see page 17). Nevelson's boxes were containers for object groupings, while those of Rogenes are already complete forms, but for both artists, the box is an essential building block from which their work begins.

What links Rogenes to other highly regarded practitioners in the fields of art, craft, and design is his ability to smoothly and seamlessly transform his materials into expressive and aesthetic objects. What sets his work apart is the radical gesture he consciously makes by appropriating a devalued material and treating it as if it were a precious one, like marble or alabaster. Although polystyrene may be a devalued material, it is actually prone to denting, scraping, cracking, and breaking apart; therefore, it must be protected and handled delicately. Accordingly, Rogenes never violates the rules governing polystyrene's physical integrity, but rather adapts its physical properties to his advantage. Through his attention to both its idiosyncrasies and its aesthetic possibilities, he offers us a way to see it as precious, too.

Rogenes' polystyrene constructions have given us futuristic cityscapes of pure geometric form; he has propelled us forward with his pristine white-shelled spaceship structures; he has offered up timeless totems to materials gods and floating-in-air personages. And ultimately—thanks to his ability to transform banal packing materials into visually compelling structures—Jason Rogenes has helped us to see underappreciated polystyrene in a new way, not just for its function, but for its beauty. This not only saves some pieces from their demise in the landfill, but it teaches us to look more carefully at the aesthetic possibilities that surround us every day. He reminds us that new kinds of beauty may not always need to be invented; many are simply waiting to be brought to light by a creative mind.

diagram 3.13c 2008
EPS foam inserts, cardboard, electrical components

diagram 3.03c 2008
EPS foam inserts, cardboard, electrical components

transpondor 3.03 2008
EPS foam inserts, electrical components
Installation at 101 California Street Plaza, San Francisco, California

dreamweaver 2004
EPS foam inserts, electrical components
Installation at Susanne Vielmetter Los Angeles Projects, Los Angeles, California

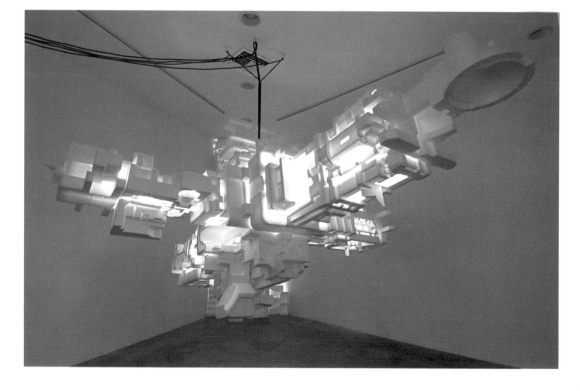

haiku for j.r.
glowing, towering
styrofoam systems of thought
phantom tectonics
—s.s.h.

Manufactured **Form Follows Accretion: Jason Rogenes**

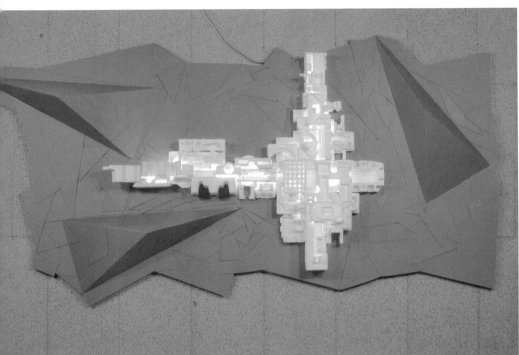

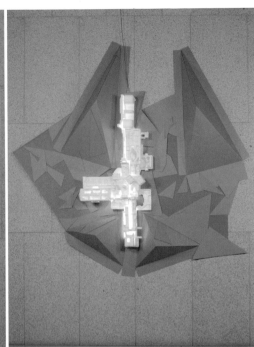

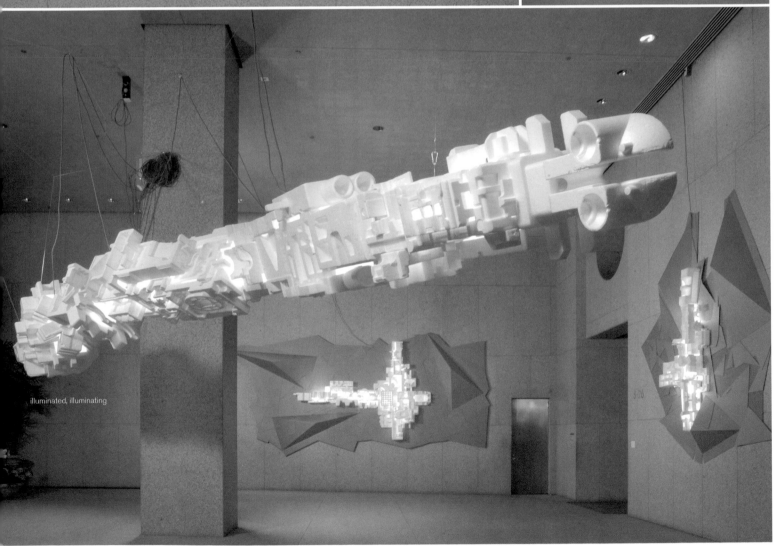

illuminated, illuminating

FORM FOLLOWS FUSION

Manufactured **Form Follows Fusion: Sonya Clark**

"Coming to know oneself and others through the rituals of hairdressing and hairstyling is a unique way of knowing." —Sonya Clark

Untitled (detail) 2008
Plastic combs, thread

Mara Holt Skov

Born in Washington, D.C., works in Richmond, Virginia

Sonya Clark. Shiny black teeth layer upon intertwined layer—a mass of controlled chaos. Hundreds of fine-toothed combs are composed in ordered stacks, gravity-defying spheres, circular basket-like constructions, and wall installations that recall textiles. A mass-manufactured, utilitarian grooming tool "Made in USA" is repurposed as a raw material for sculptures that defy both convention and logic while at the same time they display a wealth of expressive possibilities.

The fine-toothed comb is the stuff of Sonya Clark's art. Familiar to the point of banality, the comb is an object we all know from our earliest days. But Clark helps us to see the comb in a new way. She has appropriated it as a raw material for her exploration into issues of identity, beauty, form, and freedom, all under the guise of textile art. For Clark the comb offers a kind of structure with each set of teeth playing the role of warp or weft. By consciously choosing a manufactured plastic comb as her "fiber," she shakes the very notions of what a textile can be.

In one piece after another, Clark tests the expressive limits of the comb as a material for art making, all the while striking a careful balance between exploiting its formal attributes and recognizing its significance to culture and identity. The comb is, of course, an ancient object loaded with meaning and intimately connected to human history. For millennia, humans have used such tools to tame the mass of hair on their heads. The earliest combs were made of found natural materials— wood, ivory,

Raw material

and shells. As the quest for beauty and adornment found physical form, combs began to occupy a more prominent position, becoming art objects themselves. Intricately carved and bejeweled, made of ivory, ebony, bone, shells, and fine metals, combs not only served an obvious useful and decorative purpose, but they also were a place to openly display the taste, wealth, power, and social standing of their wearer.

Sonya Clark's first intimate connection with combs was with the more humble variety. It began like that of nearly every young girl, squirming on a chair while an adult armed with a comb and good intentions attempted to bring order to the disorder on her head. In Clark's multiracial, multicultural family—her mother is Jamaican of African and Scottish origin, her father is Barbadian and Trinidadian with deep Yoruba roots—she remembers being the only child whose hair defied treatment with a fine-toothed comb. Her response to the pulling, tugging, and parting was deep and lasting, leaving her with a complicated relationship to the comb. Yet Clark also realized what a gift it was to be groomed by the hands of others, as it drew her into a special closeness with family members.

Later as an artist, she began working out some of the issues of identity and culture imbedded in hair and hairstyling. Beginning with textiles, she worked with the combed and woven "hair" of plants and animals—cottons, linens, and wools—striving to get to the deeper, more symbolic aspects of textiles. She made headdresses, hats, and wigs—all objects that crowned the head, the seat of the soul, as her father's Yoruba heritage taught.

Dryad 1998
Cloth, thread

Onigi 13 1997
Cloth, thread

Triad 1998
Cloth, thread

Two Trees 2002
Cloth, thread

Onigi 13 (detail) 1997
Cloth, thread

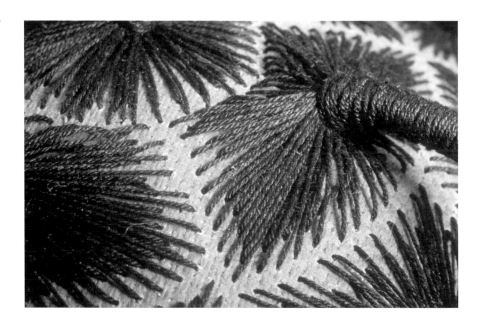

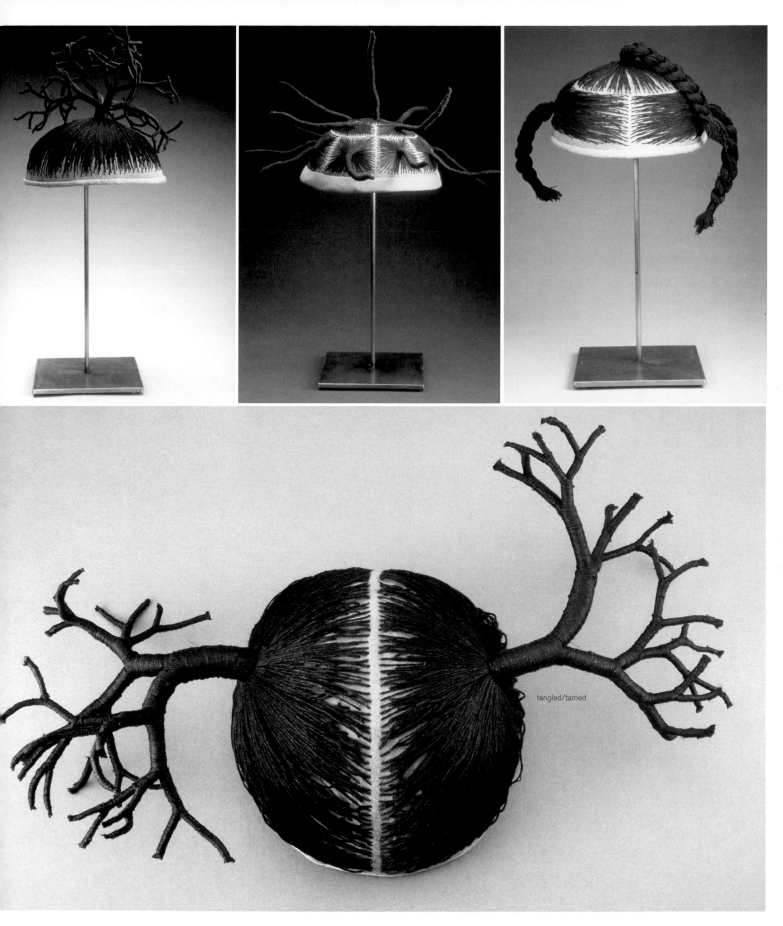

tangled/tamed

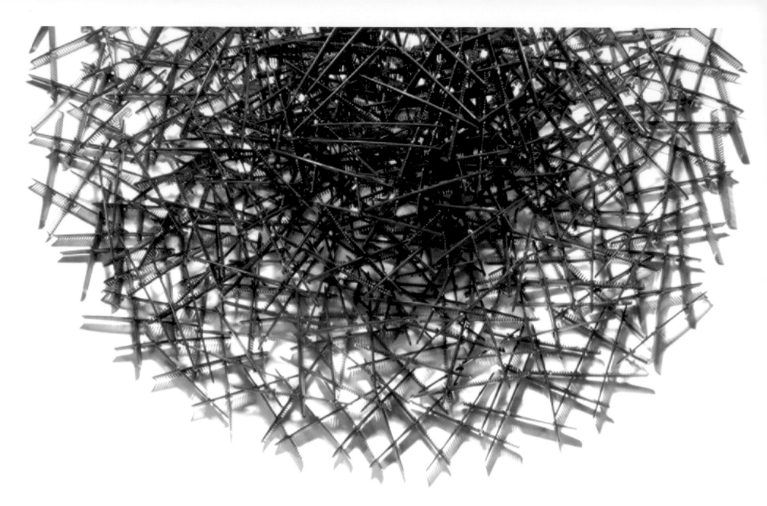

"Take something. Do something to it. Do something else to it." –Jasper Johns

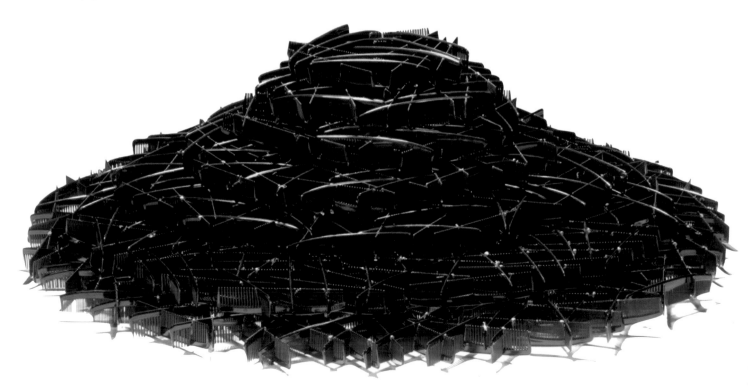

Manufactured **Form Follows Fusion: Sonya Clark**

Stacked 2005
Plastic combs

Wavy Strand 2005
Plastic combs

7 Layer Tangle 2005
Plastic combs

In 2005, Clark began what would become the *Comb Series*, a group of works in which she confronted the combs of her childhood and made them her new sculptural raw material. What had once been an adversarial relationship, she now embraced. One of the first pieces in the series, *7 Layer Tangle*, implies that the comb (like hair) can be systematically organized (into an exact number of layers), but in the end, the parts will ultimately end up in disarray—the tangle.

More orderly is *Wavy Strand*, in which each comb assumes a straight-at-attention position as it curves right and left to mimic a single strand of the artist's own hair, but shown in exaggerated relief. The tight, pure form of *Wavy Strand* stands in direct opposition to the chaotic *7 Layer Tangle* as an observation and expression of the tension between order and disorder.

Stacked provides an even more orderly display of the three-dimensional possibilities of Clark's raw material—a meditation on repetition, structure, and volume. The piece combines modular sections of combs, following a systematic pattern of organization. Clark's unwavering interest in exploring seemingly simple materials and pushing them to their formal limits is what makes works like *7 Layer Tangle*, *Wavy Strand*, and *Stacked* so curious and enigmatic.

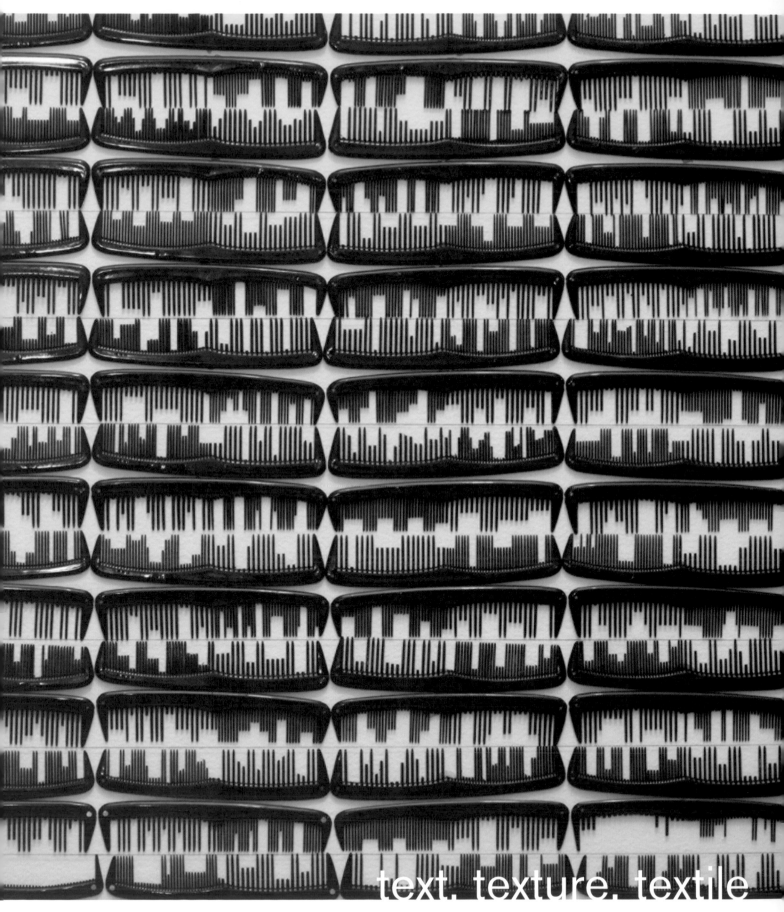

text. texture. textile

Manufactured **Form Follows Fusion: Sonya Clark**

Toothless (detail) 2006
Plastic combs

Little girl with the press and curl
Age eight I got a Jheri curl
Thirteen I got a relaxer
I was a source of so much laughter
At fifteen when it all broke off
Eighteen and went all natural
February two thousand and two
I went and did
What I had to do
Because it was time to change my life
To become the women that I am inside
Ninety-seven dreadlock all gone
I looked in the mirror
For the first time and saw that HEY

Sonya Clark studio walls
Summer 2007

I am not my hair
I am not this skin
I am not your expectations no no
I am not my hair
I am not this skin
I am a soul that lives within

—India.Arie, from the album *Testimony,
Vol. 1: Life and Relationship*, 2006

When it comes to the actual making of these pieces, Clark employs a kind of kinesthetic intelligence that kicks in automatically when she begins to work. Each individual comb is secured in position, one after another, until the overall form begins to take shape. As the piece grows, she enters a kind of meditative state in which her body does the work while her mind is free to wander. In this meditative state, she finds the open-ended creative space where her next pieces are born.

Pieces such as *7 Layer Tangle*, *Wavy Strand*, and *Stacked* proved that combs could fit together to create a wide variety of structurally and aesthetically successful sculptural forms. But would the comb stand up when expanded into a full wall textile? Were the teeth of the comb warp and weft enough for weaving? The answer lies in Clark's wall installations. There she develops the two-dimensional properties of the comb, resulting in works that function aesthetically and psychologically as textiles. For Clark, who defines herself as a textile artist, it was imperative that her new materials could find a form that resonated with her past artistic production.

Although historically, combs have occupied an important position as precious personal objects, now suitable primarily for museum collections, the combs that Clark uses are essentially throw-away items, shiny plastic mass-produced products made by the millions. But Clark shows us that there is beauty to be found in the simple fine-toothed comb and she asks us to think of it as a valuable object again: to look beyond its ordinary nature.

Sonya Clark's comb pieces not only elevate manufactured objects to a higher plane. In addition, they carry heavy loads of conceptual and social significance, and they do it in an aesthetically engaging way. Her strategy of addressing materials, making, and meaning in the same simple object elevates Clark's work from its banal material source into a thing of beauty, artfully assembled.

Untitled 2008
Plastic combs, thread

haiku for s.c.
semiotic tool
kinesthetic invention
for connecting lives
—s.s.h.

Connections: The Ornamental Comb
Until the Industrial Revolution, combs were one-of-a-kind status- defining artifacts laboriously crafted from precious materials. Mass-produced plastic changed all that. Now Clark challenges the plastic comb's commodity status— treating each one like the bone, ivory, bronze, and gold examples of the past.

Ivory comb with the story of Susanna at her bath
Gothic period

Comb decorated with Ashanti allegorical figures from Ghana n.d.

Comb ornamented with Scyths in combat from Solokha, South Russia 6th–4th BCE

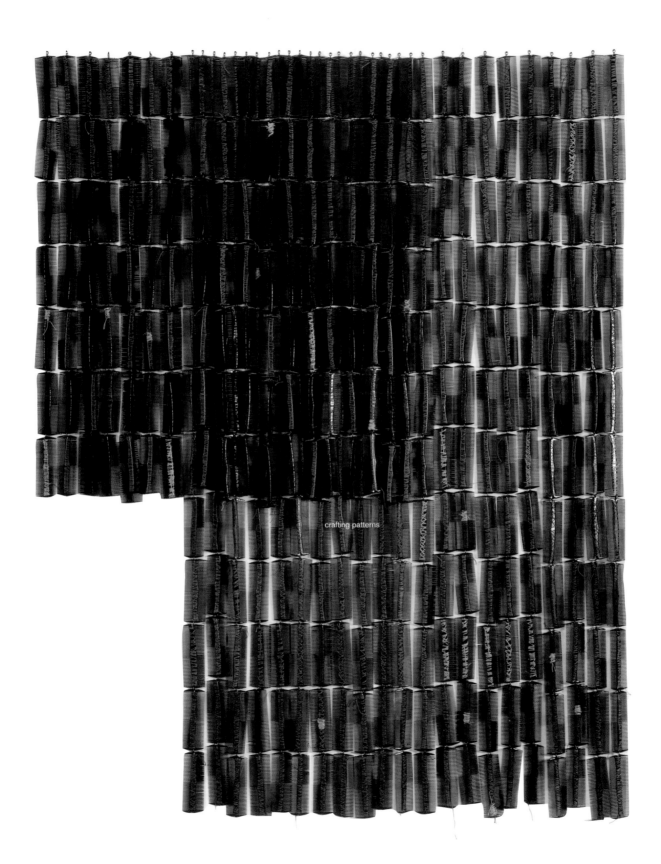

crafting patterns

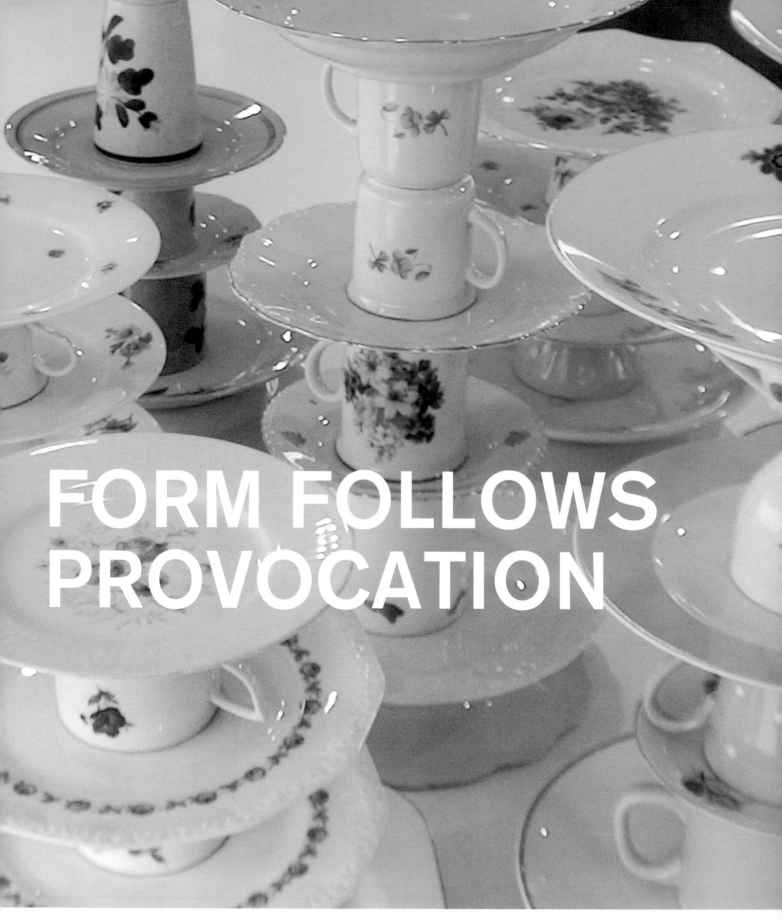

FORM FOLLOWS PROVOCATION

"Design is the subject…the language is art." —Laurene Leon Boym

Salvation Ceramics 2002
Ceramic dishes, Extreme Adhesive glue

Mara Holt Skov

Constatin born in Moscow, Russia, Laurene born in New York, New York, both work in New York, New York

Constantin and Laurene Leon Boym. Bowls, plates, cups, saucers, and vases are stacked to surprising heights. Their surfaces are variously studded with budding flowers, trimmed with gilded edges, ornamented with raised vine patterns, and encircled with bands of texture. Collected from thrift shops and assembled following a set formula, every stack is the same according to type, but completely different in its individual incarnation. Cast-offs are rescued for a higher purpose and function yields to fantasy. Yesterday's middle-class kitsch finds salvation in today's elite objet d'art.

If there is a consistent message in the idiosyncratic designs that emerge from Boym Partners, it is the message of salvation. From repurposing metaphors and materials to resurrecting cultural icons, husband-and-wife team Constantin and Laurene Leon Boym sift through the American cultural landscape for their inspiration. Their mission: to rescue obscure objects and products and usher them into the foreground. They are often drawn to the things that so-called "serious design" rarely pays attention to, teasing out the ideas not yet a part of design discourse.

Some of the Boyms' best research is done in hardware emporiums, grocery stores, and thrift shops—places that are chock-full of functional objects, manufactured products, and ready-to-use materials. Of course, every one of the objects in these stores has been "designed," as all manufactured

Raw material

products are, by necessity, designed to some degree. But the level to which thoughtful design inquiry has been integrated into their production varies greatly. In the middle-class marketplaces of America, the Boyms have found a goldmine of opportunities for their unique brand of design investigation.

Saving the rich remains of American consumer culture has been a common theme for the Boyms, beginning with the first projects that Constantin undertook upon arriving in the United States more than two decades ago. Coming from Soviet-era Moscow to the northeastern United States in the early 1980s, Boym was enchanted with the abundance of American consumer goods. Encountering rows of colorful, shapely bottles in the grocery stores, he saw a manufactured beauty that Americans were taking for granted. His enthusiasm grew into several projects that appropriated those and other found materials.

For *Recycle*, he stripped the grocery store bottles of their labels and constructed plywood armatures to frame their bare forms, drawing design attention to objects that would otherwise be considered refuse. For *Searstyle*, he ordered kitschy vinyl, Naugahyde, and corduroy replacement furniture components directly from the Sears catalog. He gave the spare parts a new life beyond their ordinary beginnings by integrating each into the framework of contemporary furniture. For *American Plumbing*, he and Laurene (by then married and partners in Boym Partners) appropriated off-the-shelf plumbing parts to create vases, gluing them together with the recommended PVC adhesive. They created every one of these projects with existing materials, without special tooling or computer aids, and as a labor of love, often at their own instigation (and expense), without a design brief from a client or manufacturer.

Recycle, *Searstyle*, and *American Plumbing* offered a kind of salvation for objects that were undervalued and overlooked. Other projects highlighted car antennas, staples, packing straps, and tin cans. Although each one originated from an entirely different design investigation and resulted in an entirely different form, they are all united by the Boyms' philosophy of infusing ordinary objects with a meaning that transcends their humble beginnings. Sparked by the Boyms' ironic sensibility, each intervention elevated yet another common object to the level of serious discourse. At the time this type of design experimentation represented an entirely new way to design, essentially creating a new model that now even mainstream designers have come to embrace and use to their own advantage.

Recycle vase (prototype) 1988
Wood frames, milk carton, laminate

Connections: The Readymade Made Anew
Boym Partners have continually found finished products to be provocative materials for their design investigations. Plastic bottles, plumbing parts, car antennas, tin cans— their rescue of the familiar but underappreciated has grounded their conceptual object-making from the beginning.

American Plumbing 1999
Antenna Clock 1989
Tin Man Canisters 1994

honest things. democratic things. things that work.

G H J K K

Sears catalog c. 1980s

Searstyle armchair and footrest (prototype)
1992–94
Wood, Sears catalog replacement parts
Produced in collaboration with artists Komar
and Melamid

meta objects

Manufactured **Form Follows Provocation: Constantin and Laurene Leon Boym**

"The design is the expression of the purpose. It may (if it is good enough) later be judged as art." —Charles Eames, designer

 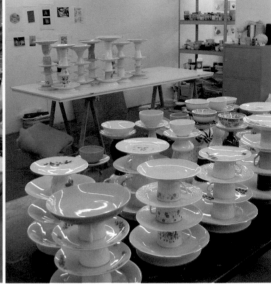

Salvation Army store shelves

Salvation Ceramics in production
at Moooi Breda, Netherlands 2002

Salvation Still Life 2000
Ceramic dishes, Extreme Adhesive glue

For the *Salvation* ceramics project, the Boyms used the same strategy of zeroing in on a select group of familiar objects. This time they found inspiration in the hodgepodge selection of dishes in Salvation Army thrift stores, antique shops, and garage sales. They purchased a variety of orphan dishes they found (bowls, teacups, mugs, plates, saucers, and vases) and began to arrange them in different groupings to see what would result. Searching for a way to assemble and secure the groupings together, they landed on Extreme Adhesive, a special glue developed for medical applications.

Dishes are designed to be stacked, and understandably, the stack form was a neat jumping-off point for many of the *Salvation* pieces. But the stacks that resulted from their experiments are anything but regular. They are a lively mix of all the components at once, both upside down and right-side up. They are idiosyncratic and quirky. They are vertical still-life sculptures that you can put cookies on. They are designed objects that keep acting like art. They are art objects that have renegade functionality.

But can we categorize these strange hybrids as art? Constantin insists that the *Salvation* project is not art, but simply a series of design explorations into form and material that embrace the idea of salvation. Laurene is more willing to consider the possibility that they exist and function (like many of Boym Partners' projects) outside the realm of traditional design and more in the realm of art. More likely, they negotiate the fertile territory between art *and* design and signal a new object type that requires a new set of descriptive terms yet to be coined.

When Dutch designer Marcel Wanders (see chapter 10) proposed that Boym Partners create a special series of *Salvation* ceramics for his production company Moooi, he had only to import the concept. The Boyms developed several simple equations for Moooi's *Salvation* pieces, and stylist Rebecca Wijsbeek was charged with putting the Boyms' formula into action in the Netherlands. She hand-selected each bowl, cup, and saucer from local Salvation Army stores. After she conferred with the Boyms at the outset of the project, the pieces were manufactured in limited editions and sold by Moooi.

Salvation Stack 2000
Ceramic dishes, Extreme Adhesive glue

Salvation Low Stack 2000
Ceramic dishes, Extreme Adhesive glue

"In a method akin to rap or hip-hop music, (their) projects sample already manufactured goods and use them as the raw materials for a new kind of familiar-but-strange

real/surreal

Ultimate Art Furniture 2006
Wood, painted canvas, mirror

Manufractured **Form Follows Provocation: Constantin and Laurene Leon Boym**

The simplest aspect of the *Salvation* project developed for Moooi was also the most brilliant: the equations, or recipes as Constantin calls them. With an equation, a *Salvation* piece could be produced nearly anywhere across the globe, assuming one could find thrift stores selling shelves of mismatched dishes and had a skilled eye to make the selections and arrangements. Just as conceptual artists such as Sol LeWitt wrote instructions for making drawings and sculptures (rather than making the pieces himself), the *Salvation* project was really a conceptual formula for object making that was to be executed by others.

Although many of the *Salvation* stacks' individual components could be considered by themselves unimpressive, the act of combining the pieces infuses them with intelligence and wit. By applying the Boyms' formula or recipe, each individual piece is lifted from its banal roots into the realm of highly intellectual conceptual design. Each individual stack becomes an eccentric member of the *Salvation* ceramics family. They all share certain formal similarities, but as in any family, each member has a different set of physical characteristics and a specific personality.

Like many of the Boyms' design projects, *Salvation* was based on a series of investigations into the possibilities of materials, strategies for making, and the meanings of the objects themselves. Other projects have appropriated the visual language of children's book illustrations (*Harold and the Purple Crayon* and *Curious George*) and historic plate designs from the collection of the Cooper-Hewitt National Design Museum, to name only a few. More recently the Boyms have literally lifted reproductions of historic paintings off the walls and integrated them with classic modernist chairs and tables. These new furniture pieces blur the boundaries between art and design in more overt ways than ever, breaking further into previously unexplored design territory. It is the Boyms' analytical and investigative process, grounded in their philosophy of cultural appropriation, that drives their design practice and makes their work unique.

There is much to be learned from this approach to creating, which privileges inquiry and process over end results. For Constantin and Laurene Leon Boym of Boym Partners, it is a way toward reenvisioning the role of the designer in today's world. It also leads to new and expanded definitions of beauty that embrace the quirky, the ubiquitous, and the "undesigned," giving new life to the discarded remains of our object-rich consumer culture.

 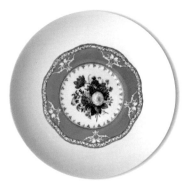

Real Plates 2004
Ceramic with digital decal

haiku for c.b. & l.l.b
rescue salvage save
cultural experiments
rules are good, break them
—s.s.h.

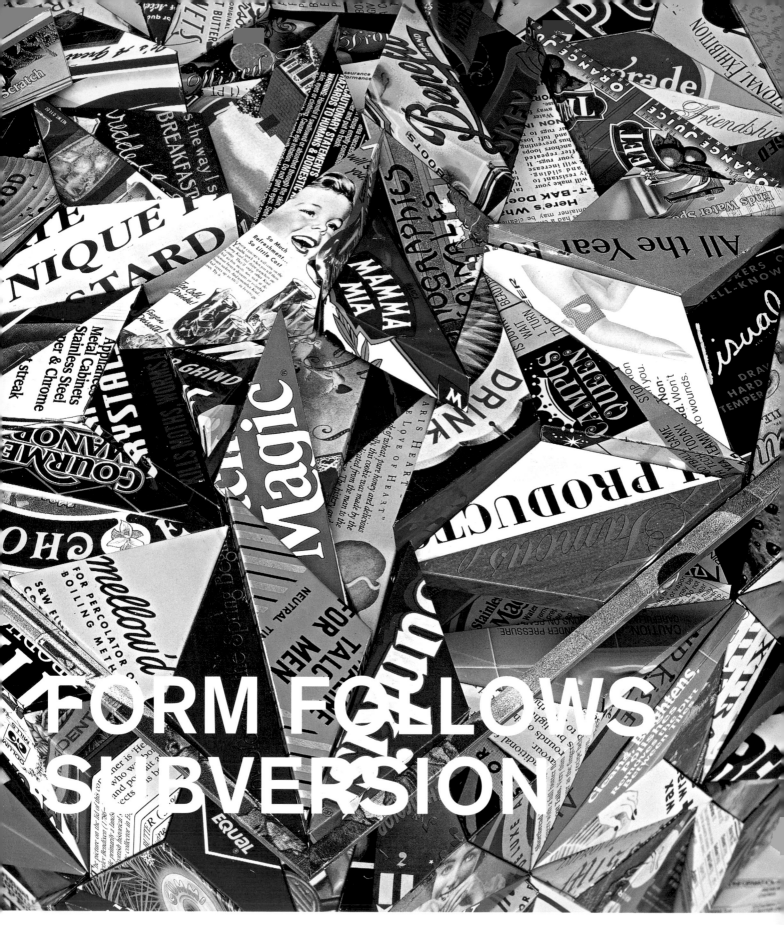

FORM FOLLOWS SUBVERSION

Witnessing the Weight of Words (detail) 1996
Preprinted steel from recycled containers

Mara Holt Skov

Born in Harrisburg, Pennsylvania, works in San Mateo, California

Harriete Estel Berman. Meticulously snipped and formed triangles, squares, and rectangles pattern together to create a patchwork of colors, images, and text. The effect is density and complexity of the first order. The pattern is familiar—a quilt? But the material is unexpected—so rigid! This is not the soft, draping quilt on your childhood bed, but instead a sharp-edged construction pieced together from scraps of metal—scavenged bits of consumer culture—printed tins complete with nutrition facts and UPC symbols.

Midcentury metal dollhouses, children's lunchboxes, and printed consumer tin cans. All are raw materials appropriated by Harriete Estel Berman for her obsessively fabricated sculptures that comment slyly on women's roles in society and on the home front. Her work reflects the attention to detail of a fine metal-worker, the intellectual observations of an artist, and the anthropological research of an industrial designer. All these, with the addition of sharp wit, combine to shed light on some of the uncomfortable truths of contemporary culture.

The uncomfortable truths that Berman takes on begin with the ways in which women have been depicted throughout twentieth-century media and visual culture. The object of desire, the domestic goddess, the saintly mother, the workingwoman juggling career and home life: Berman has played every one of these roles. With her converted garage studio just one step outside the family's kitchen door, her artistic life has never been far away from her domestic life, and more often than not, complexly intertwined.

Raw material

From her earliest pieces such as *Eveready Working Woman* and *The Family of Appliances You Can Believe In*, to the more recent *Consuming Conversation* and *Identity Complex*, Berman has made her domestic life a laboratory for research, insight, and anecdote. This serves to ground her sometimes acerbic, sometimes comedic use of words and images in her own experience. Indeed much of the power of her work stems from the fact that it springs from undeniable real-life truths.

Another source of power comes from the obsessive attention to detail she devotes to ordinary materials. Her raw materials are completely common and banal, but she treats them as if they were precious. She carefully cuts and bends each piece into her desired shape, connecting the pieces with tiny rivets. Each edge is perfectly straight; each margin meets with exactitude. This technical prowess is what first garnered attention from other metalsmiths; at the time, her peers were a highly skilled but mostly conservative group.

Much of Berman's work also has a strong affinity with the traditional craft of quilting. When she first began constructing objects from printed steel dollhouses, she drew both aesthetic and technical inspiration from quilt patterns. The dollhouses were printed with wallpaper and cabinetry on the inside, bricks and siding on the outside, offering a wealth of colors and patterns. The allover prints acted like fabric, and Berman's natural instinct was to cut and form small shapes and piece them together as a quiltmaker would. At the time, this was a radical, even subversive step to take, especially for a trained metalsmith. Berman was most drawn to quilt patterns with names that evoked domestic situations: Broken Dishes, Baby Blocks, and Log Cabin. These became the models for *A Pedestal for a Woman to Stand On*, a series of cubes based on themes of domesticity and motherhood.

From the very beginning, Berman insisted on deeper intellectual and social content in her work. Her epiphany came in the late 1980s when she read Adrian Forty's *Objects of Desire*, a look at the early twentieth-century proliferation of appliances into the domestic environment: vacuums, refrigerators, stoves, and washing machines. These marvels of industrial design promised to make women's housework easier and lo! even more pleasurable. But what really happened, according to Forty, was that housekeeping standards and expectations rose with the introduction of every new product. The promise of progress turned out to be an empty one.

Open-eyed, Berman set out to address domestic myths in her work with the depth of knowledge that comes only from experience. She exposed the poignant truths and frustrating realities of women's domestic work even while she was completely immersed in it. She cared for her home, husband, and two children. She cooked and cleaned and sewed. She gardened. She baked bread! Because she exposed her own inner conflict between domestic responsibilities and personal artistic needs, her work rang with authenticity, her point of view was clear.

Connections: Domesticity Subverted
Some of the most stereotypical and potentially damaging images of women come from advertising. Berman mines mid-20th century magazines for the messages their ads promulgate; appropriating their visual and verbal vocabulary for her piercing critique of widely-held domestic myths.

Automatic Beyond Belief

Make your Sink Center a Work Saver

Mrs. Modern Plans Her Kitchen

Patchwork Quilt, Small Pieces of Time 1989
Preprinted steel from antique dollhouses, Log Cabin quilt pattern

Baby Block to Creativity 1990
Preprinted steel from antique dollhouse, Baby Block quilt pattern

**My American Kitchen Saves Me Two Hours a Day to
Keep Myself Looking Young** 1991
Preprinted steel from antique dollhouse, Broken Dishes quilt pattern

We Are Reflected in the Objects We Choose to Surround Ourselves 1991
Preprinted steel from antique dollhouses, Attic Window quilt pattern

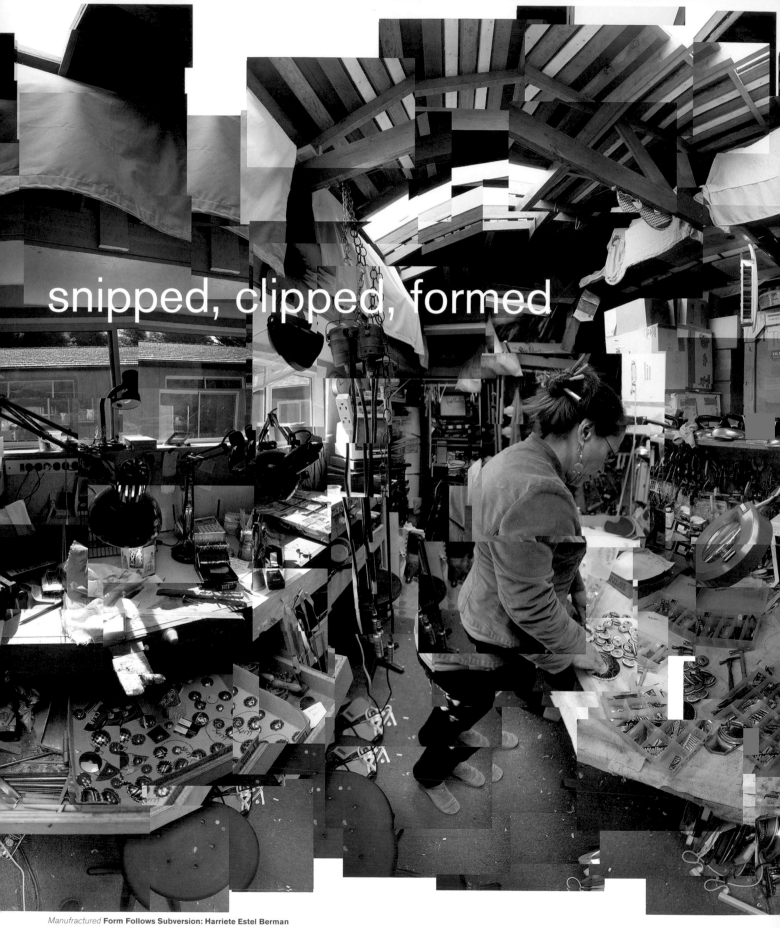

snipped, clipped, formed

Manufactured **Form Follows Subversion: Harriete Estel Berman**

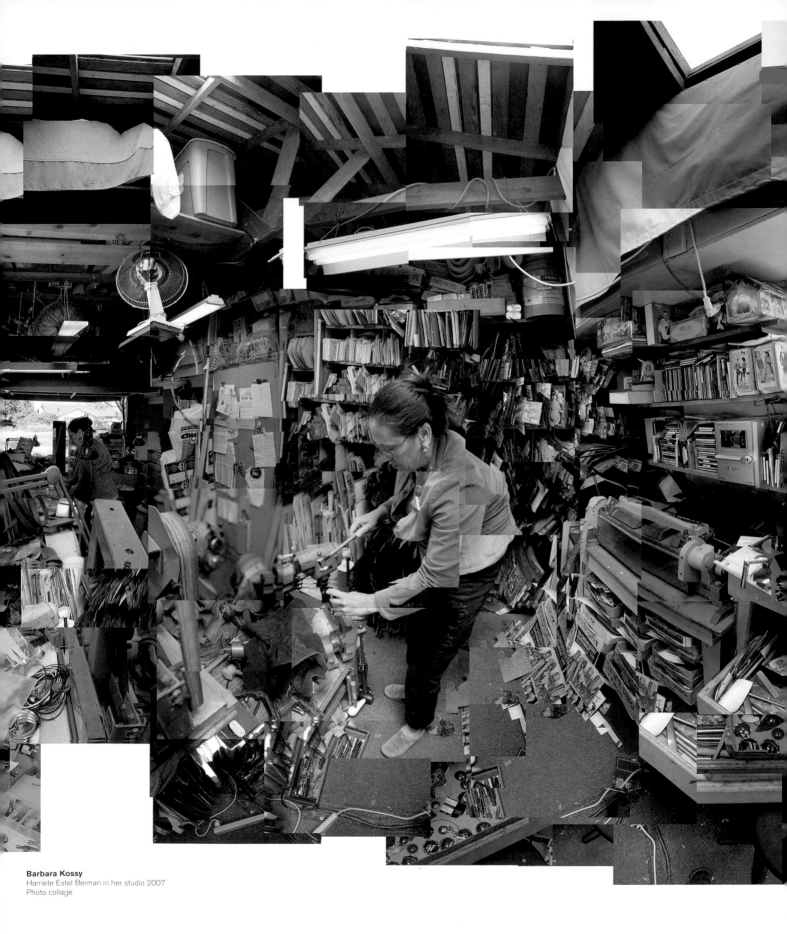

Barbara Kossy
Harriete Estel Berman in her studio 2007
Photo collage

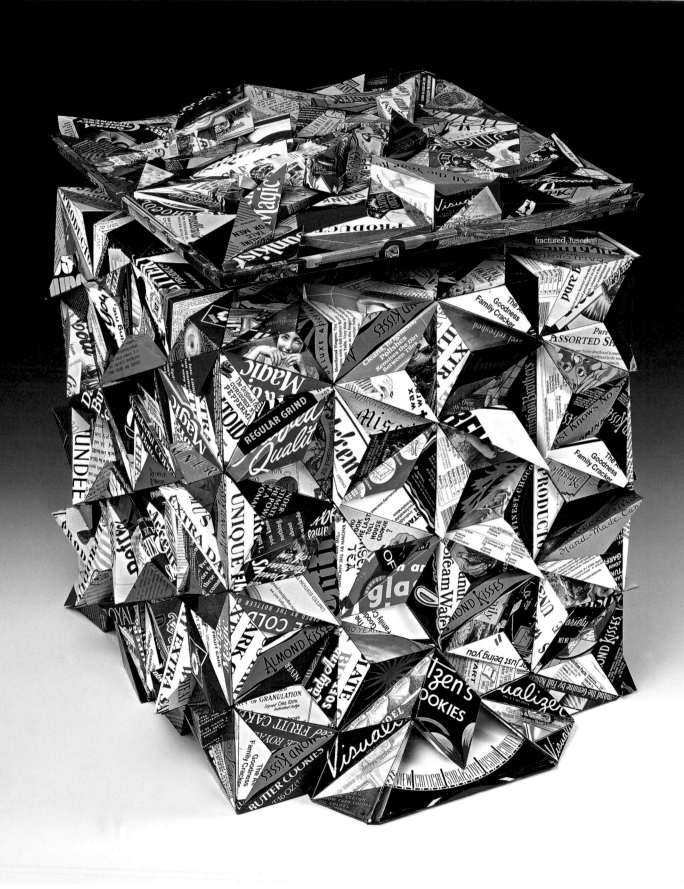

fractured, fused

Manufactured **Form Follows Subversion: Harriete Estel Berman**

Hourglass Figure, The Scale of Torture
(detail)

Witnessing the Weight of Words (detail)

Witnessing the Weight of Words 1996
Preprinted steel from recycled containers,
electric motor rotates dial

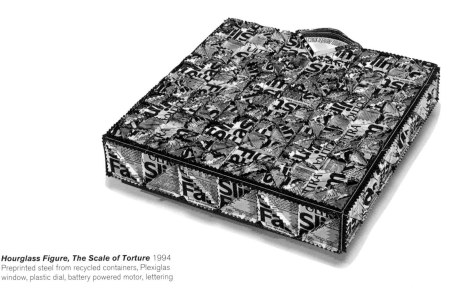

Hourglass Figure, The Scale of Torture 1994
Preprinted steel from recycled containers, Plexiglas
window, plastic dial, battery powered motor, lettering

Naming and etymology have always been central to Berman's process, beginning with her own name, "Harriete," which means "mistress of the house" in Old German. And how could any conscious feminist artist *not* exploit a surname like Ber*man*, ripe as it is with questions of identity and gender politics? Accordingly, she altered it to "Bermaid" and used it as her artist's signature to ironically emphasize the feminine in her work.

In her quest for meaning behind the printed and spoken word, Berman has often turned to advertising copy for the truisms revealed therein. *My American Kitchen Saves Me Two Hours a Day to Keep Myself Looking Young* and *Nice and Easy, Even if Your Marriage Doesn't Last Your Color Will* are lifted directly from advertisements. More recently, her teacup series *Consuming Conversation* offers multiple evocative statements inspired by media and popular culture such as "Hold on for the Ride," "Promises, Promises," and "Use for Only Outrageous Goals."

These titles and text interventions are integral to the meanings of Berman's work, delivering biting commentary tempered by ironic humor—a perfect strategy for making a difficult message more palatable. Study any of her pieces closely and you will be rewarded with sly surprises—a word, a phrase, an image juxtaposition—pieced together painstakingly in ransom note style from the text and images that her printed tins offer.

Hourglass Figure: the Scale of Torture is one such example of a title that does extra conceptual duty. Modeled after a bathroom scale, it is constructed from Slim Fast weight-loss beverage cans assembled in the *Hourglass Variation* quilt pattern. Berman employed pinking shears to cut the material in sharp zigzags and assembled the piece with the pinked edges upward as a visible metaphor for the emotional pain associated with a dieter's daily weigh-in. Instead of numbers on the dial, she substitutes the words "honeybun," "cookie," "sweetie pie," "muffin," "sugar," and other terms of endearment that are also subtley demeaning to women and carry double meanings as edibles dangerous to dieters. *Hourglass Figure* addresses women's sensitivity about their weight and their search for physical perfection, and it does so in ways never before seen in traditional metalwork.

Witnessing the Weight of Words takes Berman's serious wordplay to an even higher level. This hybrid piece combines the functionality of a scale with the experimental patterns of her "quilted" cubes. The surface is dense with printed words juxtaposed to elicit additional meaning: "magic," "kisses," "late," "extra," "assorted," "quality," "variety," "products." The scale text is rich in words with double meanings: "realize," "issue," "critical," "state," "pointed," "perspective." The entire piece provides visual commentary on both the ambiguity of words and their increasing power in text-based art and advertising. Though created more than ten years ago, *Witnessing* is more poignant than ever, as verbal literacy declines at alarming rates (even as our visual literacy has increased).

Berman's critique of long-held domestic myths has led her to such nostalgic models as samplers, teacups, teapots, side chairs, and vanity seats. In a series of radically subversive acts, she turns these traditional models upside down. But she does so in a decorative manner that masks the serious nature of each piece. If a sewn sampler is her model, then the frame is dense with images of delectable foods and flowers, and the sampler text reads "Do Not Touch." If her subject is the social institution of teatime, then she makes hundreds of teacups, each with its own biting, humorous, or catty message, stacking them up haphazardly, Alice-in-Wonderland style, for chaotic effect. If an upholstered vanity seat sparks her interest, then she constructs the entire piece from images of beautiful women but layers on text that reveals an unhealthy obsession for perfected physical appearances.

The brilliance of Harriete Estel Berman's worldview is her embrace of the complexities and contrasts of our everyday lives—the desire for intellectual fulfillment contrasted with the need to complete repetitive chores, the enormous burdens of homemaking with the joys of family connections, the comic response to a deadly serious moment. Her work reflects related oppositions—meticulous care taken with cast-off materials, intellectual inquiry preceding repetitive assembly, biting commentary served up with ironic humor. All this adds up to work that is rich with obsessive detail, visual delight, social commentary, cultural critique, gender and identity questions, and ironic humor. Strong medicine delivered with a silver spoonful of sugar.

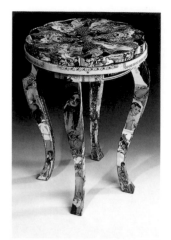

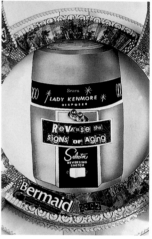

Fading Identity 2002
Preprinted tin and steel from recycled containers, aluminum, 10K gold rivets, stainless-steel screws

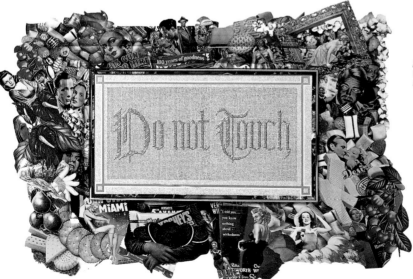

Do Not Touch 1998–2000
Printed steel from recycled containers, brass and aluminum rivets, brass wire embroidery

Consuming Conversation 2001–04
Preprinted steel from recycled containers, sterling silver and brass handles, 10K gold rivets

haiku for h.e.b.
domestic promise
contradicting reality
her work never done
—s.s.h.

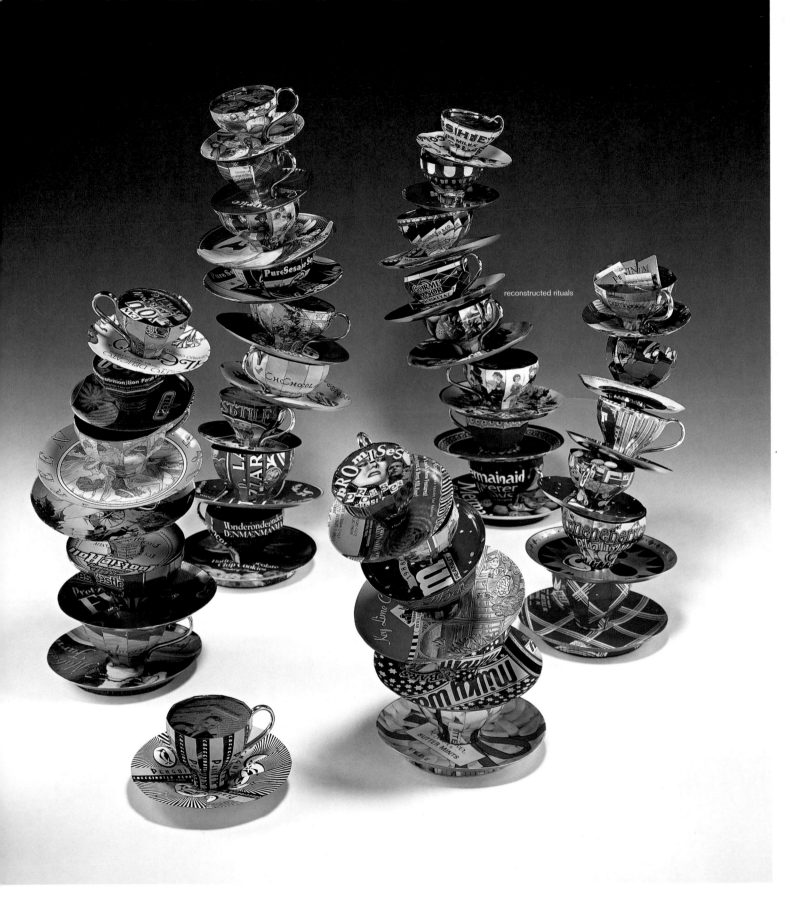

reconstructed rituals

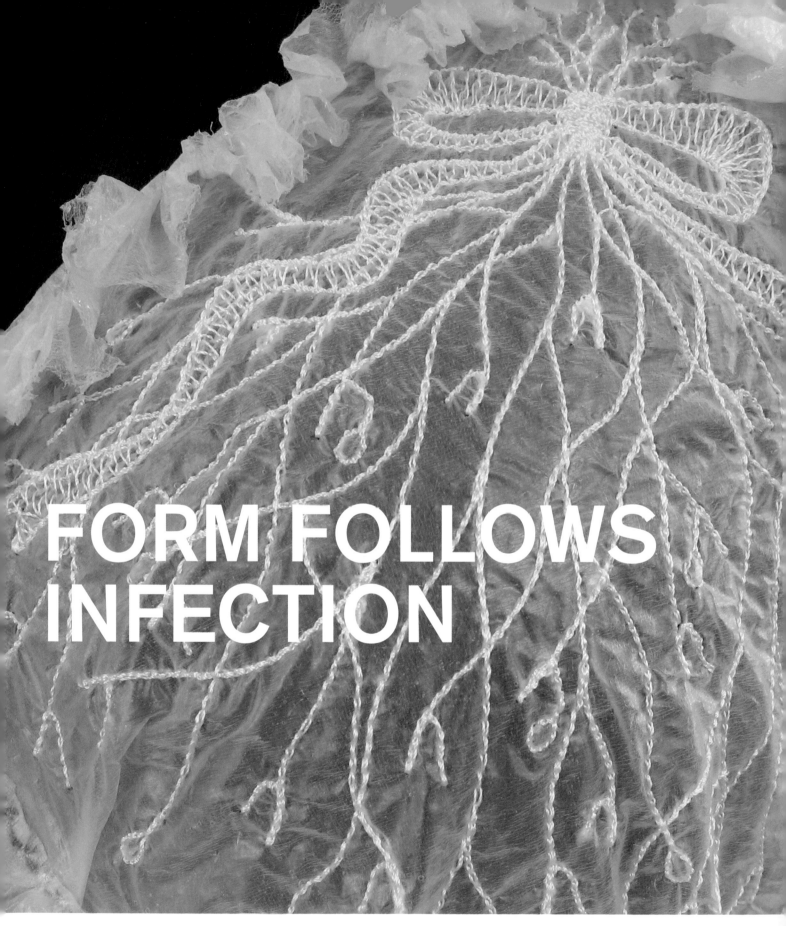

FORM FOLLOWS INFECTION

"I try to create work…that upon closer inspection reveals some uncomfortable truth about our cultural and biological conditions." —Laura Splan

Trousseau (Negligée #1) (detail) 2007
Cosmetic facial peel, machine embroidery

Mara Holt Skov

Born in Memphis, Tennesee, works in Brooklyn, New York

Laura Splan. A translucent sheath of fabric is ruffled, gathered, and embroidered with the ribbons and bows of ordinary nightgowns. But the material itself suggests something different altogether. Its surface texture hints at the ridges and fissures of human skin. A strange bond is formed where decorative ornament meets biological form, and skin becomes the textural template for sci-fi fabric.

Intricate lace embroidery, homespun hooked pillows, hand-knit scarves, trellis-patterned wallpaper— all of these objects imply a tradition-bound domestic setting from the past, the realm of the grand-mother rather than the avant-garde artist or conceptual designer. But in the hands of Laura Splan, such familiar domestic icons take on surprisingly complex and contradictory roles. The comfort of the familiar is tinged with a *frisson* of strangeness suggesting that a deeper, more disturbing story might be hidden beneath their embellished surfaces.

This strangeness in Splan's work results from her deliberate integration of classic fiber-based crafts with medical imagery and materials. Delicate doilies replicate illustrated diagrams of microscopic, often lethal viruses; overscaled latch-hooked pillows mimic the popular antidepressants Prozac, Thorazine, and Zoloft (see page 10). Similarly, a hand-knit scarf is made from blood-filled medical tubing connected to an IV line in the wearer's arm, and traditional wallpaper patterns are traced with the artist's own blood. Each of these beautifully crafted objects is simultaneously perverse and compelling.

Splan attributes her fascination with the medical field to her family's background; her grandmother was a nurse and her father and sister both worked for a medical implant company. Thus, her comfort with medical imagery and implements was fostered early on. She first studied biology at the

Raw material

University of California at Irvine but soon began making connections between biological systems and the visual arts. She found herself most attracted to cutting-edge medical research that tended toward the realm of science fiction—cloning, bacteriology, medical tools and implants, and anything to do with blood.

Her timing couldn't have been better. At the turn of the twenty-first century, the place where art and biology intersected was ripe for exploration. Splan was just beginning her post-MFA work in 2002 as the first drafts of the human genome sequence were published. This single event ignited the imagination of a new generation of scientists, artists, and the general public alike. It became the inspiration for art exhibitions such as "Paradise Now" and "Genesis," both of which focused on genetics and included artists whose work explored the intersections of art and scientific research, offering radically new models for what this art could look like.

For Splan, her search for new models led her to a place she could not have anticipated— from the science lab to the living room. Perhaps it was her graduate work at Mills, an all-women's college, that got her looking at the domestic environment in new ways, recontextualizing the latent possibilities in women's traditional craft practices. Perhaps it was the burgeoning do-it-yourself move- ment, when a whole new generation of people took to knitting, sewing, and building things on their own. Splan adopted these familiar craft-centric modes of creating objects, but subverted and radicalized them by hand-making conceptual productlike sculptures that blurred the lines separating art, craft, and design.

In Splan's hands, the doily was pulled out of the proverbial attic trunk, revived, and given new purpose. Working with a proprietary computer program designed for the Babylock mechanical embroidery machine, she created five different doilies based on microscopic images of media-hyped viruses circulating in contemporary consciousness: hepadna (hepatitis), herpes, HIV, influenza, and SARS. Each pattern was manipulated to bring the unique physical characteristics of the viruses to complete aesthetic resolution. In *Viral Doilies*, Louis Sullivan's old modernist adage "Form follows function" has shifted to become "Form follows infection," and the surprising result is a delicate and elegant beauty.

In fact, the resulting *Viral Doilies* exhibit the same visual intricacy that we find in the enlarged photographs of Wilson Bentley's snowflake dendrites or the radial structural axes of Ernst Haeckel's diatom drawings. Viruses, snowflakes, and diatoms are all compelling models of structure, symmetry, and pattern, and Splan has made the most of what nature has offered. Our order-craving minds find comfort in the regularity and symmetry of Splan's *Viral Doilies*, even if some might find her work unsettling.

Blood Scarf 2002
Chromogenic print

Connections: Scientific Inspiration in Art and Design
The sciences (especially biology) have become an increasingly valuable source of materials, techniques, and inspiration for Splan and other artists by bringing about a multitude of new and strange kinds of aesthetic models for object-making.

Ernst Haeckle
Ascidiacea 1904

Marcel Wanders
Airborne Snotty Vase: Influenza 2001

Gail Wight
J'ai des papillons noirs tous les jours (detail) 2006

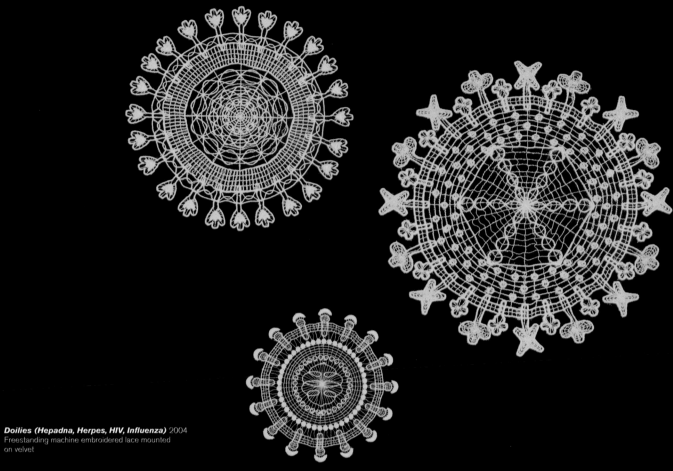

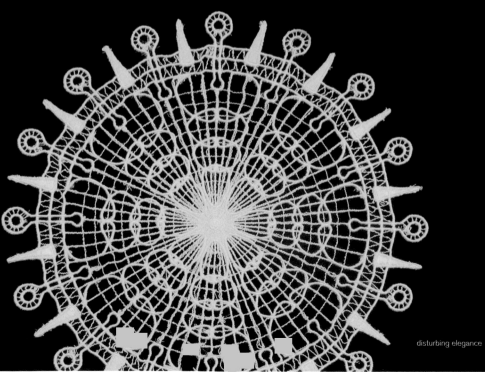

Doilies (Hepadna, Herpes, HIV, Influenza) 2004
Freestanding machine embroidered lace mounted
on velvet

disturbing elegance

Manufactured **Form Follows Infection: Laura Splan**

Opposite page
Doilies (SARS) process images 2004
Babylock computerized machine embroidery
proprietary software

Doilies (SARS) 2004
Freestanding machine embroidered lace mounted
on velvet

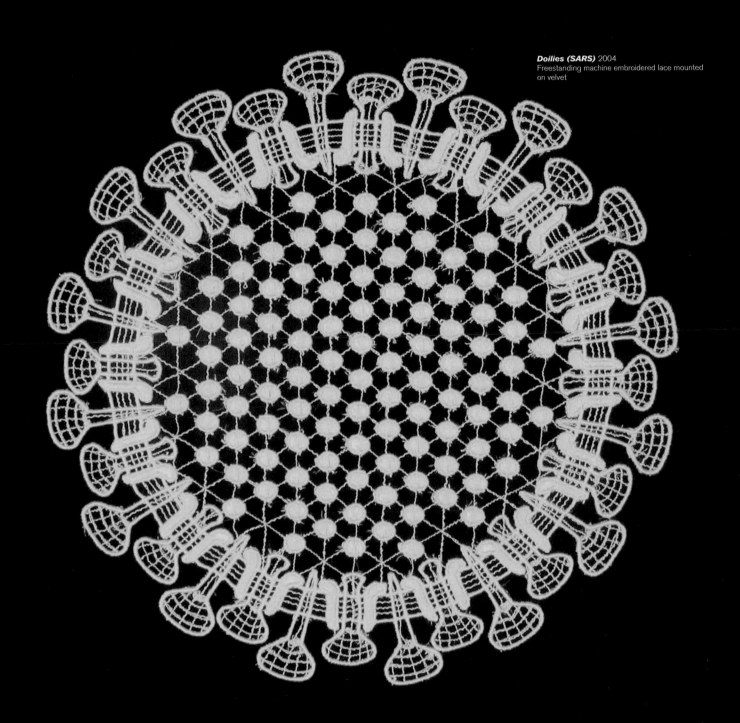

"A virus is something that we have a lot of fear around, both rational and irrational…
a lot of that fear is culturally constructed." –Laura Splan

seduction/repulsion

Manufactured **Form Follows Infection: Laura Splan**

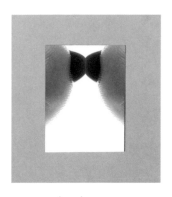

Trepidation 2004
DVD loop. DVD player, LCD monitor

This ongoing negotiation between beautiful form and disturbing subject matter has become Splan's underlying theme. In *Wallpaper/Samples*, she appropriated pages from discontinued Victorian-style wallpaper sample books and painted directly onto each page, essentially sampling the samples. She followed the existing lines, curves, floral motifs, and lattice patterns. But the nonthreatening nature of this project was quickly subverted by Splan's choice of media—her own blood. To get her "paint," for the wallpaper series and other more recent paintings, she pricks her fingertips with the same type of lancets used by diabetics. She then squeezes the blood out drop by drop until it forms a small pool, and then carefully paints each line with tiny brushes. Elements of her process have been poetically captured in the video *Trepidation* in which images of a drop of blood coming from the artist's finger are mirrored to form curious abstractions.

With this literally painstaking choice of media, challenges are leveled and questions are inevitable: What does it mean to use blood as an artistic medium? What ideas about home and domestic life does it imply? In a time of rampant bloodborne illnesses and pathogens, how should we react to blood used in so forthright a manner? Is wallpaper painted in blood beautiful or creepy?

Indeed these paintings are both beautiful *and* creepy. Splan's finely considered brush-strokes result in work that is aesthetically and technically beautiful. When the blood is completely dried to a natural sepia tone, it enhances our perception of these patterns as historic; the blood comes to personify the past, connecting these present-day conceptual works to a much deeper history of interior domestic spaces.

Splan employs domestic imagery and historic models in part because they allow people a nonthreatening entry point into her work. Then she offers subtle surprises with a conceptual kick. *Trousseau (Negligee #1)* recalls a lightweight summer nightgown with ruffles and tiny embroidered bows

Wallpaper/Samples 2003–08
Blood on wallpaper

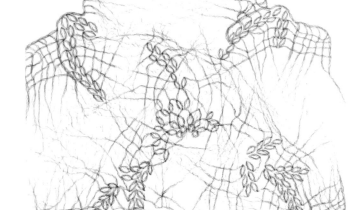

Elaborative Encoding 2007
Blood on watercolor paper

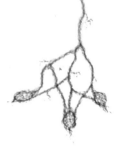

Underneath 2003
DVD (color video)

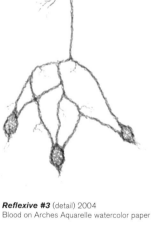

and ribbons at the bodice and hem. But upon closer inspection, the fabric reveals the telltale creases and perforations of human skin. Unbelievably, the entire piece has been assembled from sheets of dried liquid facial peel. Over a period of weeks, Splan applied the cosmetic to her body and carefully removed it section by section to create a new kind of "fabric" that she ultimately fashioned into the life-size *Trousseau (Negligeé #1)*. Subtly luminous and hopelessly delicate, the facial peel material maps the ridges and follicles of the artist's skin, creating a physical signature on the micro-thin material—not the traditional mark of the hand but rather a conceptual bodily presence.

Splan's intent in all these pieces—*Viral Doilies*, *Wallpaper/Samples*, and *Trousseau (Negligeé #1)*—is to shift her viewer's perception and bring those who experience her work to a "moment where everything is not as you thought." She aims for the same transcendent experiences in visual art that her science fiction mentors Ray Bradbury and Octavia Butler created in their writing, and David Cronenberg and David Lynch captured in their films. Their constructed worlds seem quite normal and comfortable, right up until the moment that key perceptions prove false and all becomes strange, otherworldly, and sometimes dangerous.

Laura Splan's conscious choice of unconventional materials married with her devotion to craft-based object-making techniques makes her work difficult to categorize as art, craft, or design; rather she negotiates a delicate path through the difficult spaces that separate them. In that near-miraculous way artists have of arriving first at culturally critical areas, she has connected the realms of domestic craft and medical science, creating a unique body of work by posing open-ended questions about artistic identity, material truths and aesthetic beauty.

Reflexive #3 (detail) 2004
Blood on Arches Aquarelle watercolor paper

haiku for l.s.
*domestic fictions
delicate ironies
beautify the fear*
—s.s.h.

Mother Watches Her
Red-Headed Girl

under
bud embroidered
canopy. She's begun
bleeding, a delicate, webby
first flow.

She sleeps,
hands between knees,
dreams: strawberry ice cream,
baboon bottom seen at the zoo,
new shoes,

ballet
shoes soft as skin
of other girls, the smell
of Mother's Crushed Rose
lipstick and
her Blood

and Sand
cocktail, trappings
of girlhood, the coverlet
of Pepto-Bismol pink velvet,
plush toys

piled atop
her feet, rabbit
staring back with its pink and
certain eye. A red sock's left in
the whites,

life's rosy,
writ in vessels,
new moons of belt and pad,
made of days, made of years,
made of
loosed eggs.

—Allyson Shaw

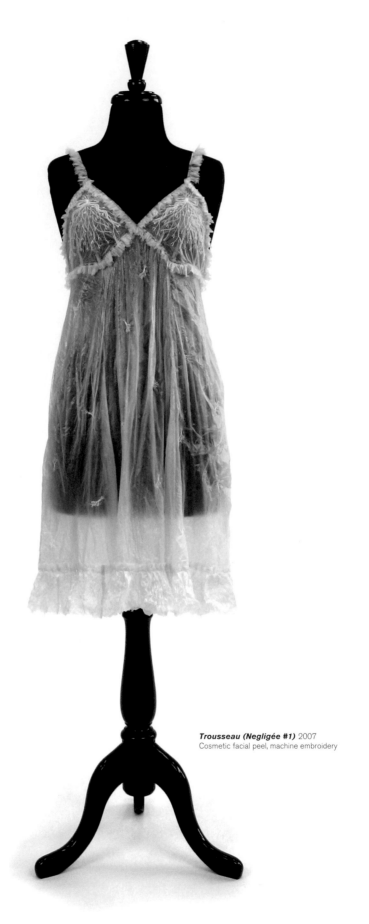

Trousseau (Negligée #1) 2007
Cosmetic facial peel, machine embroidery

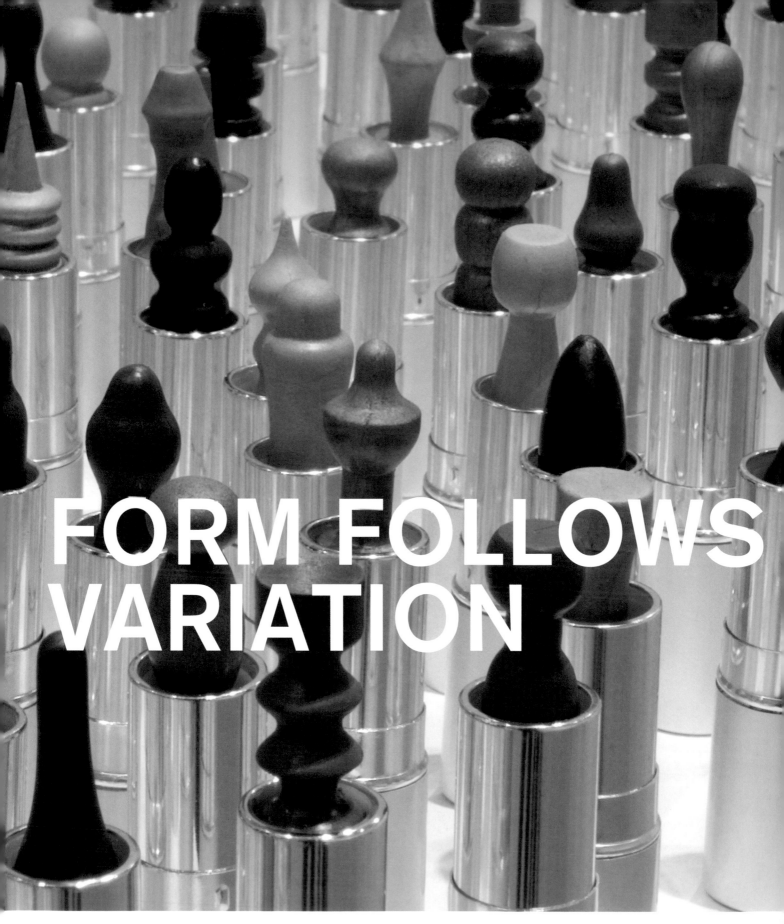

FORM FOLLOWS VARIATION

Ficciones de un uso II (detail) 2004
2,200 lipsticks

Mara Holt Skov

Born in Santiago, Chile, works in London, United Kingdom

Livia Marin. Row after row, column after column, a parade of minimal sculptures lines up in an arc formation, each one exhibiting a unique color and form. Onion domes, balloons, topiaries, nipples, lightbulbs, church spires, urns, and doorknobs are all evoked in the pastel pink, red, and purple shades of lipsticks—yes, lipsticks. The material of female illusion has become an illusion itself, now transformed through careful manipulation into a vast array of minimalist sculptures, each displayed on its own individual chrome pedestal.

Two common threads unite Livia Marin's sculptural installations. The first is her interest in transforming commonplace objects: not only generic lipsticks, but bottle caps, metal lids, plastic cups, and baby bottle nipples, to name a few. The importance of these objects in our lives is often diluted because of their ubiquity, but Marin wants us to see them for what they are—strange and wondrous forms with which we interact regularly. These banal objects have become both her inspiration *and* her raw material.

The second thread is the tension that occurs between the singularity of an object (even a manufactured one) and the effect produced when objects are displayed en masse. Much of the power of Marin's work comes from repetition, sometimes to vast proportions. Even the most ordinary bottle cap takes on a sense of purpose and meaning when repeated hundreds of times.

For every new project, she begins by exploring her materials in a fully consuming, immersive way. From there, she establishes parameters for how to work with those materials, much as the brief given to a designer at the outset of a new project spells out size, function, and budget requirements. Then she shifts into cottage-industry mode to hand make every single piece—ironically, even if she intends

Raw material

for them to look industrially produced. Marin's working method puts her in several roles at once. She is an inventor developing new formulas for object creation; she is a curious child engaging in serious play with common objects; and she is a conceptual artist searching for new definitions of what an art object can be.

For *El objecto y su manifestación (The Object and its Manifestation)*, Marin charted the endless number of shapes derived from the empty interiors of crumpled plastic drinking cups. Her strategy for capturing the dynamic effects of human use on an object involved casting more than 1,600 different iterations in white plaster. Installed on shelves stretching 125 feet across gallery walls, each cast exhibits a unique crumple—a startling demonstration of the permutations possible in even the simplest throwaway vessel. Tactile ribbing on the surface appears as a reminder of the plastic cup's manufactured roots.

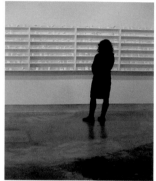

Marin's installation recalls Rachel Whiteread's castings of the undersides of chairs and the interiors of cardboard boxes. Both are examples of how the aesthetics of negative space can be elevated to the level of post-minimalist art form. In both Marin's and Whiteread's works, the object is generated from that which is unseen. But simply exploring the void within a single cup or box was not enough. Each artist pushes the limits of the invisible to grand proportions, taking over entire gallery spaces in the process. Thus, they have infused their work with a power far beyond its humble origins. By making such a commitment to the act of making, and by investing the precious resources of time and materials in such grand statements, these works, and the ideas behind them, demand to be taken seriously.

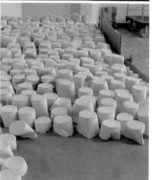

Other pieces play on Marin's interest as to what can happen when objects bump up against each other. In *El sentido de la repetición (The Sense of Repetition)*, she delighted in the strange results created by stacking simple household objects in various combinations: plastic caps, honey servers, metal lids, ashtrays, drinking glasses, baby bottle nipples, candlesticks, salt and pepper shakers, funnels,

El objecto y su manifestación II 2007
1000 plaster objects, 20 wooden shelves

El objecto y su manifestación II
(process) 2007

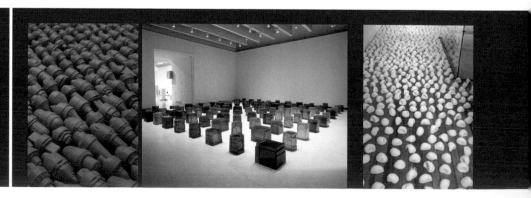

Connections: Variations on a Theme
Creating and organizing different systems of related objects is one way for artists to address the hyper-abundance of contemporary culture. Alan McCollum, Rachel Whiteread, and Devorah Sperber all create meaning from similar-but-different objects using repetition as a strategy for art-making.

Allan McCollum
Over Ten Thousand Individual Works (detail) 1987–88

Rachel Whiteread
Untitled (One Hundred Spaces) 1995

Devorah Sperber
Loitering 1999

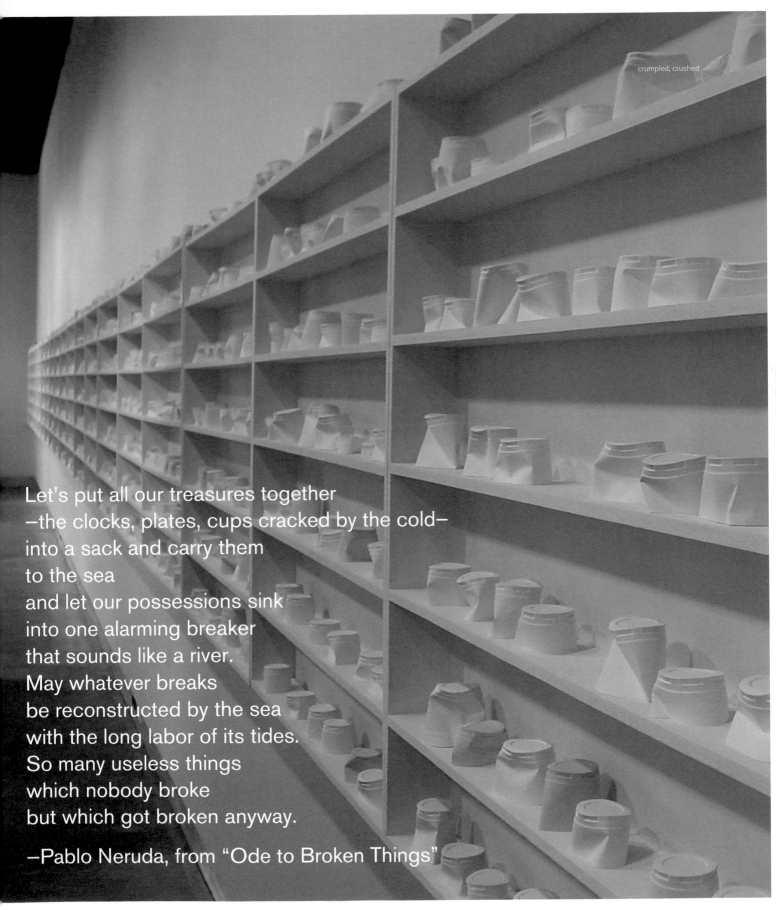

crumpled, crushed

Let's put all our treasures together
—the clocks, plates, cups cracked by the cold—
into a sack and carry them
to the sea
and let our possessions sink
into one alarming breaker
that sounds like a river.
May whatever breaks
be reconstructed by the sea
with the long labor of its tides.
So many useless things
which nobody broke
but which got broken anyway.

—Pablo Neruda, from "Ode to Broken Things"

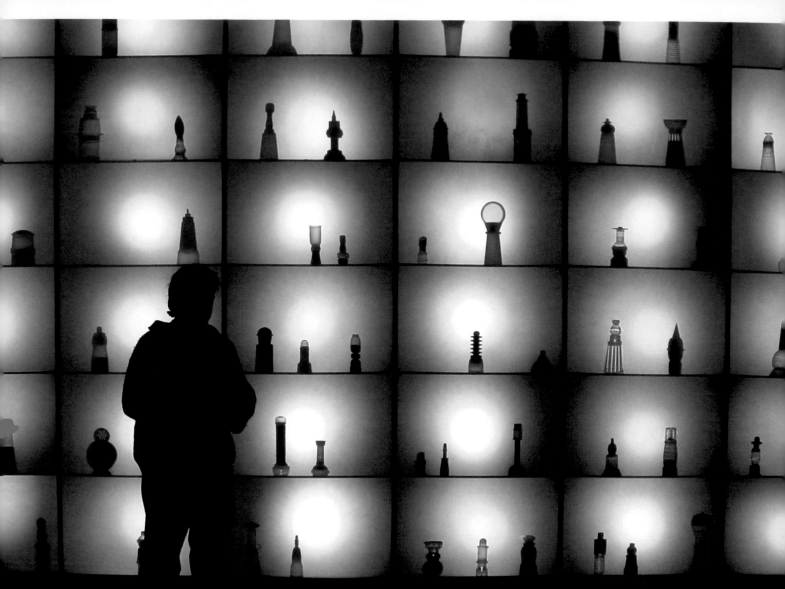

"I like to create little encounters with the real world."
–Livia Marin

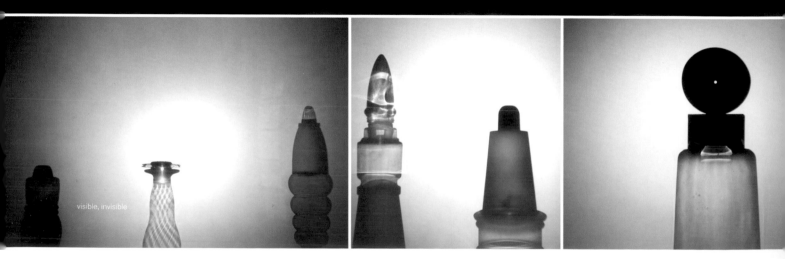

visible, invisible

Manufactured **Form Follows Variation: Livia Marin**

"I would like to change everything while remaining the same." —Raymond Queneau, author

El sentido de la repetición 2005
Various household objects, Perspex,
wood, lights

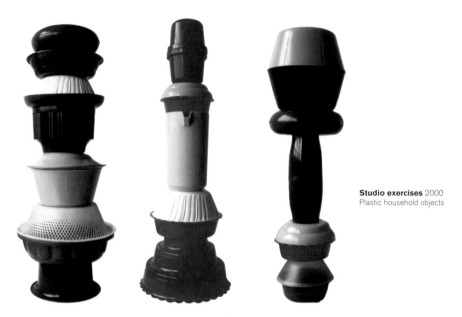

Studio exercises 2000
Plastic household objects

El sentido de la repetición (details)
2005

spatulas, egg cups, and other objects. In this project, she acted as the conductor, orchestrating the creation of each piece, bringing widely diverse objects together in service to a larger composition. Some pieces were ruled by a common diameter that enabled successful stacking, while others were more complex and called for more manipulation.

Marin chose to display her enigmatic compositions as if they were a collection of precious bottles in an exclusive shop. Each display case was lit from behind, highlighting the translucent colors and evocative silhouettes. Sheathing each case in translucent Perspex (a Plexiglas used in retail environments) created a sense of mystery, keeping each piece just out of grasp. This technique comes directly from the fashion photography used to market cosmetics and perfume, both industries that go to great lengths to manufacture the desire that fuels sales. Marin seems to understand how this desire is created, and in *El sentido de la repitición*, she uses this knowledge to full advantage.

Marin takes inspiration for many of her projects from experimental French author Raymond Queneau. In *Exercises in Style (1947)*, Queneau told and retold—in ninety-nine different ways—the story of one man's experience riding a Paris bus. Marin embraces Queneau's concept of constrained writing and adapts it to her art-making practice with surprising success. For each project she creates a set of constraints to follow, a strategy that paradoxically offers a freedom that is possible only within strict limitations. Nowhere is this more evident than in *Ficciones de un uso (Fictions of a Use)*, a room-sized installation of 2,200 sculpturally molded lipsticks displayed on an oval pedestal.

The key constraint that Marin set for this project was that every individual lipstick must be unique. To express her vision fully, she calculated that she would need X number of shapes multiplied by Y number of lipstick shades. She then created more than 500 different turned wooden forms to use as models for the lipstick molds. By melting down the original lipsticks and pouring each color

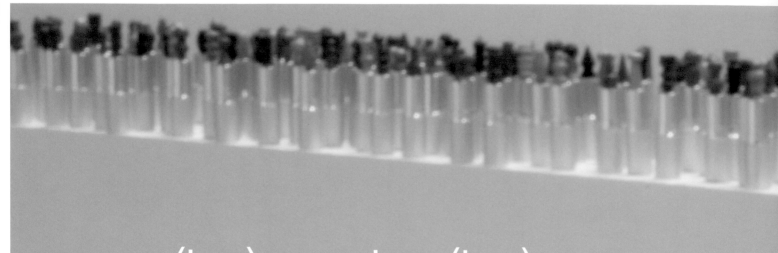

process(ion), product(ion)

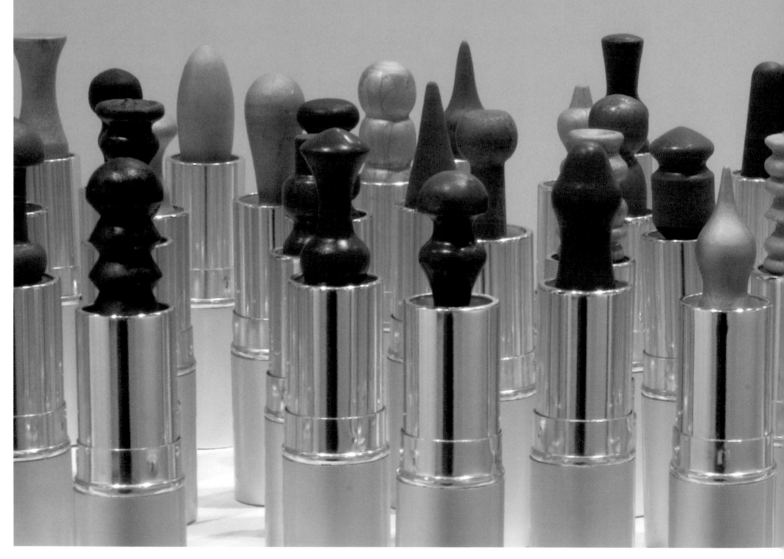

Manufactured **Form Follows Variation: Livia Marin**

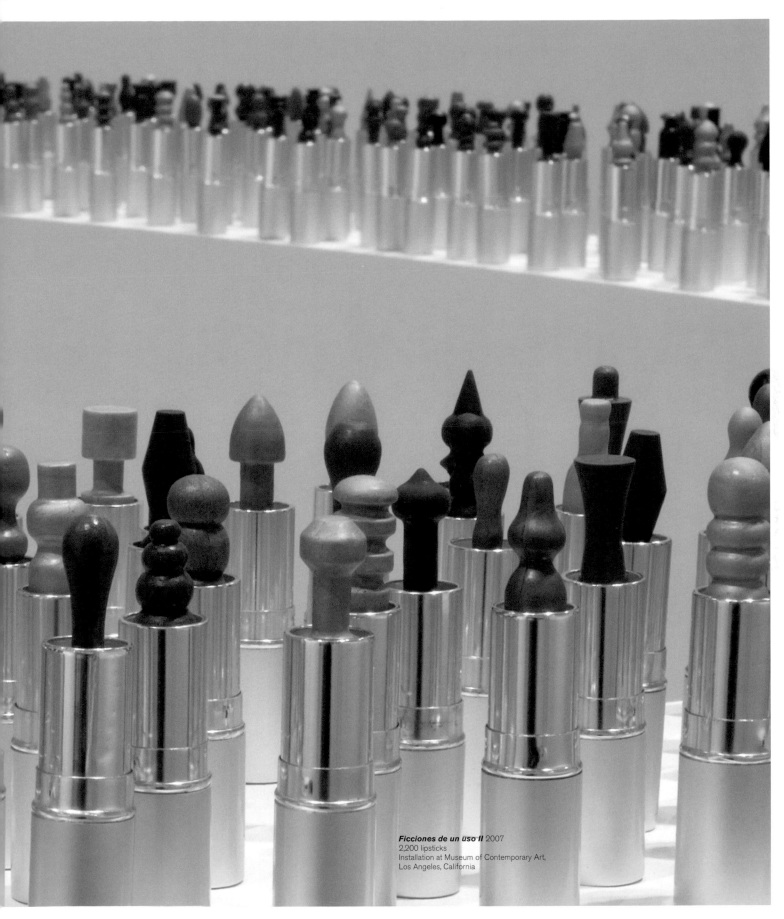

Ficciones de un uso II 2007
2,200 lipsticks
Installation at Museum of Contemporary Art,
Los Angeles, California

into the molds, she was able to recast them into her desired array of shapes. Finally she carefully placed each reformed lipstick top back into its tube—2,200 different times. Such projects are possible only in our late-capitalist environment of material hyperabundance, where such commodities are plentiful and inexpensive.

Ficciones de un uso II 2007
2,200 lipsticks
Installation at Museum of Contemporary Art,
Los Angeles, California

Always a keen observer of human activity, Marin first became interested in lipsticks as a material when a friend pointed out that each woman wore her lipstick down in a different fashion. As Marin began to look around, she found that it was indeed true. Every woman left a unique wear pattern on the end of her lipstick, a biometric signature that was peculiar to her. Some lipsticks were worn down in a flat angle, some had a convex pointed tip, and still others were left with a little concave bulb on a diagonal end. Why not think about lipsticks as a sculptural opportunity that emphasized individuality over uniformity?

Lipstick turned out to be an ideal material choice for Marin. It could be molded like ceramic, plastic, or glass into whatever form she chose. It came in a predetermined cohesive color palette designed specifically to attract attention. Like a resin, it was a homogenous material that was easy to work with and that offered predictable outcomes. The individual lipstick tubes functioned as minimalist pedestals when the pieces were on display, and doubled as protective containers for storage and shipping.

Some viewers may consider *Ficciones* a feminist statement against artificial construc-tions of beauty, the eroticization of women, the lipstick as phallus substitute, and view it as a critique on the beauty industry. However, Marin insists that is not what this piece is up to. *Ficciones*, like her other work, is an attempt to bring viewers into a special relationship with the familiar, and in so doing, to sharpen their awareness of objects and actions that are often overlooked. It is not that Marin is *not* concerned with politics, feminism, or other social readings of her work, it is just that her primary interests lie elsewhere. Her manipulation and multiplication of objects into strange new forms is meant to elevate our awareness of simple, yet meaningful acts, and to register an individual human presence on the objects we encounter.

Ficciones de un uso (model) 2004
Wood

In the end, the power of *Ficciones* comes not only from Marin's high level of crafts-manship and commitment to the conceptual thinking that it represents, but also from the individual conclusions and emotional connections that each viewer makes with her work. *Ficciones de un uso* is unmistakably Livia Marin's most complex work to date in terms of concept, craftsmanship, and creation. By completely transforming each individual lipstick from a standardized tool of cosmetic beauty to a curiously compelling sculptural icon, and by capitalizing on the power that comes with the repetition of a form, she has created a tour de force.

Ficciones de un uso (molds and models) 2004

Ficciones de un uso (unmolding the lipsticks) 2004

haiku for l.m.
grand gestures done small
minimal mastered magic
small gestures writ large
—s.s.h.

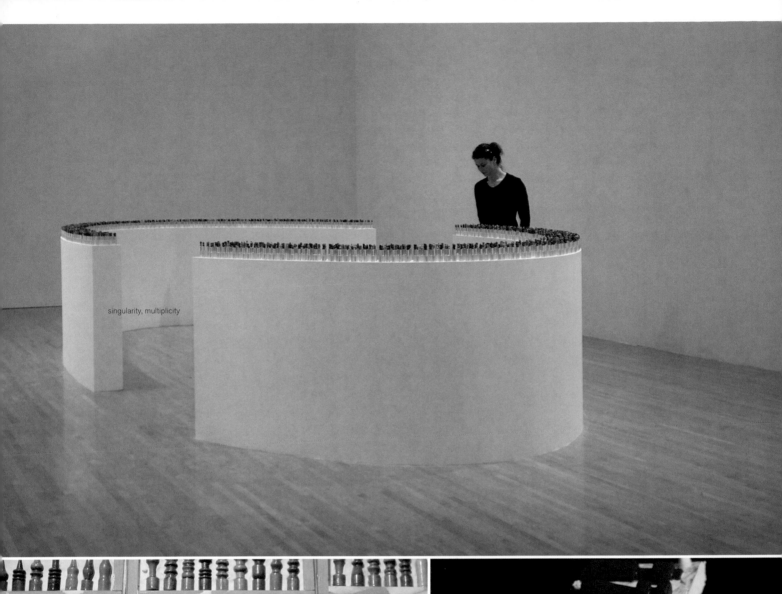

singularity, multiplicity

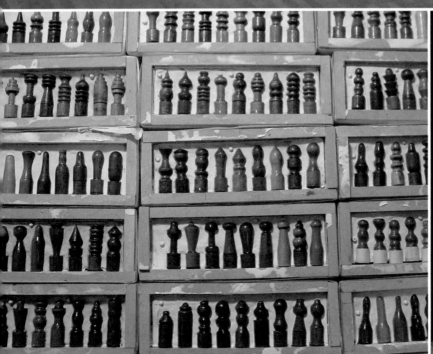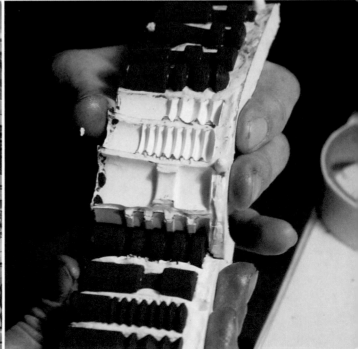

FORM FOLLOWS MANIPULATION

"Mythicism is a real element in Iceland…mythic creatures merging with humans…I try to address this in my work." —Hrafnhildur Arnardottir

Harmonic Hairdo #4 (detail) 2007
C-print of artificial hair

Mara Holt Skov

Born in Reykjavik, Iceland, works in New York, New York

Hrafnhildur Arnardottir. Yards upon yards of artificial hair are fashioned into organic spirals, dense clusters, and baroque flourishes. Natural colors evoke a rich earthiness while contrasting with artificially constructed patterns. Layers of intertwined braids are too perfectly formed to be real, and too visually compelling to ignore. Nature continues to inspire artifice as it has for centuries, and through artifice, magic is made.

Since the dawn of human culture, hair has been a medium for self-expression and identity. Hair is the original fashion accessory, possessed (at one time or another) by nearly every person. It has been braided, plaited, twisted, wrapped, piled, coiled, looped, teased, curled, straightened, twirled, sculpted, shaved, snipped, bound, and woven—manipulated in every way imaginable. It is difficult to imagine anything else that can be done with hair. However, in the hands of Hrafnhildur Arnardottir, hair is pulled and tugged to its expressive limits. Using artificial hair (typically the medium of the hairstylist and costume designer), she takes it well beyond its decorative or theatrical applications to explore its strange and supernatural possibilities.

Arnardottir braids masses of long flowing artificial tresses to tame their wildness. Transforming them into looping, organic, wall-based relief sculptures, fantastical braided wigs, and overscaled wallpapers, she proposes new ways of thinking about textiles and art—using hair as a raw material for both. Her pieces are classic examples of "more is more" thinking, expressions of excess in a visually and culturally hyperabundant time.

Raw material

Hair sculpture for Björk's Medulla album 2004
Natural and artificial hair

Asta Bjork Fridbertsdottir
Traditional memory flowers 2004
Human and horse hair

poetic lyrics, and a style that incorporates singing, spoken word, and even squeaking. Arnardottir's magically extravagant wigs were a picture-perfect conceptual match for both the music and the artist. In fact, they were such a good match that they now seem an indelible part of Björk's distinctive persona.

The first wig for the *Medulla* cover was essentially a woven helmet of human hair that extended over the forehead and around the eyes like a magically protective, spellbinding mask. In the back, braids that curved away from the head were attached to the main headpiece by a series of connecting strands that were both functional and aesthetic, adding to the visual complexity of the entire piece.

The second wig gives clues to Arnardottir's meticulous process. First, she developed a woven base that mimicked Björk's own hair. She then layered in additional braids, plaited sections, and coiled buns. To complete the arrangement, she strategically applied a considerable number of hair flowers in a range of natural hair colors; the hair flowers were hand looped and knotted by Asta Bjork Fridbertsdottir, an artisan from Hárverk, Iceland. The end result is a piece of functional art that has been carefully controlled at every step, but appears dangerously close to exploding into chaos at any moment.

The hair flowers added an additional level of intricacy to the already richly detailed wig. A traditional Icelandic ornamental craft, hair flowers are made from extra-long strands of hair braided and looped into flowers, stems, and leaves. Created from either human or horsehair, they are direct descendants of Victorian-era memory flowers made from the hair of a deceased loved one and worn or displayed at home in memory of that person. The art of making hair flowers, like many women's craft traditions, was handed down from one generation to another, typically from mother to daughter, but the tradition has fallen out of favor in recent years. Arnardottir laments that the women who make hair flowers today are getting older, and one day they will be gone. The tradition will be lost—like many other craft, cuisine, musical, and language traditions—in our rapid advance toward global assimilation.

Hair sculpture for Björk's Medulla album 2004
Natural and artificial hair, hair flowers

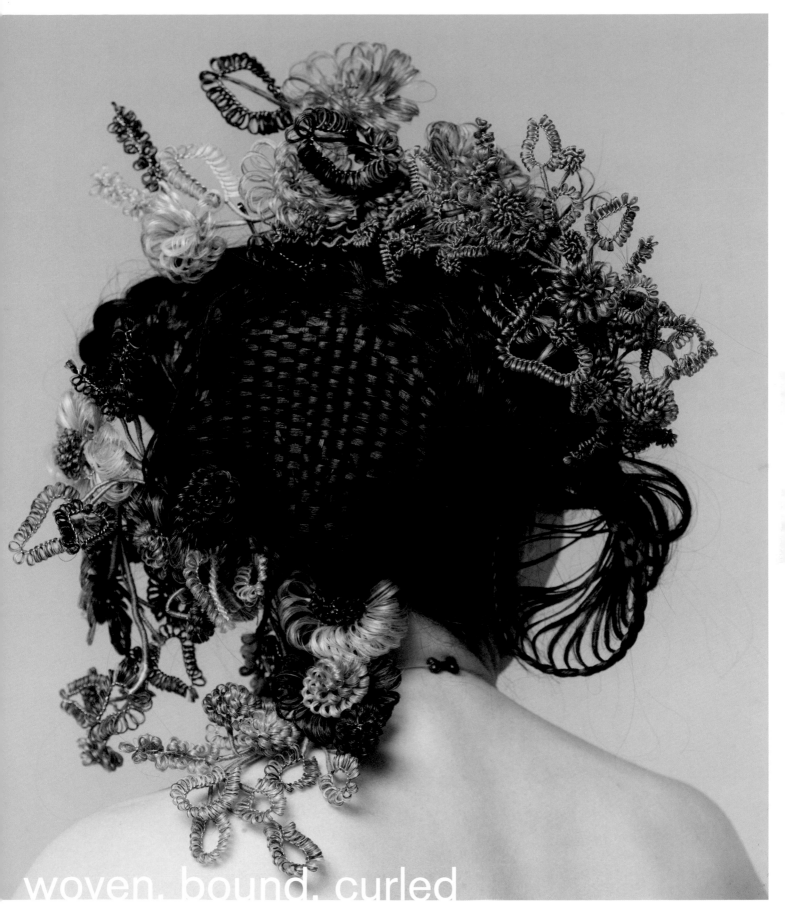

woven. bound. curled

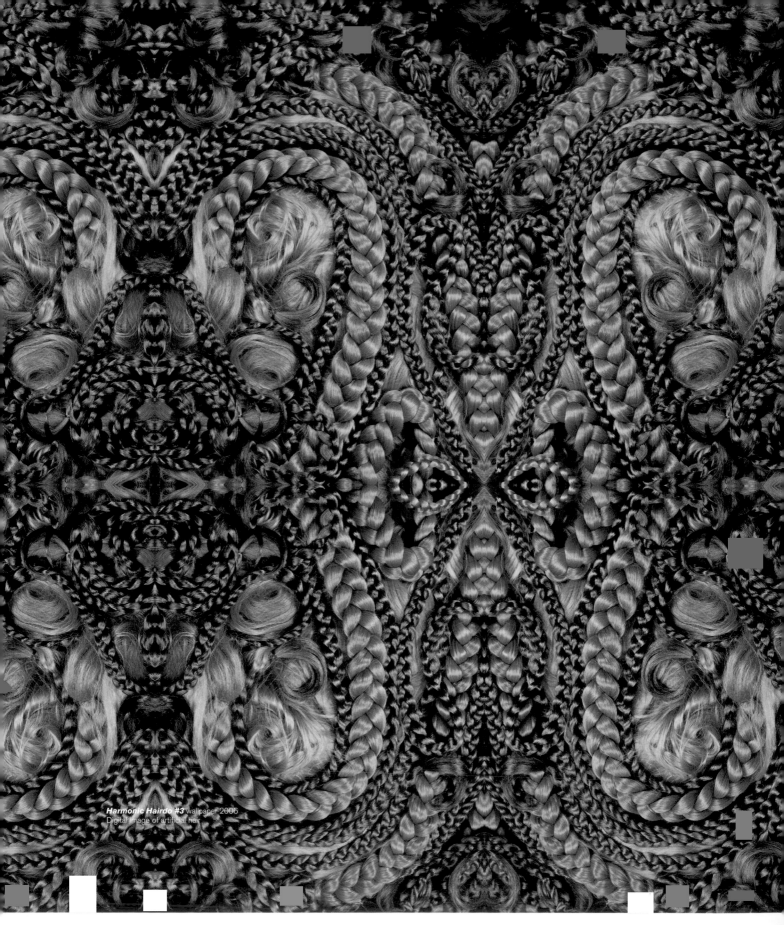

Harmonic Hairdo #3 wallpaper 2006
Digital image of artificial hair

Manufractured **Form Follows Manipulation: Hrafnhildur Arnardottir**

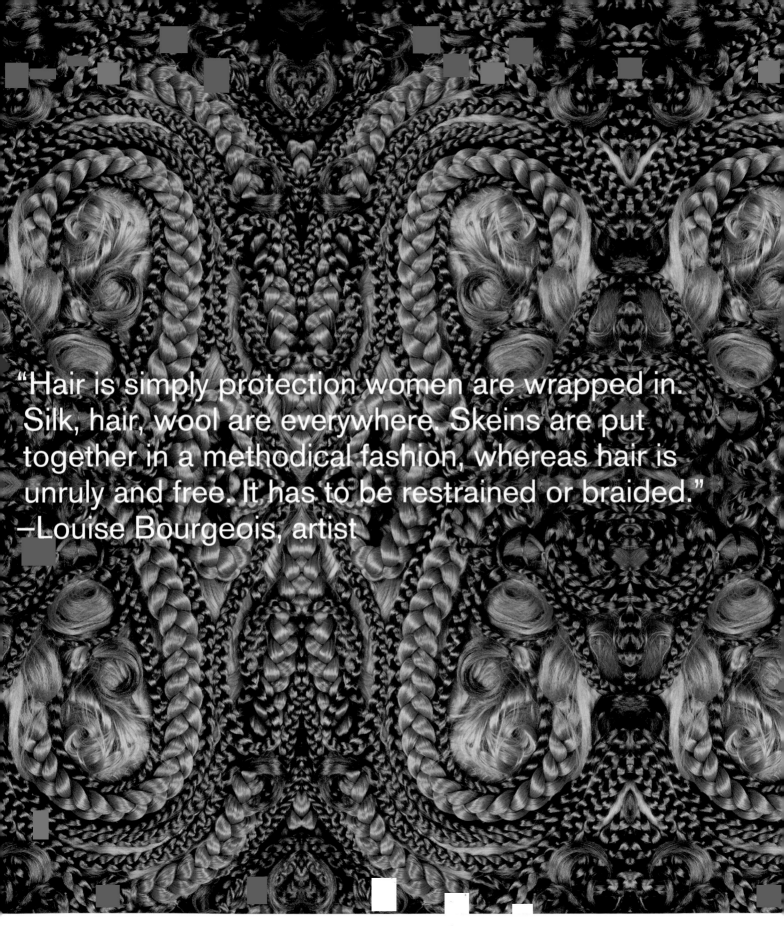

"Hair is simply protection women are wrapped in. Silk, hair, wool are everywhere. Skeins are put together in a methodical fashion, whereas hair is unruly and free. It has to be restrained or braided."
—Louise Bourgeois, artist

supernatural manes

Manufractured **Form Follows Manipulation: Hrafnhildur Arnardottir**

Arnardottir's wig sculptures grew out of her wall installations, which also provided the genesis for a series of wallpaper entitled *Harmonic Hairdo*. She digitally photographed sections of the wall pieces, and then used Photoshop to manipulate, expand, and multiply the images. Existing in pixel format, the resulting collages are essentially scaleless. The images shift from instantly recognizable to completely elusive and mysterious with just a few clicks of the mouse. When expanded to grand proportions, they can be printed as dramatic wallpaper or textiles, or even more ephemerally because they exist in the digital realm, they could be exhibited as light projections.

The *Harmonic Hairdo* pieces, as a group, reflect the centralized symmetrical patterns of Oriental carpets. They have a visual richness and color that captures our attention. They also have a strangeness resulting from an unlikely material used in an equally unconventional way. In recent years, an explosion of wallpaper designs in both art and interior design has challenged our notions of what wallpaper can be, revealing that wallpaper can be almost anything, even compellingly patterned, over-scaled braided hair.

Harmonic Hairdo, in its wallpaper or fabric form, is a functional manufactured design that is capable of engaging our intellect in the same way as great art. But since it has been drawn from a woven fiber, it also acts as the metaphoric stand-in for a textile, offering a new definition for fiber arts that is more hybrid than ever. Is it art or craft or design? Arnardottir would argue that it is all of the above, but that none of those definitions really matter.

Hrafnhildur Arnardottir's work is about many things. It is about excess, intricacy, and ornament. It is about theatrics and overt personal expression. It is about pushing materials to their limits. It is about contrasts—between the artificial and the natural, between tight control and organic looseness, between the handcrafted and the manufactured. Ultimately, it is about objects that are unmistakably magical but that are grounded in the physical reality of making, the essence of *super*natural.

Harmonic Hairdo **mural** 2006
Installation view from "The Dance"
collaboration with photographer
Ryan McGinley

Hrafnhildur Arnardottir (left) playing the
Human Hair Harp in **Skin Bone Hair** 2008
Collaboration with composer Nico Muhly,
The Kitchen, New York, New York

Harmonic Hairdo **#4** 2006
Digital image

Harmonic Hairdo **#5** 2006
Digital image

haiku for h.a.
mysterious loops
coiled, plaited, twisted, braided
supernatural
—s.s.h.

FORM FOLLOWS ORNAMENTATION

Franck topiary 2007
Handmade crochet cotton, epoxy resin

Mara Holt Skov

Born in Boxtel, Netherlands, works in Amsterdam, Netherlands

Marcel Wanders. Just as a snowflake is formed, one crystal deposited upon another, a crocheted doily grows through an accretive process—one knot built upon the previous knot until a perfectly symmetrical pattern takes shape. From a single string—knotted, looped, and twisted repeatedly—the intricate order of the doily emerges, bringing comfort to pattern-seeking minds.

The doily—a nearly invisible domestic object that most with a modern sensibility would quickly dismiss as kitsch. But in the mind of Marcel Wanders, the doily finds new life as raw material for a series of conceptual design explorations. Wanders demonstrates an altogether-too-rare attitude that he can learn from anything and be inspired by anyone. In his willingness to learn from the doily, he has revived it as an object of contemporary fascination, thus opening the door to an unanticipated discussion of kitsch's role in design and visual culture.

Wanders is an iconoclast, and the objects he creates—ranging from furniture to lighting to decorative objects and textiles—reflect his unique worldview. Nothing he dreams of is ordinary. He consistently finds inspiration in traditional Dutch craft materials and techniques as well as in the larger world of everyday objects. He has made it his mission to transform the familiar into something different and deeper, and he pursues this mission with passion and sincerity at a time when much of the conceptual design world appears steeped in ironic provocation.

Wanders is respected throughout the creative world, in part for his work with Droog, the Dutch design collective formed in the early 1990s for the sole purpose of producing limited-edition, highly conceptual objects. With Droog, Wanders had the luxury of working as an artist would, fulfilling

Raw material

Crochet Tables 2001
Handmade crochet cotton, epoxy resin

simultaneously soft and hard

Lace Table prototype 1997
Swiss fiberglass lace, epoxy, glass

his own needs for personal expression through the objects he created. From the beginning, the raw strangeness and "style-resistant" nature of many Droog projects challenged conventional notions of what a designed object should look like, how it should be made, and how it should function.

Wanders' creative process fit naturally with Droog's approach to object making. He always begins with a provocative question that progresses into an open-ended exploration of possibilities, with an equally open-ended expectation about the final form his work will take. This interrogative approach has defined his work from the outset. His first Droog project, the *Knotted Chair* (see page 11), was characterized by questions concerning the limits of knot making; for example, what would happen if the essential properties of rope—flexibility, malleability, and strength—were both embraced *and* ignored at the same time?

These questions led to others about the limits of "soft" materials and accelerated the evolution of familiar furniture forms such as the chair and the table. Enter delicate Swiss lace, which he soaked in resin and hardened into cube-shaped volumes. The resulting prototype *Lace Tables*, simultaneously soft *and* hard, explored the use of handmade textiles as raw material. At the time, this merging of craft and design production developed a following among the Droog designers; and became a defining characteristic of many of the projects that Droog supported.

As conceptual prototypes, the *Knotted Chair* and the *Lace Tables* intentionally asked more questions than they answered. Both were adept at dispelling previously held expectations of what a material could do as well as what a chair and table could look like: They challenged material properties, fabrication techniques, and object typologies. As is often the case with projects that are so largely idea-based and self-driven, they were never expected to become marketable products.

But some projects beat the odds. The *Knotted Chair* received so much critical attention when first introduced that it progressed past the prototype stage and into full production with Italian manufacturer Cappellini. It is still being manufactured today. The *Lace Tables*, however, never went further than prototype stage, but the lessons Wanders learned were transferred into a more recent project, the *Crochet Cubes* developed for Wanders' production company Moooi.

In contrast to the exuberant swoop of the *Knotted Chair*, the *Crochet Cubes* are subtle pieces—they represent a wry merging of homey, handcrafted materiality with spare, minimalist form. Their seeming simplicity belies their conceptual depth, however, for these pieces represent a classic study in contrasts: softness versus rigidity; minimal geometric form versus maximal patterned ornament; low-culture kitsch versus high-style design; handcrafted appearance versus machine aesthetic; and open web versus closed volume.

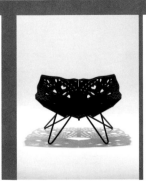
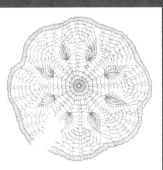

Connections: Recontextualizing the Doily
Ornament is no longer thought of as purely superficial and decorative, and accordingly the doily has been elevated from its humble kitsch roots. Now it appears in the most unexpected places—in highly conceptual, experimental art and design projects.

Mike and Maike
Empty Doily pillow 2003

Louise Campbell
Prince Chair 2001

Laura Splan
Painted Doily 2007

Crochet Lamp Blossom 2007
Handmade crochet cotton, epoxy resin

Manipulating materials and defying expectations is what these pieces are all about. The *Knotted Chair* transforms limp, knotted sailing rope into a firm, sit-able structure; the *Lace Table* fixes a delicate draping textile into a rigid cubic form; the *Crochet Tables* raise the stakes even more by taking an ornamental kitsch object and presenting it in a form often associated with conceptual art. Each of the three projects marries a traditional craft with emerging materials and production techniques to create an entirely new take on a familiar object. Each is unmistakably contemporary while at the same time deeply connected to Dutch history with its rich nautical past and domestic handcraft traditions.

Wanders' embrace of the doily's unapologetic decorative nature has since become the basis for an entire series of objects. The *Crochet Chair* is an enormous low-slung seating piece—a pure, minimal form with an intricately patterned surface structure that runs into excess visual saturation. The series also includes the mushroom-shaped *Crochet Lamp Blossom* and a family of four playfully artificial topiary objects, each displaying a distinct personality and form.

Named *Sid*, *Mary*, and *Franck*, the topiaries exist as productized souvenirs of nature, ideas of a plant instead of the plant itself. Tempting as it may be to dismiss this gleefully artificial trio, it is crucial to note that they point to a radical near-future direction for object makers: function-free products. None of them manifests any outward aspect of utility, or even shows any concern about being functionless. Instead, they serve a psychological rather than physical function; their concern is with making emotional connections. This nascent category of objects, although formed through a unique fusion of craft and design sensibilities, rises to the elevated status of art. The loss of utility might make designers and even some craftspeople uncomfortable, but that is exactly what artists are expected to do, and this is what pushes this work of Wanders into the realm of art—an argument that supports the idea that design more and more is becoming the art of our time.

Egg speakers 2005
Wood veneer

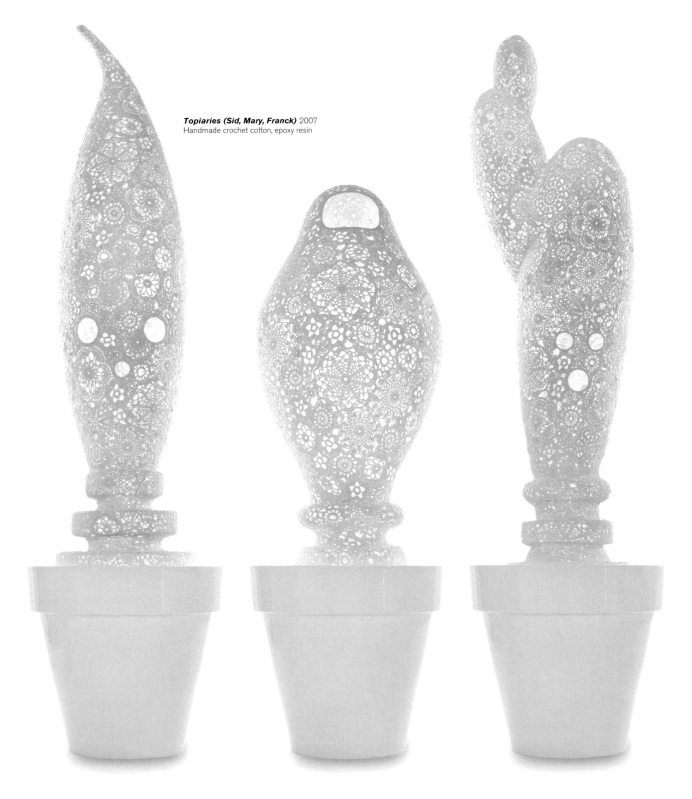

Topiaries (Sid, Mary, Franck) 2007
Handmade crochet cotton, epoxy resin

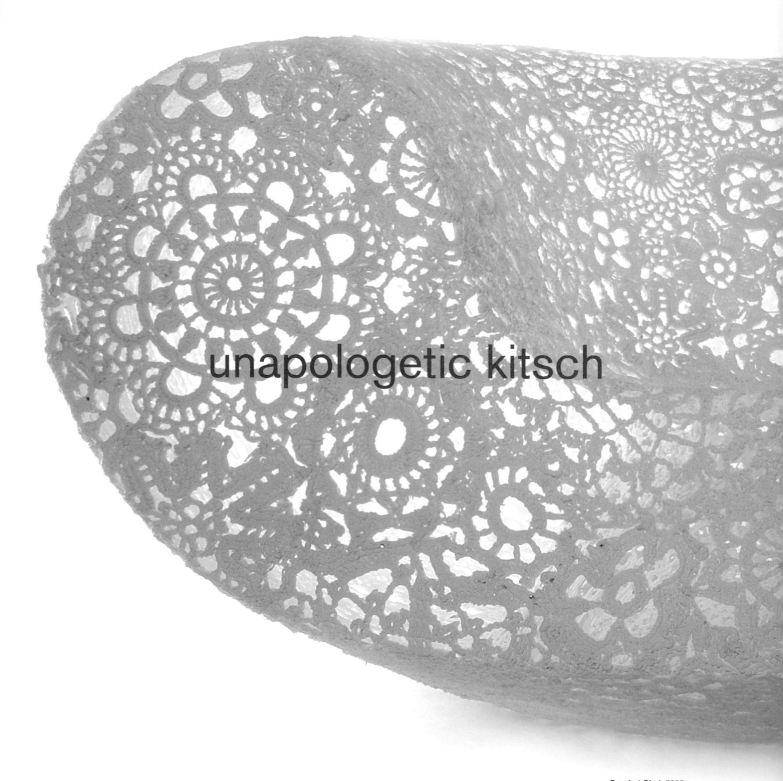

unapologetic kitsch

Crochet Chair 2006
Handmade crocheted rope, epoxy resin

"Increasingly, objects to be found in the home will have less the nature of tools and more that of gifts; they will have more of a literary value than a functional one." —Andrea Branzi, designer

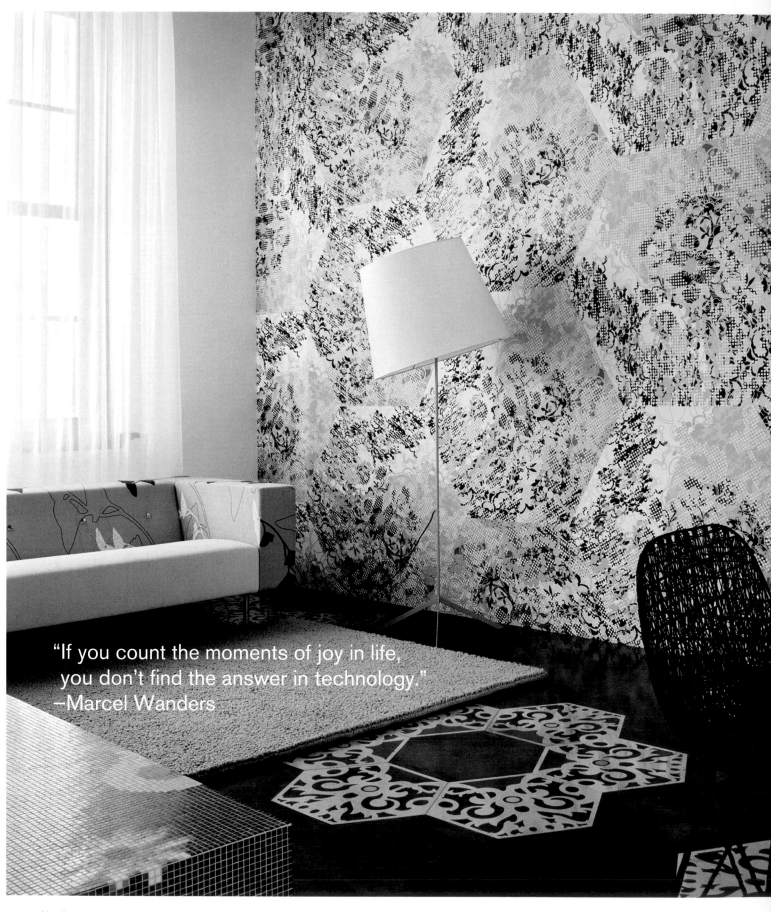

"If you count the moments of joy in life,
you don't find the answer in technology."
–Marcel Wanders

Wanders' obvious delight in the doily's decorative qualities finds further expression in a series of highly ornamental wallpapers. The *Hexagon* design begins with a symmetrical doily, then adds layer upon layer of swirling stems, flowers, leaves, and simulated perforations to give it a depth-deceiving push-pull effect. The resulting patterns suggest everything from dense jungle vines, to the web of our veins, to intertwined strands of DNA. As if it were not already complex enough, *Hexagon* is produced in a six-sided honeycomb shape, challenging the typical horizontal-vertical matrix of most wallpaper designs. The result is a mass-produced product that can be clustered in groups as an allover wall covering, but it is equally successful when hung singly as an op-art abstraction, offering yet another example of a designed product elevated to function as an art object.

Marcel Wanders has managed to merge design, craft, and art practices in his work without overshadowing any of the three. When queried on the matter, he insists that discrete disciplines are no longer relevant. Instead, what matters is to push each project to its conceptual and aesthetic limits to capture both our attentions *and* affections. He does this through the thoughtful connection of past models, techniques, and materials with present sensibilities and technologies. In his crochet projects, he has created kitsch-fueled objects that paradoxically possess a timeless appeal—objects that arrive on the scene as future antiques. It is precisely this contradictory combination of qualities that makes Wanders' work so consistently compelling.

Lute Suites 2005
Amsterdam

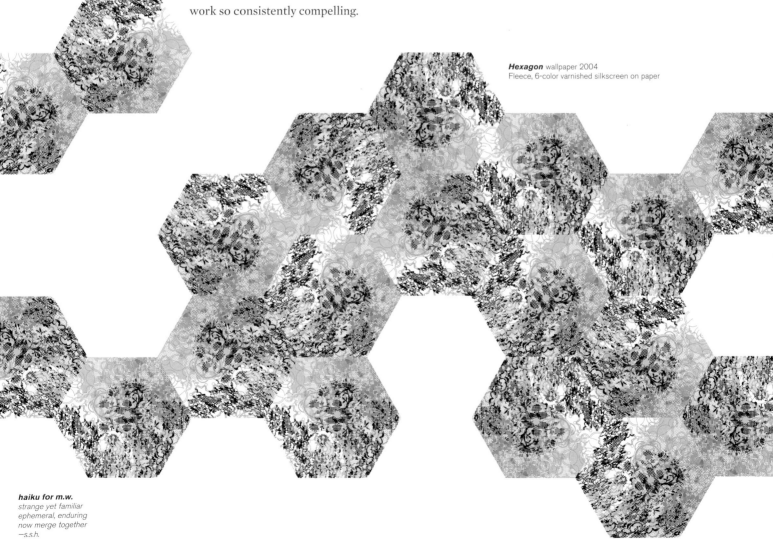

Hexagon wallpaper 2004
Fleece, 6-color varnished silkscreen on paper

haiku for m.w.
strange yet familiar
ephemeral, enduring
now merge together
—s.s.h.

FORM FOLLOWS PERCEPTION

Lie Like a Rug (detail) 2000–01
18,000 Letraset marker caps

Mara Holt Skov

Born in Detroit, Michigan, works in Woodstock, New York

Devorah Sperber. Like soldiers standing at attention in orderly rows, scores of Letraset marker caps, more than 18,000 strong, stretch out to fill a gently undulating field. Each cap is labeled with a different Pantone color, in what seems to be a random pattern. But when the expanse is viewed from a distance, it begins to form a cohesive whole. The image of a Persian carpet takes shape before our eyes, rich in color and pattern, surprisingly real yet completely artificial at the same time.

On the most elemental level, Devorah Sperber's sculptures are about the creative appropriation of manufactured objects. Map tacks. Stickers. Marker caps. Thread spools. Pipe cleaners. All offer endless aesthetic possibilities as her raw materials. However, if we step back to gain perspective, another more important element comes into sharp focus. Sperber's work is really about perception.

Sperber explores all aspects of perception—physical, intellectual, intuitive, and emotional. But her primary interest is perception of the optical kind—the mechanics of seeing. How is visual information about an object received, reflected, transmitted, reassembled, and understood? By creating work that addresses the mysteries of optical perception, Sperber elevates this scientific process to the level of poetics.

Sperber's interest in perception began as a child when she asked the question: How do we know that we experience things in the same way as others? Do we see the same green in the grass, smell the same aroma of bread baking, hear the same tone of a musical note? The answer, of course, is

Raw material

"We do not see the world merely as it is, her pieces remind us; we see the end product of the brain's information processing." —Amanda Gefter, journalist

that we *don't* know. Every person is different and it follows that everyone has different perceptions of reality. This kind of revelation, coming to the artist at such an impressionable age, laid the foundation for a lifetime of exploration.

Her childhood not only gave her the questions to explore as an artist, it gave her the subject matter with which to pose those questions. She addressed issues of optical and emotional perception by pulling the subjects straight out of the hippie culture of her childhood in the 1960s and 1970s, and by using materials more readily associated with children's artmaking. Her *Bandanas* series employed thousands of Moore brand map tacks inserted into clear vinyl sheets. Created as optical tricks as much as ironic icons, each *Bandana* hangs on a wall, draping on the bias to mimic the fabric squares they are modeled after.

A logical companion to the *Bandanas* is *VW Bus: Shower Power*. The piece is a full-scale representation of a 1967 vintage bus created on a continuous wall of vinyl shower curtains. The surface was decorated in a riot of flower-shaped Chartpak colored film stickers selectively placed to map out the vehicle's distinctive details—the flat nose, VW medallion, convex hubcaps, chrome bumper, and wraparound windows. Sperber's nostalgia for the period led her to create a full-color floral pattern for the exterior—the "flower power" wordplay of the piece's title. The strategically lit installation glows from within, giving the van an appropriately mythic aura that is arresting, belying the ordinary materials used to replicate it.

This was not the first time that Sperber (initially trained as a traditional stone sculptor) had appropriated unlikely materials. In *Reflections on a Lake* thousands of thread spools come together to create the pixilated image of a forested landscape. Since that piece, the spools have become her signature material, installed in conjunction with perception-bending convex mirrors and clear acrylic spheres. Guided by similar square proportions, the thread spool is an unlikely but surprisingly successful analog

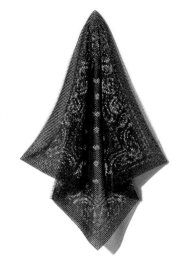

Blue Bandana 3 2001
14,280 Moore map tacks, clear vinyl

Reflections on a Lake 1999
5,760 thread spools, aluminum ball chain, hanging apparatus, 36 convex viewing mirrors

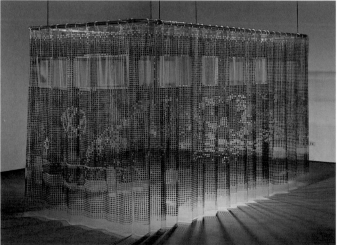

VW Bus: Shower Power 2001
60,000 Chartpak colored film flowers on clear vinyl shower curtains, aluminum frame

VW Bus: Shower Power (detail) 2001
60,000 Chartpak colored film flowers on clear vinyl shower curtains, aluminum frame

Manufractured **Form Follows Perception: Devorah Sperber**

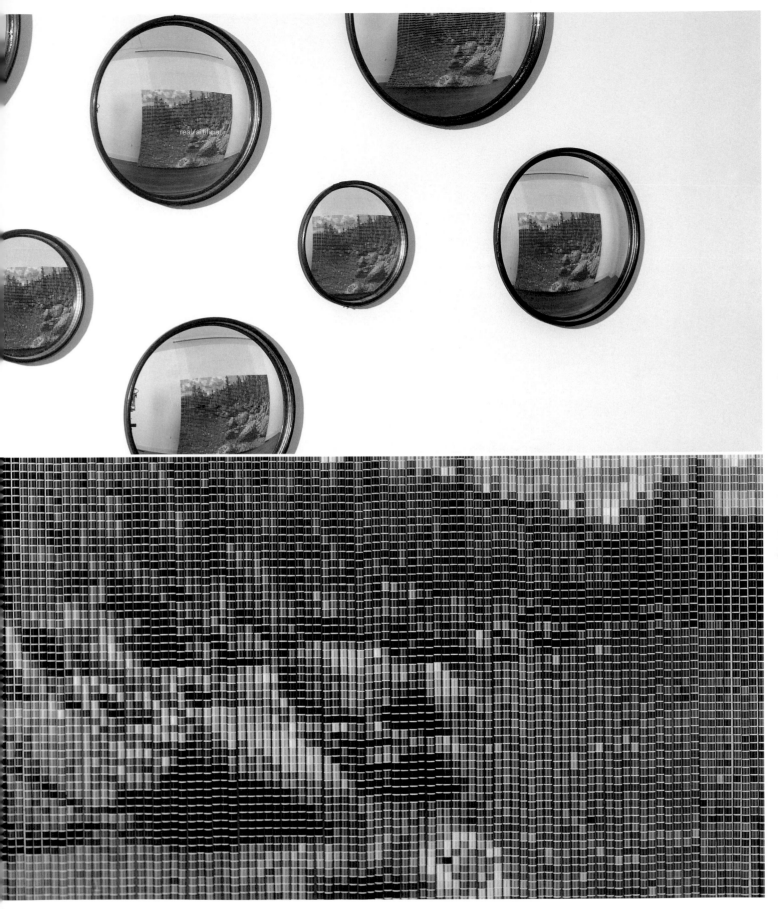

illusion of an illusion

Manufactured **Form Follows Perception: Devorah Sperber**

Lie Like a Rug (detail) 2000–01
18,000 Letraset marker caps, on flexible
canvas, rubber edging, convex viewing
mirror

of the pixel, an apt material for the three-dimensional expression of two-dimensional computer images. When viewed through spheres or mirrors, the brain fills in any gaps in the "pixels," giving the impression that each image is complete.

Reflections on a Lake also marked the beginning of her relationship with American thread manufacturer Coats & Clark. Asking for industry donations was a gutsy way to secure art materials, but such an unconventional material called for an equally unconventional approach. Sperber sought out other manufactured products, and she was drawn to the array of Pantone colors available in Letraset's marker collection. When she inquired about a donation of markers, the company offered thousands of caps instead. She immediately set out to find the right form to fit the material.

The inspiration did come, as many great ideas do, completely out of the blue. In her search for digital images on her computer, Sperber happened to look down at the family heirloom Persian carpet underneath her feet. Right there, hiding in plain sight, was the perfect form for the pen caps. She devised a canvas structure and set about carefully selecting colors from among the hundreds of Pantone colors available. The result is a radically simplified version of the intricately patterned carpet. For dynamic interest, she made the piece undulate—a flying carpet—and that undulation is what brings *Lie Like a Rug* to life.

On one hand, *Lie Like a Rug* is an earnest rendition of the original carpet; on the other, it is a multilayered deception. The actual carpet on Sperber's office floor was not a hand-knotted piece from the Middle East, but a machine-made rug, manufactured in the United States by the Karastan Company. In her conscious choice of an American machine-made carpet as a model, Sperber is complicit in the deception. *Lie Like a Rug* is in fact an illusion of an illusion of a Persian carpet. When installed in a gallery setting, the illusion is enhanced by viewing the carpet through a convex mirror hanging on an adjacent wall. Clearly this is a piece in which the artist delights in testing sharp intellectual perception at the same time as her rounded pixel format challenges optical perception.

Lie Like a Rug 2000–01
18,000 Letraset marker caps, on flexible
canvas, rubber edging, convex viewing
mirror

Letraset store shelf

Sperber family rug c.1950s

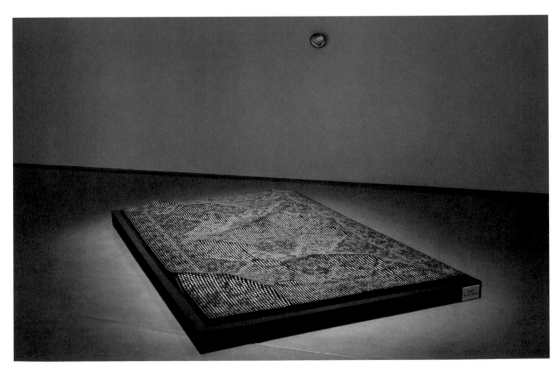

Eastern Standard Time (Original Clock at the Old Penn Station) 2007
5,024 thread spools, aluminum ball chain, hanging apparatus

Manufactured **Form Follows Perception: Devorah Sperber**

conception/deception

"The pixel, from a technology standpoint, is a unit of information; for Sperber, the pixel is a point of intrigue." —Leslie Umberger, curator

Up close, Sperber's work reveals her raw materials in a pure, unaltered state. Each component relates directly to a specific action that she undertakes to create the work—each sticker stuck, each spool of thread strung. Like a painter who leaves visible brush strokes on the surface of the canvas, she has made her process remarkably transparent. It takes a certain confidence to pull the curtain aside and show the apparatus of one's method of creation, and Sperber has shown that confidence time after time.

Some of this confidence comes from the artist's painstaking approach to making each one of her works by hand in the time-honored craft world tradition. Like a designer, she begins by developing a set plan for the design of the entire piece. Then using natural kinesthetic intelligence that engages the body with the mind, she meticulously places one element after another into its proper position. This is her favorite part of any project—the calming meditative period of hand production that is as integral to her process as it is emotionally rewarding.

Sperber's insistence on the handmade in her work does not mean that she is unwilling to use technology. On the contrary, she has embraced the use of computers and scientific processes. In doing so, she belongs to a longstanding tradition of artists who have employed optical techniques and apparatuses to enhance and advance their art. In the sixteenth century, Hans Holbein experimented with anamorphic perspective, adding symbolic imagery to his tightly controlled portraits, the most famous of which was a stretched skull that he added to his painting *The Ambassadors*. A century later, Johannes Vermeer used the camera obscura as a framing device to visualize his interior settings, giving his paintings their characteristic intimate and timeless nature in the process. More recently, Chuck Close developed a reductive strategy for segmenting his subjects into color components that seamlessly assemble into a whole. Although the technique emerged from degrading printing blocks, the resulting patterns prefigure the pixel well before digital technology made the aesthetic obvious. Sperber pays homage to all three by translating their paintings into her own artistic language.

As a compelling provocateur of perception, Devorah Sperber creates art that engages the body, the intellect, the intuition, and the emotions all at once. Because her work operates at so many different levels, it has the ability to connect with a wide variety of viewers: From the casual museum visitor to the art critic, from the scientist to the layman, all can experience something of value in a Sperber piece. By tending to all types of perception, she has created a body of work that is highly intellectual and highly technical at the same time that it highly accessible. Finding unique ways to engage her audience was not only her goal at the outset but it has proved to be her greatest success.

After Chuck Close (31,684 units, 20,164 units, 4,900 units) 2002–03
Chenille stems, foam board, aluminum panel

haiku for d.s.
abstract, liminal
poetry of the pixel
blurring to focus
—s.s.h.

Connections: Art About Art
Sperber re-envisions some of history's most celebrated paintings, reproducing them in thread spools, chenille stems, and other unexpected already-made materials. Each element works together to create a pixilated representation of the iconic original; the brain's perceptual and cognitive abilities become the real subject of each of these pieces.

After Holbein 2003–04

After The Mona Lisa 4 2006

After Vermeer 1 2003–04

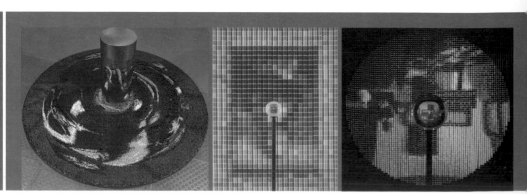

Manufactured **Form Follows Perception: Devorah Sperber**

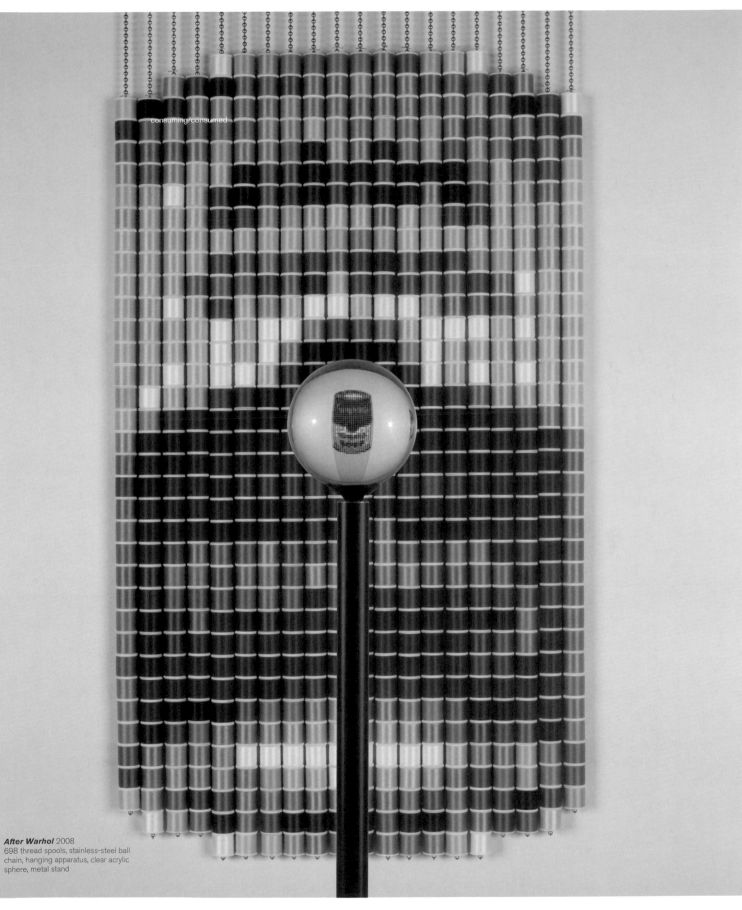

consuming/consumed

After Warhol 2008
698 thread spools, stainless-steel ball
chain, hanging apparatus, clear acrylic
sphere, metal stand

Credits and Extended Captions

All photos courtesy of the artist unless otherwise specified. Raw materials photos pages 47, 67, 77, 87, 97, 107, 117, 127, 147 by Katherine Gin.

Title Page
Hella Jongerius
Groove and Long Neck Bottles 2000
Glass, porcelain, plastic packing tape
Distribution JongeriusLab Rotterdam,
Netherlands

Contents
Régis Mayot
Dissection 2001
Photograph of carved plastic bottles
35.5 x 35.5 in.

Acknowledgments
Harriete Estel Berman
Polysyllabic 1986
From *Critic's Choice* (series)
Nickel-plated and painted brass body, sterling silver helicoid blade with stamped lettering
7.5 x 6 x 3 in.

Introduction: Art, Craft, and Design Realigned
Kathryn Spence
Paper Towels 2003
Embroidered paper towels, thread
11 x 4–6 in. each
Courtesy of Stephen Wirtz Gallery,
San Francisco, California

Sonya Clark
Twenty One 1998
Cloth, thread
13 x 5 x 5 in.
Photo by Tom McInvaille

Laura Splan
Prozac, Thorazine, Zoloft 2000
Hand latch-hooked rug on canvas pillows
11 x 36 x 11 in. each pillow

William Sistek
BubbleWare #1™ 2007
Blown glass
15 x 6.5 in.

Marcel Wanders
Knotted Chair 1996
Carbon fiber, epoxy-coated aramid fibers
21 x 25.25 x 28.75 in.
Manufactured by Cappellini, Italy

Daina Taimina
Knitted Math: Five Fold Symmetry 2007
Cotton yarn
20 x 20 x 20 in.

From Readymade to Manufactured: Some Assembly Required
Marcel Duchamp
Fountain 1950 (replica of 1917 original)
Glazed ceramic, urinal, black paint
12 x 15 x 18 inches
Collection of the Philadelphia Museum of Art,
Philadelphia, Pennsylvania
Gift (by exchange) of Mrs. Herbert Cameron Morris, 1998
Photo by Graydon Wood
© Artists Rights Society (ARS), New York/
ADAGP, Paris/Estate of Marcel Duchamp

Pablo Picasso
Still Life with Chair-Caning 1912
Oil and oilcloth on canvas, rope frame
10.625 x 13.75 in.
Collection of Musée Picasso, Paris, France
©2008 Estate of Pablo Picasso/Artists Rights Society (ARS), New York, New York

Robert Rauschenberg
Bed 1955
Oil and pencil on pillow, quilt, sheet on wood supports
75.25 x 31.5 x 8 in.
Collection of the Museum of Modern Art,
New York, New York
Gift of Leo Castelli in honor of Alfred H. Barr, Jr.

Louise Nevelson
Dawn's Wedding Feast 1959
Wood construction painted white
Installation view of the exhibition "16 Americans" at the Museum of Modern Art,
New York, New York
Digital image © The Museum of Modern Art/
Licensed by SCALA/Art Resource, New York,
New York
© Estate of Louise Nevelson/Artists Rights Society (ARS), New York, New York

Dan Friedman in collaboration with Paul Ludick
Mutant Chair 1985
Painted wooden furniture parts
89 x 53 x 56 in.
Collection of San Francisco Museum of Modern Art,
San Francisco, California
Gift of Rebecca and Michael Friedman in memory of their uncle Dan Friedman
Photo by Joe Coscia Jr.

Qunnie Pettway
Lazy Gal Variation quilt 2003
Corduroy
81 x 70 in.
Courtesy of the artist, William Arnett, and the Tinwood Alliance, Atlanta, Georgia
Photo by Steven Pitken/Pitken Studio

John Chamberlain
Glossalia Adagio 1984
Painted, chrome-plated steel vehicle panels
83 x 7 x 124 in.
Collection of the Philadelphia Museum of Art,
Philadelphia, Pennsylvania
Gift of Mr. and Mrs. David N. Pincus, 2000
Photo by Graydon Wood
© John Chamberlain/Artists Rights Society (ARS), New York

Sarah Sze
Things Fall Apart 2001
Mixed media installation with vehicle
Installation at San Francisco Museum of Modern Art atrium
Collection of San Francisco Museum of Modern Art , Accessions Committee Fund
Gift of Collectors Forum, Jean and James E. Douglas, Jr., Doris and Donald Fisher, Mimi and Peter Haas, Lenore Pereira-Niles and Richard Niles, and Helen and Charles Schwab
© Sarah Sze
Photo by Frank Oudeman

Nina Katchadourian
Austria (photo) 2006
C-print of dissected Austrian road map
30 x 40 in.

Boris Bally
Pennsylvania 79 c. 2001
Ride! c. 2005
Man in Stereo: Muybridge Platter 2007
Recycled traffic signs
25.5 x 4 in. each
Humanufactured (hand-spun, lathe-turned components, riveted, pierced)

Gaetano Pesce
Pharmacie Bleu bowl 1988–92
Glass bottles
Collection of CIRVA, Marseille, France
Courtesy of CIRVA Centre international de recherche sur le verre e les arts plastiques

Kim Beck
Holymoley Land 2006
Laser-cut insulation foam, paper chipboard, wall drawing
Installation at Pittsburgh Center for the Arts,
Pittsburgh, Pennsylvania

Hella Jongerius
Groove and Long Neck Bottles 2000
Glass, porcelain, plastic packing tape
Manufactured by JongeriusLab Rotterdam,
Netherlands

Rik Nelson
Clear Cut 1994-95
134 assorted plastic containers, wood frame
78 x 78 in.
Photo by Pipo Nguyen-Duy

Chris Jordan
Shipping Containers 2007
Photograph of digital composition
60 x 120 in.
Depicts 38,000 shipping containers, the number of containers processed through American ports every twelve hours.

Willie Cole
With A Heart of Gold 2005–06
Shoes, wood, screws, metal, staples
85 x 16 in.
Courtesy of Alexander and Bonin,
New York, New York
Photo by Jason Mandella

Harriete Estel Berman
Square Yard of Grass 1998
Recycled tin containers, copper base
6 x 36 x 36 in.
Photo by Philip Cohen

Jerry Bleem
Monument (After Barlach) 2001
Found corrugated plastic, staples
10.5 x 17.25 x 11 in.

Fred Tomaselli
Echo, Wow and Flutter: Sideways, Flopped and Mirrored 2006
Wallpaper
40 x 120.5 in.
Published by Wallpaper LAB,
New York, New York
Courtesy of Wallpaper LAB,
New York, New York

Rex Ray
Paper Collages 1997–2006
Magazine clippings on watercolor paper
8 x 11 in. each

Tara Donovan
Untitled (Paper Plates) 2003
Paper plates, glue
13 x 38 x 32 in.
Courtesy of PaceWildenstein,
New York, New York
Photography by Ellen Labenski

Devorah Sperber
Virtual Environment 1 1999–2000
20,000 thread spools, aluminum ball chain and hanging apparatus, 36 convex viewing mirrors (2-6 in. diameter)
8 x 21 x 8 ft.
Partial funding by Coats & Clark
Photo by Joshua Neffsky

Tejo Remy
Chest of Drawers (You Can't Lay Down Your Memory) 1991
Found drawers, maple wood, packing strap
23.75 x 43.25 x 47.25 in.

Dominic Wilcox
War Bowl: Green Soldiers 2002
War Bowl: Knights 2002
Melted plastic army soldiers
Approx. 17 x 4 in.

Fernando and Humberto Campana
Transplastic Installation 2007
Plastic lawn chairs, woven apui, lighting components
Installation at Albion Gallery,
London, United Kingdom
Courtesy of Albion Gallery,
London, United Kingdom

Cat Chow
Keeper 2008
Keys, steel ring
28 x 28 x 1 in.
Photo by James Prinz

Stuart Haygarth
Tide Chandelier 2004
Found plastic objects
59 in. diameter
Edition of 10

Donna Rhae Marder
English/Irish Teapot 2003
Sewn teabag wrappers, wire, fabric
6.6 x 9 x 7 in.
Photo by Dean Powell

Tom Fruin
Phillie Clouds 2006
Found drug bags, thread
30 x 33 in.
Courtesy of Vanessa Buia Gallery,
New York, New York
Photo by Tom Powel

Chakaia Booker
Acid Rain 2001
Rubber tires, wood
150 x 252 x 24 in.
Courtesy of Malborough Gallery,
New York, New York

Mitra Fabian
Proliferation Series 2005
Tape, mixed media
Approx. 14 x 14 x 8 in. each

Eduardo Abaroa
Untitled 2005
Plastic straws, silicone
18 x 18 x 18 in.
Courtesy of Wignall Museum, Chaffey College,
Rancho Cucamonga, California
Photo by Jan Volz, 2006

Jason Rogenes
Icecreammaker lamp 2004
EPS foam inserts, electric components
22 x 11 x 10 in.
Private collection
Courtesy of Susanne Vielmetter Los Angeles Projects
Photo by Gene Ogami

Gloria Crouse
Tying the Knot wedding ensemble 1996
Plastic six-pack rings, rip-stop nylon selvage

El Anatsui
Sacred Moon 2007
Aluminum liquor bottle caps, copper wire
103 x 141 in.
Courtesy of Jack Shainman Gallery,
New York, New York

Liz Hickok
The City 2005
San Francisco in Jell-O Series
C-print of orginal sculpture in Jell-O brand gelatin

Brian Jungen
Cetology 2002
Plastic lawn chairs, metal
Collection of the Vancouver Art Gallery,
Vancouver, British Columbia
Purchased with the financial support of the Canada Council for the Arts Acquisition Assistance Program and the Vancouver Art Gallery Acquisition Fund, 2003
Photo by Trevor Mills, Vancouver Art Gallery

Nancy Rubins
Big Pleasure Point 2006
Stainless steel, aluminum, and fiberglass boats,
stainless steel wire
45 x 55 ft.
Installation at Josie Robertson Plaza, Lincoln
Center, New York, New York
Presented in partnership with Public Art Fund
Courtesy of Gagosian Gallery, New York, New York
Photo by Eric Ansel Koyama

Constantin and Laurene Leon Boym
Salvation Stack 2002
Ceramic dishes, Extreme Adhesive glue
Approx. 17 in. tall
Photo courtesy of Moooi, Breda, Netherlands

Form Follows Dissection: Régis Mayot
All work by Régis Mayot unless otherwise
specified

Grand Magasin (detail) 2001
Carved plastic bottles, metal, Plexiglas
71 x 43 x 9.25 in.

Grand Magasin 2001
Carved plastic bottles, metal, Plexiglas
71 x 43 x 9.25 in.

Enfin, y'a plus de pétrole 2005
Carved plastic bottles
43 x 43 x 8 in.

Andy Warhol
One Hundred Campbell's Soup Cans 1962
Synthetic polymer paint on canvas
72 x 52 in.
Collection of the Albright-Knox Art Gallery, Gift
of Seymour H. Knox, Jr., 1963
Photo courtesy of The Andy Warhol Foundation,
Inc./Art Resource, New York, New York
© 2008 Andy Warhol Foundation for the Visual
Arts/ARS, New York, New York

Andreas Gursky
99 Cent 1999
C-print mounted to Plexiglas in artist's frame
81 x 133 in.
© 2008 Andreas Gursky/Artists Rights Society
(ARS), New York/VG Bild-Kunst, Bonn

Kevin Landers
Chip Rack 2005
Wire, electrical conduit, epoxy, polypropylene,
vinyl, Mylar, metallic tape, styrofoam
88 x 48.5 x 22.5 in.
Courtesy of Elizabeth Dee Gallery,
New York, New York

Mètres 1999
Carved plastic bottles
39.5 in. high

L'echantillon (prototype) 2007
Carved plastic bottles
12 x 12 x 14 in.

Bidonville 2007
Carved plastic bottles
36.5 x 11 x 14 in.

Flip book (vert) 2007
Process photographs of a bottle dissection
1.5 x 2 in.

Mine 2005
Recycled plastics, rivets, fluorescent lights
20 x 16 x 12 in.

Mexican Mine (Tulum Beach) 2007
Recycled printed plastics, rivets, fluorescent lights

Scribemine 2005
Recycled plastics, rivets, fluorescent lights
24 x 16 x 12 in.

Mines (couple) 2001
Recycled plastics, rivets, fluorescent lights
10 x 12 x 12 in., 10 x 10 x 12 in.

Form Follows Fabrication: Cat Chow
All work by Cat Chow unless otherwise
specified

Zipper Dress (detail) 1999
Single length of zipper, thread
72 x 28 x 25 in.
Photo by James Prinz

Zip Set 2001
Two single lengths of zipper, thread
72 x 24 x 14
Photo by Nicole Radja

Zipper Dress 1999
Single length of zipper, thread
72 x 28 x 25 in.
Photo by James Prinz

Zipper Dress (process) 1999
Photo by J. Patrick Walsh III

Tied 2000
Cardboard bobbins, plastic twist ties
72 x 15 x15 in.
Collection of Beverly Valfer
Photo by James Prinz

Trained 2000
Plastic jewelry tags
75 x 28 x 74 in.
Photo by James Prinz

Bonded 2000
Single length of zipper, thread
76 x 30 x 31 in.
Photo by James Prinz

Not for Sale 2003
1000 shredded U.S. dollar bills, fishing line,
glue, list of 1000 sponsors
72 x 31 x 28 in.
Collection of the artist
Photo by James Prinz

Measure for Measure 2003
Woven measuring tapes, fishing line, buttons
72 x 32 x 21 in.
Photo by James Prinz

Eva Hesse
Ringaround Arosie 1965
Pencil, acetone, enamel paint, ink and cloth-
covered electrical wire on papier maché and
Masonite
26.375 x 16.375 x 4.5 in.
Collection of the Museum of Modern Art,
New York, New York
© The Estate of Eva Hesse. Hauser & Wirth,
Zürich, Switzerland and London, United Kingdom

Eva Hesse
Untitled or Not Yet 1966
Net bags, polyetheylene sheeting, paper, metal
weights, string
71 x 15.5 x 8.25 in.
Collection of the San Francisco Museum of
Modern Art, San Francisco, California
Purchased through a gift of Phyllis Wattis
© The Estate of Eva Hesse. Hauser & Wirth,
Zürich, Switzerland and London, United Kingdom

Eva Hesse
Accession II 1969
Galvanized steel, rubber tubing
30.75 x 30.75 x 30.75 in.
Collection of the Detroit Institute of Arts
purchased by Founders Society with funds of
Friends of Modern Art and miscellaneous gifts.
© The Estate of Eva Hesse. Hauser & Wirth,
Zürich, Switzerland and London, United Kingdom

Consume 2003
Two single lengths of zipper, thread
60 x 60 x 3 in.
Photo by James Prinz

unDress 2004
Single length of zipper, thread
1 x 18 x 18 in.
Photo by Martha Williams

One Hit Wonders 2007
Leather belts, nails
12 x 120 x 1 in.
Photo by Aimee Koch

Ceremony 2008
Brass chain mail
20 x 5 x 3 in.
Photo by James Prinz

Repeater 2007
Leather belts, nails
40 x 40 x 1 in.
Photo by Aimee Koch

Form Follows Accretion: Jason Rogenes
All work by Jason Rogenes unless otherwise
specified

project 7.47a (detail) 1998
EPS foam inserts, electrical components
120 x 120 x 18 in.
Installation at Henri Duarte,
Los Angeles, California

transpondor 2005
EPS foam inserts, electrical components
45 feet x 24 x 30 in.
Installation at One Colorado Tower,
Pasadena, California
Courtesy of the artist and Susanne Vielmetter
Los Angeles Projects

Neal Stephenson
Snowcrash (book cover) 1992
Used by permission of Bantam Books, a
division of Random House, Inc.

2001: A Space Odyssey (poster) 1968
Courtesy of Warner Bros.

Stanley Kubrick
2001: A Space Odyssey (film still) 1968
Photo by John Jay/MPTV.net

project transmission 2002
EPS foam inserts, electrical components
26 ft. x 38 x 35 in.
Installation at Art Chicago, Navy Pier, Chicago,
Illinois
Courtesy of the artist and Susanne Vielmetter
Los Angeles Projects
Photo by Saverio Truglia

locus 2007
EPS foam inserts, cardboard, electrical
components
38 ft. x 36 x 31 in.
Installation at Whitney Altria, New York, New York
Courtesy of The West Collection
Photo by George Hirose

project 7.47a 1998
EPS foam inserts, electrical components
120 x 120 x 18 in.
Installation at Henri Duarte,
Los Angeles, California

leroy lightning 2007
EPS foam inserts, electrical components
10 x 13 x 6 in.
Courtesy of Jenny Gage and Tom Betterton
Photo by Tom Betterton

project 9.08f 2001
EPS foam inserts, cardboard, electrical
components
45 ft. x 24 x 30 in.
Installation at Susanne Vielmetter
Los Angeles Projects, Los Angeles, California
Courtesy of the artist and Susanne Vielmetter
Los Angeles Projects
Photo by Gene Ogami

project 5.13 2002
Pen, ink on paper
20 x 30 in.
Private Collection

dreamweaver 2004
EPS foam inserts, electrical components
68 x 112 x 130 in.
Installation at Susanne Vielmetter
Los Angeles Projects, Los Angeles, California
Courtesy of the artist and Susanne Vielmetter
Los Angeles Projects
Photo by Gene Ogami

diagram 3.13c 2008
EPS foam inserts, cardboard, electrical
components
120 x 216 in.
Installation at 101 California Plaza,
San Francisco, California
Courtesy of the artist and Susanne Vielmetter
Los Angeles Projects

diagram 3.03c 2008
EPS foam inserts, cardboard, electrical
components
120 x 120 in.
Installation at 101 California Plaza,
San Francisco, California
Courtesy of the artist and Susanne Vielmetter
Los Angeles Projects

transpondor 3.03 2008
EPS foam inserts, electrical components
35 ft. long
Installation at 101 California Plaza,
San Francisco, California
Courtesy of the artist and Susanne Vielmetter
Los Angeles Projects

Form Follows Fusion: Sonya Clark
All work by Sonya Clark unless otherwise
specified

Untitled (detail) 2008
Plastic combs, thread
65 x 45 x 1 in.
Photo by Taylor Dabney

Dryad 1998
Cloth, thread
15 x 8 x 8 in.
Collection of James Dozier
Photo by Tom McInvaille

Onigi 13 1997
Cloth, thread
18 x 12 x 12 in.
Collection of the Madison Museum of
Contemporary Art, Madison, Wisconsin
Photo by Tom McInvaille

Triad 1998
Cloth, thread
13 x 5 x 5 in.
Collection of the Madison Museum of
Contemporary Art, Madison, Wisconsin
Photo by Tom McInvaille

Two Trees 2002
Cloth, thread
12 x 20 x 5 in.
Collection of the Indianapolis Museum of Art,
Indianapolis, Indiana
Photo by Tom McInvaille

7 Layer Tangle 2005
Plastic combs
10 x 30 x 30 in.
Photo by Tom McInvaille

Stacked 2005
Plastic combs
12 x 24 x 24 in.
Photo by Tom McInvaille

Wavy Strand 2005
Plastic combs
5 x 10 x 20 in.
Photo by Tom McInvaille

Toothless (detail) 2006
Plastic combs
96 x 65 x 6 in.
Photo courtesy of John Michael Kohler Arts
Center, Sheboygan, Wisconsin

**Ivory comb with the story of Susanna at
her bath** Gothic period
Collection of the Museo Nazionale del Bargello,
Florence, Italy
Photo courtesy of George Tatge, Alinari/
Art Resource, New York, New York

**Comb decorated with Ashanti allegorical
figures from Ghana** n.d.
Private Collection
Photo courtesy of Werner Forman/Art Resource,
New York, New York

**Comb ornamented with Scyths in combat
from Solokha South Russia** 6th-4th century
BCE
Collection of the Hermitage, St. Petersburg,
Russia
Photo courtesy of Werner Forman/Art Resource,
New York, New York

Untitled 2008
Plastic combs, thread
65 x 45 x 1 in.
Photo by Taylor Dabney

**Form Follows Provocation: Constantin
and Laurene Leon Boym**
All work by Constantin and Laurene Leon Boym
unless otherwise specified ·

Salvation Ceramics (close-up) 2002
Ceramic dishes, Extreme Adhesive glue
Sizes variable
Manufactured by Moooi, Breda, Netherlands
Courtesy of Moooi, Breda, Netherlands

Recycle vase (prototype) 1988
Wood frames, milk carton, laminate

American Plumbing 1999
PVC plumbing parts, plumbers glue
8 x 9 in., X x 10 in.
Manufactured by Benza, New York, New York

Antenna Clock 1989
Cardboard, staples, clock mechanism
Size variable
Manufactured by Morphos, Seriate, Italy

Tin Man Canisters 1993
Stainless steel
7.75 x 4 in.
Manufactured by Alessi, Crusinallo, Italy

Searstyle armchair and footrest (prototype)
1992-94
Wood, Sears catalog replacement parts
Produced in collaboration with artists Komar and
Melamid

Salvation Still Life 2000
Salvation Stack 2000
Salvation Low Stack 2000
Ceramic dishes, Extreme Adhesive glue
Sizes variable
Photo by Gordon Joseph

Salvation Ceramics 2002
Ceramic dishes, Extreme Adhesive glue
Sizes variable
Manufactured by Moooi, Breda, Netherlands
Photos courtesy of Moooi, Breda, Netherlands

Ultimate Art Furniture 2006
Wood, painted canvas, mirror
Chair 39 x 21 x 22 in.
Mirror 42 x 32 in.

Real Plates 2004
Ceramic with digtial decal
9 in. dia.
Manufactured by Conduit for Cooper-Hewitt
National Design Museum, New York, New York
Photo by Cooper-Hewitt National Design
Museum, New York, New York

**Form Follows Subversion: Harriete Estel
Berman**
All work by Harriete Estel Berman unless
otherwise specified

Witnessing the Weight of Words
(detail) 1996
Pre-printed steel from recycled containers
20 x 18 x 18 in.
Collection of the Racine Art Museum,
Racine, Wisconsin
Photo by Philip Cohen

Patchwork Quilt, Small Pieces of Time
1989
Pre-printed steel from antique dollhouses,
Log Cabin quilt pattern
10.5 x 10.5 x 10.5 in.
Photo by Philip Cohen

Baby Block to Creativity 1990
From *A Pedestal for a Woman to Stand On*
(series)
Pre-printed steel from antique dollhouses,
Baby Block quilt pattern
12 x 12 x 12 in.
Photo by Philip Cohen

**My American Kitchen Saves Me Two
Hours a Day to Keep Myself Looking
Young** 1991
From *A Pedestal for a Woman to Stand On*
(series)
Pre-printed steel from antique dollhouses,
Broken Dishes quilt pattern
14 x 12 x 12 in.
Photo by Philip Cohen

**We Are Reflected in the Objects We
Choose to Surround Ourselves** 1991
From *A Pedestal for a Woman to Stand On*
(series)
Pre-printed steel from antique dollhouses,
Attic Window quilt pattern
12 x 12 x 12 in.
Photo by Philip Cohen

Barbara Kossy
Harriete Estel Berman in her studio 2007
Photo collage

Witnessing the Weight of Words 1996
Pre-printed steel from recycled containers,
electric motor rotates dial
20 x 18 x 18 in.
Collection of the Racine Art Museum,
Racine, Wisconsin
Photo by Philip Cohen

Hourglass Figure, The Scale of Torture
1994
Pre-printed steel from recycled containers,
Plexiglas window, plastic dial, battery powered
motor, lettering
3 x 12.5 x 13 in.
Photo by Philip Cohen

Fading Identity 2002
Pre-printed tin and steel from recycled
containers, aluminum, 10K gold rivets,
stainless steel screws
19 x 14.5 x 15 in.
Photo by Philip Cohen

Do Not Touch 1998-2000
From *The Deceiver and the Deceived* (series)
Pre-printed steel from recycled containers,
brass and aluminum rivets, brass wire
embroidery
17 x 25 x 3 in.
Photo by Philip Cohen

Consuming Conversation 2001-04
Pre-printed steel from recycled containers,
sterling silver and brass handles, 10k gold rivets,
variant edition of 200 cups
Size variable
Photo by Philip Cohen

Form Follows Infection: Laura Splan
All work by Laura Splan unless otherwise
specified

Trousseau (Negligée #1) (detail) 2007
Cosmetic facial peel, machine embroidery
64 x 16 x 16 in.

Blood Scarf (detail) 2002
Chromogenic prints
24 x 20 in. each
Edition of 5 + 2 AP

Ernst Haeckel
Ascidiacea 1904
Plate 85 in Ernst Haeckel: Art Forms in Nature
1904
Courtesy of Wikipedia Commons

Marcel Wanders
Airborne Snotty Vase (Influenza) 2001
Polyamide
6 x 6 x 6 in.
Manufactured by Marcel Wanders Studio,
Amsterdam, Netherlands
Courtesy of Marcel Wanders Studio,
Amsterdam, Netherlands
Photo by Maarten van Houten

Gail Wight
J'ai des papillons noirs tous les jours
(detail) 2006
Silk, paper, plexiglass, lights, electronics, 2800
bug pins
57 x 31 x 3 in.
Photo by Craig Weiss

Doilies (Hepadna, Herpes, HIV, Influenza)
2004
Freestanding machine embroidered lace
mounted on velvet
16.5 x 16.5 in. each framed
Edition of 10 + 2 AP

Doilies (SARS) process images 2004
Babylock computerized machine embroidery
proprietary software

Doilies (SARS) 2004
Freestanding machine embroidered lace
mounted on velvet
16.5 x 16.5 in.
Edition of 10 + 2 AP

Wallpaper/Samples 2003-08
Blood on wallpaper
Size variable

Trepidation 2004
DVD loop, DVD player, LCD monitor
Running time 11min. 17sec.

Elaborative Encoding 2007
Blood on watercolor paper
15 x 15 in.

Underneath 2003
DVD (color video)

Reflexive #3 (detail) 2004
Blood on Arches Aquarelle watercolor paper
40 x 40 in.

Trousseau (Negligée #1) 2007
Cosmetic facial peel, machine embroidery
64 x 16 x 16 in.

Form Follows Variation: Livia Marin
All work by Livia Marin unless otherwise specified

Ficciones de un uso (detail) 2004
2,200 Lipsticks
126 x 291 x 39 in.
Installation at Museum of Contemporary Art,
Los Angeles, California
Photo page 116 courtesy of Museum of
Contemporary Art, Los Angeles, California

Allan McCollum
Over Ten Thousand Individual Works (detail)
1987-88
Acrylic enamel on cast hydrocal, each piece unique
2 in. dia., lengths variable

Rachel Whiteread
Untitled (One Hundred Spaces) 1995
Resin
Courtesy of the artist and Luhring Augustine
Gallery, New York, New York

Devorah Sperber
Loitering 1999
900 unique hydrocal forms, 3 in. each
Installation at Coffey Gallery, Kingston, New York

El objecto y su manifestación II 2007
1,000 Plaster objects, 20 wooden shelves
Installation at the Peck School of the Arts,
University of Wisconsin, Milwaukee, Wisconsin

El sentido de la repetición 2005
Various household objects, Perspex, wood, lights
Installation at Galeria Animal, Santiago, Chile

Ficciones de un uso 2004
2,200 Lipsticks
126 x 291 x 39 in.
Installation at Museum of Contemporary Art,
Los Angeles, California
Photo page 122-3 courtesy of Museum of
Contemporary Art, Los Angeles, California

**Form Follows Manipulation: Hrafnhildur
Arnardottir**
All work by Hrafnhildur Arnardottir unless
otherwise specified

Harmonic Hairdo #4 (detail) 2007
C-print of artificial hair
Photo by Christopher Lund

Haunted in the Maze of My Mind 2007
Natural and artificial hair
Size variable

Louis-Simon Boizot
**Queen Marie Antoinette, wife of King
Louis XVI**
1781
Marble
35.5 in. high
Collection of the Louvre, Paris, France
Photo by Erich Lessing/Art Resource,
New York, New York

Utamaro Kitagawa
**Geisha of the House of Sumiyoshi before
a mirror** c.1800
Collection of the Musee des Arts Asiatiques-
Guimet, Paris, France
Photo by Erich Lessing/Art Resource,
New York, New York

Dante Gabriel Rossetti
Aurelia (Fazio's Mistress) 1863-73
Oil on mahogany
17 x 14.5 in.
Collection of the Tate Gallery, London, United Kingdom
Photo by the Tate Gallery, London/Art Resource,
New York, New York

Hair Sculpture for Björk's Medulla album 2004
Natural hair
Photo by Inez van Lamsweerde and Vinoodh Matadin

Asta Bjork Fridbertsdottir Traditional memory flowers 2004
Human and horse hair
12 x 5 in.
Photo by Marcus Donates

Hair Sculpture for Björk's Medulla album 2004
Human and horse hair, hair flowers
Approximately 15 x 15 in.
Collection of Bjork
Photo by Inez van Lamsweerde and Vinoodh Matadin

Harmonic Hairdoo #3 wallpaper 2006
Digital image
64 x 44 in.

Harmonic Hairdoo mural 2006
Installation view from "The Dance"
collaboration with photographer Ryan McGinley
14 x 120 ft.
Commissioned by Nike Inc., Portland, Oregon

Human Hair Harp from **Skin Bone Hair** 2008
Collaboration with composer Nico Muhly
Performance commissioned by The Kitchen, New York, New York, March 7, 2008
Photo by Michal Jurewicz

Harmonic Hairdoo #4 2006
C-print
64 x 44 in.

Harmonic Hairdoo #5 2006
C-print
64 x 44 in.

Form Follows Ornamentation: Marcel Wanders
All work by Marcel Wanders unless otherwise specified

Franck Topiary (detail) 2007
Handmade crochet cotton, epoxy resin
32.75 x 32.75 x 112.5 in.
Edition of 5

Crochet Tables 2001
Handmade crochet cotton, epoxy resin
12 x 12 x 12 in.
24 x 12 x 12 in.
Manufactured by Moooi, Breda, Netherlands

Lace Table 1997
Swiss fiberglass lace, epoxy, glass
Manufactured by Droog Design
Courtesy of Marcel Wanders Studio

Mike and Maaike
Empty Pillow 2003
Hytrel thermoplastic polymer
11.75 x 11.75 in.

Louise Campbell
Prince Chair 2001
Laser cut steel, water cut neoprene rubber laminated with felt, powder coated steel frame
37 x 30 x 29.5 in.
Manufactured by HAY, Horsens, Denmark
Courtesy of Louise Campbell

Laura Splan
Painted Doily 2007
Blood on watercolor paper
15 x 15 in.

Crochet Lamp Blossom 2007
Handmade crochet cotton, epoxy resin
55 in. tall
Manufactured by Wanders Wonders, Netherlands

Egg Speaker 2005
Wood veneer
4.875 x 2.5 in.
Manufactured by Holland Electro, Zwolle, Netherlands
Photo by Maarten Van Houten

Topiaries (Sid, Mary, Franck) 2007
Handmade crochet cotton, epoxy resin
Sid 30.25 x 30.25 x 117 in.
Mary 30.25 x 30.25 x 149.5 in.
Franck 32.75 x 32.75 x 112.5 in.
Edition of 5
Manufactured by Wanders Wonders, Netherlands

Crochet Chair 2006
Handmade crocheted rope, epoxy resin
51 x 51 x 25.25 in.
Manufactured by Wanders Wonders, Netherlands

Patina Black Tile 2005
Ceramic tile
6 x 6 in., 8 x 8 in.
Manufactured by Art On Tiles, Mijrecht, Netherlands

Lute Suites 2005
Amsterdam, Netherlands
Photo by Inga Powilleit
Styling by Tatjana Quax

Hexagon wallpaper 2004
Fleece, 6 color varnished silkscreen on paper
43.5 x 45.5 in. diameter
Manufactured by Wanders Wonders, Netherlands

Form Follows Perception: Devorah Sperber
All work by Devorah Sperber unless otherwise specified

Lie Like a Rug (detail) 2000-01
18,000 Letraset marker caps
63 x 99 x 4 in.
Photo by Max Yawney

Blue Bandana 3 2001
14,280 Moore maptacks, clear vinyl
36 x 21 x 2 in. (edition of 3)
Partial funding by Moore Push-Pin Company
Photo by Michel Delsol

VW Bus: Shower Power 2001
60,000 Chartpak colored film flowers on clear vinyl shower curtains, aluminum frame
80 x 63 x 136 in.
Photo by Eric Roper

Reflections on a Lake 1999
5,760 thread spools, aluminum ball chain, hanging apparatus, 36 convex viewing mirrors
72 x 120 (thread spools only)
Partial funding by Coats & Clark
Photo by Nancy Donskoj

Lie Like a Rug 2000-01
18,000 Letraset marker caps on flexible canvas, rubber edging, convex viewing mirror
63 x 99 x 4 in.
Photo by Max Yawney (detail)

Eastern Standard Time (Original Clock at the Old Penn Station) 2007
5,024 thread spools, aluminum ball chain, hanging apparatus
95 x 99 in. (thread only)
Commissioned by NYFA for Vornado Realty Trust for the Lobby of One Penn Plaza, New York, New York
Partial funding by Coats & Clark
Photo by Aaron Deetz

After Chuck Close (31,684 units, 20,164 units, 4,900 units) 2002-03
Chenille stems, foam board, aluminum panel
60 x 60 x 3 in.
48 x 48 x 3 in.
24 x 24 x 3 in.

After Holbein 2003-04
Chenille stems, mixed media, polished stainless steel cylinder
35 x 76 in. diameter

After The Mona Lisa 4 2006
875 thread spools, stainless steel ball chain, hanging apparatus, clear acrylic viewing sphere, metal stand
41 x 31 in. (thread only)
Edition of 5
Partial funding by Coats & Clark

After Vermeer 1 2003-04
4,669 thread spools, clear vinyl tubing, aluminum hanging apparatus, acrylic sphere, metal stand
90 x 96 in. (thread only)
Partial funding by Coats & Clark
Photo by Nils Schlebusch

After Warhol 2008
698 thread spools, stainless steel ball chain, hanging apparatus, clear acrylic viewing sphere, metal stand
42 x 25 in. (thread only)
Partial funding by Coats & Clark

Credits
Ingo Maurer
Porca Miseria! 1994
Porcelain, silverware
Courtesy of Ingo Maurer GmbH
Photo by Tom Vack, Munich, Germany